C O N T R A C T

W I T H T H E

S K I N

C O N T R A C T

W I T H T H E

S K I N

K A T H Y O ' D E L L

M A S O C H I S M

P E R F O R M A N C E A R T

A N D T H E 1 9 7 0 s

University of Minnesota Press
Minneapolis • London

MINNESOTA

Copyright 1998 by the Regents of the University of Minnesota

Published by the University of Minnesota Press
111 Third Avenue South, Suite 290
Minneapolis, MN 55401-2520
http://www.upress.umn.edu

Printed in the United States of America on acid-free paper

Library of Congress Cataloging-in-Publication Data

O'Dell, Kathy.
 Contract with the skin : masochism, performance art, and the 1970s /
 Kathy O'Dell
 p. cm.
 Includes bibliographical references and index.
 ISBN 0-8166-2886-6 (hc : alk. paper). — ISBN 0-8166-2887-4 (pbk.
 alk. paper)
 1. Performance art. 2. Masochism in art. I. Title.
 NX456.5.P38034 1998
 700'.9'045—dc21 97-45530
 CIP

10 09 08 07 06 05 04 03 02 01 00 99 98 10 9 8 7 6 5 4 3 2 1

For John Mernit

CONTENTS

ILLUSTRATIONS

PREFACE

BREATHLESS and excited, I am racing toward an old brick warehouse with my trophy: a heavy-duty, thirty-foot, orange extension cord hanging in multiple loops over my shoulder. Careening around the corner, through the double doors and down a ramp, banging into everything and everyone I pass, I arrive just in time to plug in the cord and allow the performance to begin. This is the image that comes to mind when I ponder my introduction to performance art. It was 1977, and I was the program coordinator at 80 Langton Street, a defunct coffin factory in San Francisco that had been converted into a nonprofit art space. Our mission was to present work that commercial galleries and museums would not touch at the time—such as performance art. My main task, besides helping the board of directors review artists' proposals and search for funds, was simply getting the show on the road. This meant making lots of runs to the airport, finding the cheapest palatable wine for receptions, and scrounging up those last-minute items the artists always seemed to need. "The neighbor *must* have another thirty-foot extension cord we could borrow." I'm not sure I could have provided a definition of performance art while I was at 80 Langton Street, or that I wanted to. During those heady days of the alternative art space movement, all I knew was that what I was experiencing was important and alive.

Later, when I did decide to seek out definitions, I had the good fortune of enrolling in Kristine Stiles's seminar on the history of performance art at the Univer-

sity of California at Berkeley in the fall of 1979. What I did not know at the time was that Stiles's course was one of the first on performance within the discipline of art history (RoseLee Goldberg had taught a similar course at the School of Visual Arts in New York the year before). Since then, many other scholars and critics have started to teach and study performance art. All of us owe a great deal to the work of Kristine Stiles and RoseLee Goldberg.

In her classic book *Performance: Live Art 1909 to the Present*, published in 1979, Goldberg showed that visual artists had been engaging in "performance art," as it came to be called in the early 1970s, since the beginning of the twentieth century. But Goldberg's book was the first comprehensive book to survey this topic. It was a gutsy move. Every general art historical survey of this sort is criticized mercilessly for who is included, who is not included, and which issues are addressed. Goldberg willingly faced such criticisms because she was—and *is*—devoted to the topic. Her rapture, her ongoing work on performance art, and her spirit of inclusiveness toward all of us who have joined her in this field have made Goldberg a model and an inspiration. She is, indeed, "la grande dame" of performance art history.

But Kristine Stiles had an even more direct effect on the course of my own work. While she was teaching the Berkeley seminar, she was also entrenched in research for her doctoral dissertation, a one-thousand-page manuscript titled "The Destruction in Art Symposium (DIAS): The Radical Cultural Project of Event-Structured Live Art," which will no doubt remain the definitive analysis of that landmark event. Stiles's commitment to grappling with the topic of destruction in art inspired me to take on a similarly controversial topic—masochism in art. The turning point in my interest came, I believe, the day Stiles introduced to the seminar a visiting lecturer: Chris Burden. As he spoke, I kept looking back and forth between the slides of his performances and the actual person standing before me. Burden was calmly talking about crawling across broken glass or having nails pounded through his hands, but his short descriptions did not match the overwhelming power of what I was seeing. At the time, I was confused and a little anxious. Now, I think that what Burden was saying—precisely by not saying it—was what Stiles had been saying in her lectures: we, as viewers, are an active part of the artist's work.

By now, this view is commonly accepted. But it is important for me to recall the strange sensation of a time when it was not. And performance art has been instrumental in making that case. As I looked at Burden's slides that day and listened to him speak, I knew I wanted to dig deeper, to try to understand and explain this work. Why, I asked myself, would artists push their bodies to such extreme physical and psychological limits? Intuitively, I knew that women's rights, gay rights, civil rights, and the Vietnam War were all part of the reason. But I also sensed that the masochistic bond between performers and audiences was a key to the situation. In the end, it was the

intensely political connections among these various levels that proved most enigmatic and deserving of nuanced investigation. This book is the culmination of my inquiry. I thank Stiles for serving as my mentor in this intellectual pursuit. I treasure our years of friendship, conversations over coffee, critical readings, and mutual support.

Such close and energizing relationships, in which thoughts flow freely and rapidly, are invaluable, but they sometimes make the proper attribution of ideas difficult. Therefore, let me apologize in advance to all my colleagues, friends, and students for any oversights that you may discover as you read this book; these are the inadvertent consequences of intellectual camaraderie. Many individuals have written on performance in the last few decades and have prompted my own thoughts. Among the most notable are Maurice Berger, Kelly Dennis, Saundra Goldman, Chrissie Iles, Amelia Jones, Liz Kotz, Peggy Phelan, and Rebecca Schneider. In related areas of scholarship, Martha Buskirk, Rosalyn Deutsche, David Joselit, Therese Lichtenstein, Micki McGee, Leslie Prosterman, Ann Reynolds, and Mary Anne Staniszewski have also been consistent sources of insight and support.

I also thank Hal Foster, Amelia Jones, Rosalind Krauss, Rose-Carol Washton Long, Linda Nochlin, Ann Reynolds, and Kristine Stiles for very specific feedback on earlier versions of this manuscript. Moreover, the extraordinary editorial talents of Brian Wallis have gone the furthest in helping to enrich and refine my text. I am indebted to his assistance.

Special thanks go to Biodun Iginla, my first editor at the University of Minnesota Press, for his enthusiasm for this project, and to my subsequent editor, William Murphy, and his associate, Robin A. Moir. The following individuals at the press were also enormously helpful in preparing the book for publication, and I deeply appreciate their skillful attentiveness: Daniel Leary, production coordinator; Amy Unger, production manager; Laura Westlund, managing editor; and Tammy Zambo, copyeditor. I am also grateful to David Yager, chair of the Department of Visual Arts at the University of Maryland Baltimore County, for consistently supporting my scholarly efforts, and to Jo Ann E. Argersinger for granting me a Provost's Research Fellowship to complete this manuscript. Other UMBC colleagues who have taken special interest in my topic include Carol Fastuca, Colin Ives, Preminda Jacob, and Phyllis Robinson. The efforts and insights of Kate Schaffer, my research assistant in the later stages of this project, were a true gift.

Family members who have cheered me on over the years are too numerous to list, but I trust they know how crucial their support has been. I do need to highlight Larry Landphair and John Mernit, who have consistently rescued me from taking masochism too seriously.

Finally, I thank the artists who are the central focus of this book. Marina Abramović, Vito Acconci, Chris Burden, and Ulay generously granted interviews and

engaged in correspondence with me; their contributions were invaluable. Regrettably, Gina Pane's death in 1990 precluded any such possibility for dialogue. I am also grateful for conversations with Ron Athey, Lutz Bacher, Robby Garfinkel, and Simon Leung, artists whose work I address in the conclusion. Above all, I thank the artists mentioned in the book for their profoundly moving, if disturbing, works. In being disturbed, we ask questions. In being moved, we seek answers.

HE GOT SHOT

W H A T is arguably the best-known example of performance art—Chris Burden's 1971 performance *Shoot*—might easily be described as masochistic. After all, the performance consisted entirely of Burden's allowing himself to be shot in the arm. As Burden stood before a small audience of friends at a cooperative gallery in Santa Ana, California, his accomplice, a trained sharpshooter, fired a rifle at him at point-blank range (fig. 1). Although Burden had instructed the shooter just to graze his skin, the wound was so severe that the artist had to be given emergency medical attention. But is such an action "masochistic" in the popular sense of the term? Does it suggest pleasure in being subjected to pain? Or are there larger issues and meanings at stake?

Burden's own description of the event is almost neutral in tone: "At 7:45 P.M. I was shot in the left arm by a friend. The bullet was a copper jacket 22 long rifle. My friend was standing about fifteen feet from me."[1] With its calm emphasis on technical details—time, caliber of gun, distance from the shooter—Burden's account reads more like a police report than an account of what for most people would be a shocking and traumatic event. Any critic looking to explain the performance through recourse to intentionality or psychobiographical information from the artist would gain little insight from Burden's tight-lipped statement.

In 1973, when the *New York Times* ran an article about Burden's performance, it was headlined "He Got Shot—

for His Art."[2] The author seemed to suggest that people should be shocked that some-
one would stage actions such as Burden's and, what is more, call them art. Apparently
this was the response of many in the general public: disbelief. Many people felt not
only that they were being put on by these antics, but also that, as art, such perfor-
mances could have little meaning or value.[3]

Despite the public's incredulity, however, Burden's performance was far from
atypical. In fact, it was entirely consistent with a wide strain of 1970s performance art
that centered around individual acts of bodily violence—what I call "masochistic per-
formance." By the early 1970s, numerous performance artists, in various countries,
had begun using their own bodies in highly unconventional ways in performance art-
works. Though from very different backgrounds, all these artists seemed to share a
common set of concerns that can now be regarded as typical of masochistic perfor-
mance. These concerns include the mechanics of alienation in art and everyday life;
the psychological influences of the domestic site on art and everyday life; the sensation
of being both a human subject and an object; the function of metaphor in art; and, es-
pecially, the relationship between artist and audience.

I say "especially" because if there is, in fact, an answer to the often-asked question
"Why would anyone want to do such a thing as willingly endure pain?" it has to do
with the highly complex dynamic between the artist and the audience. In the case of
Burden's *Shoot*, for example, audience members chose not to stop the shooting, just as
the sharpshooter himself chose not to turn down Burden's request. Each of the indi-
viduals involved, therefore, agreed to tacit or specified terms of a "contract" with the
artist. Thus, beyond the other possible meanings of *Shoot* (that it refers to the alien-
ation of the artist from society, to classic film shoot-outs in American westerns, or to
the friendly-fire accidents prevalent in Vietnam, for instance), I would argue that the
crucial implication of such masochistic performances concerns the everyday agree-
ments—or contracts—that we all make with others but that may not be in our own
best interests.

Beyond its specifically legal function, the contract is a central metaphor in mod-
ern life, from the lease on a first home to the Republican Party's vaunted "Contract
with America" of 1994. Masochistic performance artists of the 1970s, such as Burden,
sought to call attention to *the structure of the contract* to emphasize that the real power
of the agreement lies there. In this regard, the artists followed a very basic premise: by
pushing their actions to an extreme, they could dramatize the importance of a trans-
action that is often overlooked or taken for granted.

Certainly, masochistic artists like Burden did not set out to produce a didactic
message about interpersonal contractual arrangements. On the contrary, we might as-
sume that their reliance on masochism (that is, on a desire to suffer or on an active re-
sponse to that desire) issued from impulses beyond rational thought and intention.
Perhaps for this reason, many of the artists specifically rejected the term "masochistic"
when it was applied to their own work. In a 1975 collage called *Novitiate Franciscan*,

for example, Burden incorporated the *New York Times* article about *Shoot* and anno-
tated the author's discussion of masochism with this disclaimer: "The masochist in-
tends to hurt himself, that's not my intent." Nevertheless, as Italian critic Lea Vergine
has argued, masochistic performance artists were always conscious of the process in
which they were involved, even if it did not strike them as masochistic.[4] Similarly, I will
argue that these artists were always conscious of agreements with other people in or at
their performances, even if those agreements did not register for them as contractual.[5]

Five artists, in particular, exemplify the characteristics that I associate with
masochistic performance: Chris Burden, Vito Acconci, Gina Pane, and the perfor-
mance duo Marina Abramović/Ulay (or Ulay/Marina Abramović). All had formal
training in the arts (visual or literary) in their home countries before becoming in-
volved in the international art scene.[6] By the early 1970s, however, all five had turned
from engaging in more traditional art practices to staging performances, which they
did in a variety of settings, ranging from low-key commercial galleries or early alterna-
tive art spaces to private homes or studios.[7] Although, at the time, other artists were
also performing acts of violence against their bodies, some quite extreme, few contin-
ued using their bodies to achieve such far-reaching psychological and physical limits as
Burden, Acconci, Pane, and Ulay/Abramović.[8] In this sense, their performances can be
seen as what film theorist Deborah Linderman calls "limit-texts," works that "quer[y] a
boundary that is normatively repressed in other texts."[9] As limit-texts, the masochistic
works of these five performance artists expose certain aspects or meanings that are ob-
scured in other performance or in more conventional art.

Of course, to speak of performance art of the 1970s as "masochistic" is to engage
in a bit of hyperbole. Putting out fires with one's bare hands and feet (Pane), repeat-
edly biting oneself (Acconci), breathing in water at the risk of drowning (Burden), or
sewing one's mouth shut (Ulay) are not, strictly speaking, masochistic acts, even
though they may reflect some desire to suffer. According to the recent *Diagnostic Sta-
tistical Manual of Mental Disorders* (commonly known as the *DSM-IV*, the primary
reference for official psychiatric diagnoses), masochism must be technically linked
with sexual practice and must entail "recurrent, intense sexually arousing fantasies,
sexual urges, or behavior involving the act (real, not simulated) of being humiliated,
beaten, bound or otherwise made to suffer."[10]

However, if one takes a broader, less clinical approach to masochism, if one tracks
the social history of the term and its fundamental components, then these perfor-
mances clearly qualify as masochistic. The term "masochism" was first employed by the
psychoanalyst Richard von Krafft-Ebing in the late nineteenth century to label what he
recognized as a desire to harm one's own body. Krafft-Ebing derived the name from
the nineteenth-century erotic writings of Léopold von Sacher-Masoch, whose scan-
dalous texts were based in part on his own relationships with women who, under
signed contract, took up roles and committed violence against his body that resulted in
his heightened sexual satisfaction.[11] Although many psychoanalysts after Krafft-

Ebing—including Freud, of course—developed theories of masochism based on such practices, it was not until the late 1960s and early 1970s that these psychosexual views were expanded to include a long overdue legal perspective.

In 1967, French philosopher Gilles Deleuze published the first detailed literary analysis of the novels of Sacher-Masoch (Deleuze's text was first translated into English in 1971).[12] In his cross-referencing of literary and psychoanalytic principles, particularly those laid out in 1949 by psychoanalyst Theodor Reik in an in-depth clinical study of masochistic behavior, Deleuze noticed an important lack. Reik had observed four components to masochism, including fantasy (a "mental preview" of self-induced pain), suspense (the waiting period before the act), demonstration (the act), and provocation (the enticement of a partner to assist in the act).[13] But, as Deleuze pointed out, Reik failed to acknowledge the importance of the agreement between the partners, which Sacher-Masoch had literalized by drawing up actual contracts. Deleuze coined the term "masochistic contract"—a term I am borrowing for this study—to describe such explicit or implicit agreements.[14]

It is my contention that a similar sort of contract exists in masochistic performance art, sometimes between performers themselves (as in the case of Burden and his sharpshooter friend) and always between the performer and audience members. A concrete example of the masochistic contract at work is Pane's *Nourriture, actualités télévisées, feu* (1971), a performance in which she extinguished small fires with her bare hands and feet (fig. 3).[15] Prior to the performance, audience members were informed that before entering the space they would have to agree to deposit a certain percentage of their salaries in a safe at the door. By so doing, Pane demonstrated the otherwise unseen, yet powerful, contractual underpinnings of the relationship between viewer and performer. Moreover, she pointed out the monetary nature of those underpinnings and thereby clarified the interconnectedness of the institutions of art, law, and economics.

Acconci also highlighted these connections, though in a very different way, in his 1970 performance *Trademarks*.[16] After biting himself on as many parts of his naked body as possible, Acconci made ink prints from the bite marks. These prints—"marks" for "trade"—could be seen as artist-produced commodities waiting to be bought by anyone wishing to enter into the economics of such an agreement. But in fact Acconci withheld this opportunity, only publishing photographs of the performance and one print in an art magazine (fig. 4).[17] This mediated gesture perhaps signaled his own wariness of the links between art and commerce and the increasing commodification of the artist's persona.

Thinking of these art world agreements as based in structures of law and economics suggests the social relevance of masochism. Of course, claiming social relevance for masochistic acts is tricky business, as is proven by literary critic Leo Bersani's attempts in *The Freudian Body: Psychoanalysis and Art*. Bersani argues that representations of violence distract the viewer, making it impossible to resolve an image's narrative coherently. In a ninth-century B.C. Assyrian wall relief, for example, Bersani notes how

the bodies of two men and a lion are intertwined so that the viewer cannot tell which hand belongs to which body; they become mere formal integers repeated across the flat stone space. Yet recognizing this repetition does not help the viewer organize the relief's pictorial logic. Rather, the repetition upsets the observer's vision, jerks attention away from the violent anecdotal situation in which the bodies so clearly play a role, and functions "as an arresting movement, or as an agitated and differential reproduction."[18] According to Bersani, this distraction denarrativizes the work and releases the observer from linear logic, reintroducing the viewer to "shattering stimuli" that Bersani calls "masochistic."[19]

Furthermore, Bersani points out that Freud, in his *Three Contributions to the Theory of Sex*, had shown that such masochistic stimuli are typical of the developmental stages of infantile sexuality and that the shattering tension of sexuality is something one seeks to repeat in life, not suppress through logic. Bersani even suggests that there is a benefit to these masochistic distractions: they remind viewers of their relation to real violence in the everyday world. In other words, observations of representations of violence make an individual aware of the power of such "mimetic appropriations *of* the world," (my emphasis), thus deterring destructive impulses from being brought to dangerous climax *in* the world.[20] Bersani regards the viewer's engagement in fantasy as a form of continual self-shattering that resists the identificatory closure suggested by the rigid narrative structure of most art and literature. For him, this imaginary fragmentation is enough to offset the possibility of an actual shattering of the body, of the mind, or of life itself.

Although I would agree that fantasy—a key component of masochism, as Reik noted—can facilitate an individual's journey through the developmental stages of the psyche, I cannot accept that it is sufficient to deter violence. Unless fantasy continually loops individuals back to the materiality of the human body and to an understanding of its complexity as both subject and object, invulnerable and vulnerable, fantasy risks becoming a frivolous avoidance of the vicissitudes of daily sociopolitical relations in which violence is routinely meted out. In the work of the five performance artists being considered here, this loop is always made with the artists' bodies serving as primary material for their performances. For example, Burden began his performance *Velvet Water* (1974) with the fantastical statement that "when you breathe water, you believe water to be a richer, thicker oxygen capable of sustaining life."[21] He then plunged his head repeatedly into a basin of water (fig. 5). In *Talking about Similarity* (1976), Abramović vocalized what she imagined Ulay was thinking as he sewed his own mouth shut (figs. 7-12).[22] No matter how much fantasy such theatrics employed, the audience's attention could never wander far from the reality of the artists' self-tortured bodies. In the end, Burden collapsed from exhaustion. Ulay sat, brutally silenced, staring at the audience.

Some readers may draw connections between the masochistic acts described in this book and the torture of criminals, victims, or political prisoners.[23] But the differences

between the situations are vast—the principal one being that the artists and their audience members had the freedom to stop or walk out of their temporarily incarcerating circumstances. Nonetheless, such performances reminded viewers of their own roles as witnesses and of their own capacity to occupy the position of either perpetrator (subject) or victim (object) of violence.[24] Although this reminder had existed in earlier performance art, as art historian Kristine Stiles has pointed out, it was the obvious evacuation of pleasure in the situations I am addressing that distinguished masochistic performances of the 1970s from their precedents.[25] Even the notorious destruction-oriented performances of the 1960s, which often took the body to extremes and thus presaged masochistic performance, involved a degree of pleasure. The brief but historically important Destruction in Art Symposium (DIAS), organized by Gustav Metzger in London in 1966, brought together artists from around the world whose work concentrated, Stiles has argued, on the dialectic between destruction and creation.[26] Some of the participants most directly connected to this venture were members of the Wiener Aktionismus (Viennese Actionism) group, including Hermann Nitsch, Günther Brus, and Otto Mühl. Nitsch was well known for his Orgies Mysteries Theatre (OMT), which involved, among other things, the destruction of animal carcasses for ostensibly creative, ultimately pleasurable purposes.

As early as 1957, Nitsch had begun his complicated theorization of the OMT, and the structure of his dozens of performances since then has remained fundamentally the same. The works always involve Nitsch's directing a group that manipulates ritual elements such as milk, honey, and carcasses, a process aimed at the pleasurable renewal of the human body through its interaction with the animal world.[27] According to Stiles, in Nitsch's works the body functions as a kind of metonym, a literary device in which an attribute stands for the whole (as in "the punishment was mandated by *the crown*"). Stiles maintains that in these situations the body-as-metonym serves as a bridge, linking audience and performer and making all individuals present feel that they are a material part of a larger, collective social entity.[28] Indeed, in Nitsch's OMT, nobody is allowed to enter Nitsch's performance site merely to observe; all audience members are simultaneously performer-participants.

The metonymic function of the performing body, then, attempts to blur the line between art and life—a concept that held a powerful attraction for performance artists of the 1960s. Robert Rauschenberg had ushered in the decade with his claim "Painting relates to both art and life. Neither can be made. (I try to act in the gap between the two.)"[29] And in his 1966 book *Assemblage, Environments, and Happenings*, Allan Kaprow extended this remark to a veritable credo for Happenings: "The line between art and life should be kept as fluid, and perhaps indistinct, as possible."[30] Although Nitsch's work bore a superficial affinity to Rauschenberg's and Kaprow's principles, it made evident, as Stiles clarifies, that any desire for the complete eradication of the distinctions between art and life was naive, an ideal that could not (and perhaps should not) be realized.[31]

Other early performances that gave 1970s artists permission to push the limits of self-abuse include the quite different works of Viennese Actionism artist Günther Brus and Fluxus artist Yōko Ono. Brus tried to bridge the art/life gap in simple spatial terms, by performing his acts of masochism as close to the audience as possible. In the final performance of his career, *Zerreissprobe* (1970), Brus dressed in a woman's garter belt and stockings as he contorted and cut his body within arm's reach of the audience.[32] And Ono, in works such as *Cut Piece* (performed in Kyoto in 1964, in New York City in 1965, and at DIAS in 1966), figuratively "cut" the dividing line between audience and performer by literally offering viewers a pair of scissors with which to snip the clothing from her body.[33] Erotic and voyeuristic pleasures were offered in both of these pieces: viewers could watch Brus cross-dress and Ono be undressed. But because of their proximity or participation, audience members found themselves involved in an admixture of pleasure and pain, perhaps glossing over the latter in preference for the former.

Even with these precedents in mind, masochistic performance artists of the 1970s generally took a profoundly different route in their work. They relentlessly established a distance between themselves and the viewers, opted for a dynamics of pain rather than pleasure, and severed (or at least problematized) the popular link between these two sensations. Increasingly, the artist's body became the primary material of performance pieces, a development that coincided with the first attempts to coin a term—"body art"—to describe this type of work and to establish a critical discourse about it.[34] One of the important early texts on body art appeared in 1970, in the inaugural issue of *Avalanche*, a New York magazine devoted to avant-garde art. In an essay called "Body Works," editor Willoughby Sharp cataloged recent uses of the body by performance artists under two general concepts: labor and theater. The body was considered either as a "tool" (as in Richard Long's "walk" pieces, in which he uses his feet to create a work, much as a sculptor might use his or her hands) or as a "theatrical backdrop" (as with William Wegman's *Wound*, in which the artist's face appears in five photographs with a different letter of the title spelled across it in Band-Aids). A third category, which Sharp raised only to reject, was that of the body as object. "The only case in which a body approaches the status of an object," Sharp claimed dismissively, "is when it becomes a corpse."[35]

Sharp's curt denial of the body's objecthood was undoubtedly prompted by critic Michael Fried's widely read 1967 essay "Art and Objecthood." In this attack on Minimal Art, Fried not only dismissed the objecthood of the body itself but also denied that work involving the body could be considered art. Instead, he argued that such work—namely, Minimalist, or what he called "literalist," sculpture, which required the viewer's bodily response—was actually a form of theater, because its meaning hinged on a body being present with the work, a condition he termed "presence . . . a kind of *stage* presence."[36] But whereas Sharp accepted or even encouraged the theatrical in art, for Fried, the theatrical quality destroyed what he saw as art's essential mission: to establish a sense of "presentness" (not to be confused with presence), which might de-

liver the viewer to a state of "grace."[37] The passivity inherent in this quest for transcendence was something that Fried regarded in terms of the health or legal protection of the body. He spoke of theatricality in medical terms, calling it "infectious," and he used legal terminology when speaking of the literalist sensibility as "corrupted" by theater.[38] This assignment of pathological and extralegal characteristics to "theatrical" forms of art (such as performance) was ripe for debate and proved controversial at the time. Sharp never addressed these issues outright (nor, for that matter, did he critique Fried's text directly), but in his insistence on the term "body art" and his denial of the objecthood of the body, he offered some pointed critical objections to Fried's influential theory.[39]

Soon, others began to grapple with the issues of subjecthood and objecthood in performance. In a 1971 article titled "Subject-Object Body Art," critic Cindy Nemser raised the possibility of considering more than one identification of the body in a particular spatial context. Specifically, Nemser argued that an artist focusing on the body in a live work of art was mobilizing a "desire to know oneself as both subject and object in relation to one's surroundings."[40] She very nearly reached the conclusion that the body holds various identities in balance, a view favored by the five artists under discussion here. Her specific wording, however, reveals a slight bias toward mythic theories of metamorphosis: "The subject is continuously *transformed* into the object and then back into the subject through his ongoing physical interaction with the environment."[41] Nemser was apparently the first writer to apply this discourse of subject-object relations to performance art.[42] Unfortunately, however, even after noting a "strain of bizarre, sadomasochistic exhibitionism that runs through this account of body art," she did not pursue possible conjunctions between subject-object relations and sadomasochism in performance.[43] As is typical of art critics and art historians of the early 1970s, she did not take into account psychoanalytic theory, which might have allowed her to expand her observations.[44] Nonetheless, her attention to the environmental context of performance and to the shuttling motion inherent in identificatory processes is important and laudable.

With much more material at hand, Lea Vergine continued the critical analysis of body art in her landmark 1974 book *Il corpo come linguaggio (La "Body-art" e storie simili)*.[45] Written with a sense of urgency and passion, Vergine's book consists of a long essay and an ambitious catalog of dozens of artists and their contributions to this type of art. Among the artists she includes are Pane and Acconci. In her introductory text, Vergine ranges across a wide variety of discourses that she claims influenced artists' extreme manipulation of their bodies. She quotes psychoanalysts, philosophers, and phenomenologists but resists embracing any single theory or methodology to explain the work. For example, she makes passing reference to the dynamics of masochism but quickly elides further discussion by claiming,

If we were interested in relations to perversion, we could talk about fetish-
ism, transvestism, voyeurism, kleptomania, paedophilia, necrophilia, sado-
masochism, rupophobia, scatophagia. A search for psychotic symptoms
would lead our attention to the aspects of the work connected to dissocia-
tion, melancholy, delirium, depression, and persecution manias. But this
procedure would lack commitment.[46]

Vergine's statement does not prevent her from speaking of subject-object rela-
tions, however. The artist, she argues, "becomes his object. . . . [T]he artist is the thesis
with respect both to himself and his subject, this is to say that he *posits* himself as ob-
ject since he is conscious of the process in which he is involved."[47] With this reference,
Vergine gives a nod in the direction of a discourse on subject-object relations and
leaves open the possibility of making necessary connections between these general re-
lations and the more specific subject (and object) of masochism.

Pane, Acconci, Burden, and Ulay/Abramović all investigated the self as a subject
through the mechanism of fantasy but never really moved beyond seeing the body as a
material object with symbolic potential. Thus, they rooted themselves in the funda-
mental art historical notion that the overriding value of art lies in its play within the
arena of the symbolic, its representational status, and its reliance on metaphor. I am
thinking of metaphor here in the simple linguistic sense, in which a figure of speech
that literally denotes one thing is used to represent another. This is quite different from
Stiles's notion of metonymy, in which a part is used to stand for a larger whole. It is my
contention that in the work of masochistic performance artists of the 1970s, the body
and its actions served metaphoric roles.[48] Pane's work presents the most vivid exam-
ples of this function. When she cut her skin with a razor blade or a broken mirror, the
metaphor of the body was presented as a paradox: the closer one gets to the body, it is
often assumed, the less easy it is to represent and the easier it is to comprehend. But
this assumption is based on the misconception that the body can be known purely, as a
totality standing outside the arena of the symbolic. Said another way, it can be under-
stood fully only on one side of the mirror. Pane and the other artists highlighted in this
book disprove this belief.

The mirror and the symbolic hold a special place in the psychoanalytic theories of
Jacques Lacan, which are particularly useful in understanding masochistic perfor-
mance.[49] My own argument, which relies heavily on the writings of Lacan, holds that
masochism is generally used by artists as a metaphor representing key moments in
one's psychic development, particularly the stages leading up to the oedipal phase. Ac-
cording to Lacan, whose work amplifies Freud's, the oedipal scenario (Freud's term) is
the process in psychic development in which the field of the symbolic (Lacan's term) is
constructed, once and for all, in the form of language.[50] Although this topic might
seem too esoteric for performance artists to tackle, I will demonstrate that in numer-

ous masochistic performances from the 1970s, the artists focused specifically on what elsewhere would be called the oral, mirror, and oedipal stages of psychic development. The oral and mirror stages are especially important, because they constitute triggers or roots for the (oedipal) symbolic, the basis of all human art making and perception. In psychoanalytic terms, these triggers are manifested in painful processes: first, separation from the mother in the latter part of the oral stage; and second, the recognition of the "split self" in the mirror stage, an experience based on the individual's first glimpse of his or her reflected image.[51]

To my mind, the viewer of masochistic performances is metaphorically guided along this trajectory of psychic development by the use of various mnemonic devices. For example, the repeated use of the mouth, the mirror, and the bed as focal points helps the artist and the viewer to consider the structure of the unconscious through these key metaphors for the oral, mirror, and oedipal stages, respectively.[52] Of course, there is much more at stake in the rituals enacted by these artists than a vague, text-book reminder of the stages in one's own development. Rather, what is signified is the relation between that growth and the institutional structures of the everyday world. What prove especially compelling for both the artist and the viewer, then, are the contexts in which the performances occurred. Two sites of vital significance are the home and the gallery (or other public institutions in the art world). The artists' choices of particular performance sites—for example, Pane's decision to present *Nourriture, actualités télévisées, feu* in a friend's apartment in Paris—are, therefore, not arbitrary but central to the meaning and impact of their works.

The oedipal stage culminates in the rigidification of symbolic systems, the establishment of a problematic hierarchy, and the positioning of the individual within another institutional construct—the world of law. The social practice of law issues from what Lacan calls the "law of the father," an outgrowth of the developmental phase in which the paternal figure emerges as more symbolically powerful than the mother or child.[53] This concept weds the "law" as patriarchal power with the domestic site in which it is initially formulated. Together, these serve as paradigmatic metaphors for the literal institution of law that regulates daily life in a myriad of perceptible and imperceptible ways. Masochism takes this legal construct seriously, requiring a tacit agreement between the individual who practices masochism and anyone else who observes, allows, or participates in that practice.

Within the literal institution of law, the execution of contracts involves a series of distinct activities; in legalese these are referred to as "offer," "acceptance," and "consideration." The terms "offer" and "acceptance" can be taken at face value, the latter being thought of as including the process of negotiation.[54] I will use the term "negotiation" interchangeably with "acceptance" to keep the reader mindful of both the activity inherent in this stage of contract making and the fact that although "acceptance" implies a finality, no contract is complete without a consideration. "Consideration" is a more complicated term and can be thought of, for now, as involving payment, in the sense of

either a benefit or a detriment at stake in a pending contractual agreement—all of which makes it clear that a deal is being made.[55]

Important changes in the theory of the contract took place from the mid-1960s into the 1970s, oddly congruent with the rise of masochistic performance art. This was also the point at which Deleuze began to forge a connection between the subjects of masochism and contractual agreement. The sudden changes in contract law theory during this period are worth noting because they halted a long stretch of time in which the contract had worked, unquestioned, in virtually a single manner. As legal scholar Grant Gilmore points out in *The Death of Contract* (1974), almost a century had passed since jurist Oliver Wendell Holmes Jr. first stated that "the true ground of the decision [about a contract dispute] was not that each party meant a different thing from the other . . . but each said a different thing."[56] Most of the changes in contract theory in the early 1970s had to do with this issue of "meant-said" distinctions. Gilmore shows that more credence was then being given to what was meant in an agreement, favoring a "meeting of the minds" rather than the more literal and objective evidence of the contract itself, which he calls an "'abstraction'—a remote, impersonal, bloodless abstraction."[57]

Changes in "meant-said" distinctions were not confined to the world of law, however. By 1970, it had become clear in the context of the Vietnam War that there was a growing discrepancy between what was fact and what was being *represented* as fact by individuals in positions of power. As people followed the war from home (on television or in the newspaper), they became aware that body counts were being inflated and that atrocities such as the My Lai massacre were common. The gap between "what was said" by those in power and "what was meant" grew wider and wider.[58] This erosion of faith in the allegedly consensual relationship between the citizen and the state in the early 1970s was tied to both the disaffection with the ongoing Vietnam War and the changes then taking place in contract law. In this sense, any individual's repudiation of the war may be seen as a response to political leaders' exploitation of the century-old pattern in contract law of privileging what is said (the signifier) over what is meant (the referent) in such a way that the latter simply disappears as it is merged ideologically with the former.[59]

Masochistic artists responded to this social and political confusion in two ways. On the one hand, they duplicated the painful effects of such a separation, and, on the other, they showed the paradoxical necessity of splitting the signifier and referent to clarify their difference and to make sense of the representations that shape our lives. Using masochism as a metaphor, performance artists of the 1970s articulated this split and its inherent pain. In addition, they dispelled myths of collapse, which were as prevalent in contract law as they were in the art world debate about art-equals-life. Refusing to act in the gap between what is said and what is meant—that space in which Rauschenberg and Kaprow so delighted—many performance artists of the 1970s chose instead to point to it and offer a critique.[60]

I have been arguing that masochistic performance artists of the 1970s took suffering upon themselves in order to point to trouble in two interconnected social institutions: the law and the home. Quite specifically, these artists directed their attention to a mechanism upon which both of these institutions were founded: the contract. In part because masochism always relies on a contract between partners, it became a key metaphor through which these artists could address the volatile social and political issues that affected the everyday lives of individuals in the early 1970s.

Yet to infer a direct relation between these performances and specific motivations in the sociopolitical arena is too pat. Moreover, it is still too suggestive of a simplistic collapse of art into life. Clearly, the actions of these artists were in many ways metaphoric. Although the artists performed dangerous or harmful acts, they *chose* those actions. A quite different circumstance existed for soldiers in Vietnam or political demonstrators at home: although they also chose to carry out acts in which they might get hurt, they rarely made this choice because they were attracted to the idea of pain.[61] As for civilians, citizens, or family members caught in the midst of military, urban, or domestic violence, a very limited opportunity existed (as it ever does) to make any choices at all. It is imperative to keep these differences in mind when considering the social relevance of masochistic performance works.

Critic-artist Peter Plagens, the author of "He Got Shot—for His Art," the *New York Times* article on Burden, was careful to make just this distinction. At the end of his text, Plagens reported that he had asked Burden about "comparing his bullet wound to a *real* one, suffered by a Vietnam vet or a street-gang member. 'Isn't it small potatoes?' I said. 'Yes,' he said. But so—it came to me later—is all art: yours, mine, Burden's."[62] Together, the writer and artist confirm the impossibility of making a direct connection between art and life, while demonstrating the metaphoric function of an artistic act to entreat comparison to something beyond itself.

Although this referential "something" may have lent a social relevance to masochistic performance of the 1970s, it was not political in obvious ways. Masochistic performances emphasized the artists' distantiation from their audiences and attended to concepts of alienation. Thus, they could never have served as models for public protests, as did the Happenings of French artist Jean-Jacques Lebel, who helped Renault factory workers outside Paris utilize his performance format to organize strikers in the late 1960s.[63] The adaptability of Lebel's performance style to direct political activism hinged on its capacity to establish a closeness between performer and audience and to solicit participation from an otherwise passive viewer. Political protest aims at not only confronting an audience with complaints but also winning it over to particular solutions. In this way, the audience's potential alienation is attenuated.

By the same token, in many 1960s-style performances, pleasure was valorized. Cultural historian Maurice Berger has pointed out that:

A number of sixties performances (such as those by Robert Morris, Carolee Schneemann and Lucio Pozzi) were about pleasure and art as a mechanism of desublimation, as a response to being a worker in industrial society. Perhaps these were naive or utopian gestures but the artists thought they could possibly skirt oppression or show how, in the end, that possibility itself was a myth.[64]

In contrast, masochistic artists of the 1970s did not try to "skirt oppression." Nor did they avoid the alienation that Stiles claims Nitsch succeeded in "reduc[ing], although not resolv[ing]."[65] Instead, they defied pleasure in the most easily misinterpreted manner possible: by presenting and representing pain through the material of their own bodies. In the process, these artists nullified the expectation that pleasure should accompany pain, an anticipated response so deeply engrained that it sometimes allows the viewer to avoid dealing with the complexity of an individual's choice to endure pain.[66] The performance artists of the 1970s proved that if there is any pleasure whatsoever attainable in masochism, it has to do with alienation.

In making the point that alienation is the only legitimate complement to pain, these artists sought to deconstruct alienation, to use it toward critical ends. A large part of the deconstructive capacity of their performances lay in its documentation, that is to say, the photographic record. Even the contract made between artist and viewer in the performance arena was certified by photographic documentation. This key point is often elided by critics but rarely by the artists themselves.[67] For the performers, photography was an imperative, the chief record of their otherwise ephemeral performances. These photographic "documents" have a style all their own, tending more often than not toward grainy black-and-white shots taken in half-lit performance spaces. Despite the anachronistic, snapshotlike quality of the pictures and the fact that any individual image represents only a split second of the performance, photographs are widely circulated as the principal relics and records of these events.[68] It is the fragmented effects of these reproductive procedures that open up the deconstructive potential of performance art, inasmuch as any desire for traditional narrativist closure will always be short-circuited by the limited information available.[69]

In a larger sense, any understanding of the photographic documentation of performance depends on the way it supplements visual responses. For one thing, the photographs allow for an ongoing (if fragmentary) experience of a performance on the part of a beholder. Unlike reproductions of other types of artworks, photographs of performances, by virtue of their focus on the artist's body, allow the viewer to engage with the artist in a haptic as well as a visual sense. Encountering the shared ontology of the body makes the viewer mindful of his or her own physical presence as witness to the pictured event (even if it is well after the fact). One's involvement in the event—the choice to become a "contracted partner"—is thus made tangible.

This contracted partnership is made manifest by the visual and haptic dynamics that one experiences in literally "handling" the performance photographs.[70] While leafing through publications (still by far the predominant way one comes to know about performance art), the viewer participates in a sort of narrative. Unlike an ideal "documentary" narrative, however, this story unwinds in ways that may not be anticipated. In fact, the viewer's experience is one of a narrative-in-reverse. An unconscious haptic response is mobilized as the viewer touches a photograph taken by a photographer who touched the trigger of the camera as the performer touched his or her own skin, used his or her own body both as an instrument of touch and as performance material. This chain of experiences, working backward in time, subtly locks the viewer into a metaphoric complicity with the photographer/viewer, as well as with the performer.[71] These links recreate the largely tacit bonds that allowed the performer's action to be played out in the first place. The photograph thus becomes a pseudolegal form of "proof" (a term relating photography to law) that an agreement took place.

Every time that agreement is struck, every time that contract is "signed," a complex and powerful psychodynamic is set into motion that reroutes the viewer's attention back in time to the domestic site, the home, where identities are first formulated. It could be argued that this psychodynamic underlies the viewing experiences of all forms of art. But this reference is clearest in these limit-text performances, which not only employ the human body as material but also touch or tamper with it.[72] The fact that photographs of such performances have the look of old family snapshots and are circulated in art magazines, books, and exhibition catalogs designed to be contemplated and handled at home (as family photo albums are) reinforces the beholder's connection to the domestic site on a psychic level.

Arguing that a sort of photographic proof is embedded in documentation procedures puts a new spin on what Roland Barthes called the denotative function of photography. In his influential 1964 essay "Rhetoric of the Image," Barthes argued that photographic denotation—that which can be seen at a glance—creates a "new space-time category," a "real unreality." This category involves "spatial immediacy and temporal anteriority, the photograph being an illogical conjunction between the 'here-now' and the 'there-then.'"[73] At first, this claim seems to fit precisely the experience of performance photographs, which comprise an entity in the "here-now" (one can touch a photograph of a performance with one's hands) as well as a record of the "there-then" (the place and time of the performance can never be fully recaptured for their material meanings, only for their symbolic and metaphoric significations).

However, the ways in which Barthes explains his claim and the way I have parenthetically applied it are very different. For Barthes, the photograph's "unreality" is its "here-now" quality, which is implicitly overridden by what he calls the "real" or temporal quality of a "having-been-there."[74] Even without questioning Barthes's notion of realism, one might wonder about his compulsion to believe that one quality of the photograph overrides the other. What might be called his "override theory" appears to

foreclose the possibility of the development of a complex spatiotemporal balance by the viewer of a photograph.[75] To think of the "here-now" quality of photography as providing a kind of "presence" is, in Barthes's mind, to think metaphysically or, as he puts it, "magically." He insists rather dogmatically that "the magical character of the photographic image must be deflated."[76] Such an authoritatively dismissive tone is generally uncharacteristic of Barthes's theorizing. It is a tone that arouses a suspicion that, if pursued, points in the direction of fear, fear of the power of the photograph to operate in a "presence-producing" domain that might not be magical (or theatrical, to recall Fried's interpretation of the same concept). Far from magical, this presence-producing domain is, I would argue, utterly mundane: it is the domain of touch.

Barthes actually betrays a deeper fear of photography in this essay. He argues that photography offers a sort of protection, because "in every photograph there is the always stupefying evidence of 'this is how it was,' giving us, by a precious miracle, a reality from which we are sheltered."[77] But why would one need such shelter, except for the fact that the viewer is made vulnerable by photography's denotative solicitation of the sense of touch? This awareness can be painful, especially when the photographs being handled show acts of violence or their aftermath. A good example is the photograph of Burden after *Shoot*, staring glassy-eyed into the camera as two hands pull a tourniquet around his arm just above a blood-stained bandage (fig. 2). Can we really be sheltered as we peruse a photograph such as this?

The connotative, "there-then" aspect of a photograph's meaning does not always shelter the viewer as Barthes might wish. Nor does it efface a viewer's identification with the denotative subject matter pictured—what Barthes calls the "it's me" quality of the photograph that gets defeated, he feels, by a pure spectatorial consciousness telling us, "this was so."[78] Rather, the material possibility of a photograph's being touched (a possibility formally encouraged in the Burden photograph by the appearance of his assistant's hands touching him) works in tandem with the merely spectatorial (particularly strong in the Burden photograph as he returns our gaze) to provide the viewer with a general point of identification.

The "it's me" quality of the body is particularly palpable in masochistic performances, not only because of the enormous attention the artist brings to the body but also because of the focus on the performer's skin. One could say that skin is the denotative aspect of the body. Or, as psychoanalyst Didier Anzieu has observed, it is the body's only "external sense" that functions reflexively. Touching oneself, Anzieu writes, renders the sensation of "being a piece of skin that touches at the same time as being a piece of skin that is touched. . . . It is on the model of tactile reflexivity that the other sensory reflexivities (hearing oneself make sounds . . . looking at oneself in the mirror), and subsequently the reflexivity of thinking, are constructed."[79]

After the development of reflexive actions involving touch (which take place in what Freud designated the oral stage), an individual has his or her first reflexive visual experience in front of a mirror (during what Lacan calls the mirror stage). These

events are followed by a leap into the realm of thought referred to by Lacan as the symbolic, the benchmark of which is Freud's oedipal scenario. These episodes in psychic development—oral stage, mirror stage, oedipal scenario—constitute a three-stage course traversed by Acconci, Burden, Pane, and Ulay/Abramović in their masochistic performances. Moreover, I would argue, there is a direct correlation between these stages and the contract law notions of offer, acceptance, and consideration.

Before I develop this argument further, I must offer two caveats. First, one must be wary of ascribing to the psychic processes a totalizing universalism. In fact, the types of touch and vision that propel an individual through the oral, mirror, and oedipal stages *are* experienced for a brief but intense moment by everyone. But the emphasis here is on brevity, with the shared quality of experience in psychic experience constituting what might be called a "conditional universalism." Just as the scream-inducing shock of touching a finger to a hot iron or the jolt of unexpectedly happening upon one's reflection in a hidden mirror or the surprise of discovering a person's biological sex to be other than previously thought (three hypothetical events that connect to the three stages of psychic development at issue) might be shared for a fleeting moment by all individuals, so are they followed by protracted moments in which the interpretation of those events will be determined by the personalized context in which they occurred. An individual's passage through the stages of human development is always dependent on the more narrowly defined economic, political, and psychological makeup of the specific sites in which that development occurred.[80]

The second caveat is that masochistic performance art can hardly be seen as a model for better living. These artists did not advocate masochism for its own sake but used it to reveal symbolically the structure of agreements that we make as we try to come to terms with an unsettling, indeterminate consciousness of our own bodies. And, significantly, the artists carried out this venture without (Barthesian) fear or dogmatism.

Artists who stage performances of any sort necessarily foreground the body, risking a simplistic reading of the human form as the ultimate emblem of nature. By meddling with the apparent seamlessness of that emblem in visual and haptic ways, they can temporarily restore for the observer proof of the "it's me" sameness of the body and provide access to experiences of the body that are culturally specific but suppressed. In so doing, they challenge the stereotyped fixity of those differences. Performance brings this proof into view and makes it undeniably graspable, particularly through its reliance on photography. For photography has the capacity to keep the observer in the here and now while simultaneously prompting a return to the past—to the formative stages of the psyche, to the home, to the place where every "contract with the skin" is first forged.

HIS MOUTH HER SKIN

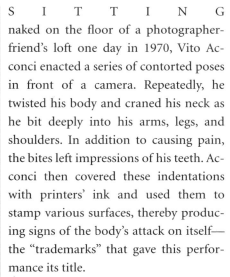

SITTING naked on the floor of a photographer-friend's loft one day in 1970, Vito Acconci enacted a series of contorted poses in front of a camera. Repeatedly, he twisted his body and craned his neck as he bit deeply into his arms, legs, and shoulders. In addition to causing pain, the bites left impressions of his teeth. Acconci then covered these indentations with printers' ink and used them to stamp various surfaces, thereby producing signs of the body's attack on itself—the "trademarks" that gave this performance its title.

Strictly speaking, *Trademarks* was not a performance work; Acconci never carried out the action before a live audience. Rather, the performance was intended to be reproduced as documentation. Indeed, it appeared as a two-page layout in the fall 1972 issue of *Avalanche* magazine (a special issue devoted to Acconci's work).[1] The published piece includes a text written by Acconci and a series of photographs of the performance (fig. 4). On the left-hand page are eight photographs of Acconci biting various parts of his body. The photographs are arranged around the edge of the page, forming a sort of frame for a black printed impression of a bite mark in the center. On the right-hand page is an enlarged photograph of a bite mark in the flesh of Acconci's upper arm. The shape of the bottom of every tooth is visible, the edges of some indentations appearing much darker than the surrounding skin. Clearly, blood had risen to the surface and almost broken through.

The excessively detailed, textured

close-up of the bite mark engages the viewer's sense of touch. It solicits the viewer to physically trace the contour of the individual tooth indentations, as if touching them will draw the viewer closer to the artist's body, will help heal the wound, will perhaps even make it disappear, or at least will make the dripping saliva—a visual analogue for tears—disappear under the eraserlike movement of the fingertip. But just as this representation seems to draw the viewer closer to the wounded body, it also demonstrates the impossibility of such closeness. The act of touching is mediated by the photographic reproduction and by the line of the wound itself, traced into the surface of a skin that is not one's own. Instinctively, the viewer pulls away from the photographic object, and in so doing is forced to contend with conflicting experiences of (as Barthes would have put it) "here-now" and "there-then"—of closeness and distance, attachment and separation. These are ambivalences characteristic of the oral stage, especially its later moments. It is precisely these moments that are central to the significance of Acconci's performance, as emphasized by the prominent part played by his mouth. On a very basic level, the repeated biting simulates attachment and separation from the body of the maternal figure—which is to say, from her skin.

In the photographs, Acconci emphasizes the spatial aspect of these ambivalences by establishing a physical distance from the camera. On the one hand, this gives the viewer a rather perplexing medium shot of his contorted body. On the other hand, the viewer can study the pictures up close to ascertain exactly what is going on in the piece. Acconci underscored the conceptual aspect of these ambivalences by choosing a title that suggests that the viewer's intimately haptic and visual connections to the teeth *marks* involve a *trade* of responsibility. It almost seems as if the viewer, although literally at a distance from Acconci's original act of masochism, is as responsible for it as he himself is.

Even if it is impossible to imagine the bite mark as one's own, a certain share of the responsibility for the body and its wounds is solicited as the narrative-in-reverse unfolds. The viewer's haptic interaction with the photograph metaphorically duplicates the photographer's own haptic interaction with the camera at the exact moment that Acconci touched his mouth to his skin. The viewer feels complicit in the represented act, then, at the same time that he or she recognizes the vast gap separating viewer and artist. This is the same gap that separates "what is said" (as well as what is seen and felt) from "what is meant" in *Trademarks*—the very gap that Acconci's masochism elucidates for purposes of critique. In *Trademarks*, critique takes the form of polemic.

Trademarks functions as a consummate trademark of masochism.[2] More precisely, it serves as a trademark of "reflexive masochism," both illustrating and polemicizing Freud's definition of that term. In his 1915 essay "Instincts and Their Vicissitudes," Freud claims that masochism is nothing other than "sadism turned round upon the subject's own ego."[3] In his own brief text for *Trademarks*, Acconci plays with this wording (without ever mentioning Freud's name). He describes his gesture as

"[t]urning in on myself, turning on myself,"[4] and he gives that description a visual analogue in the form of the eight contortionist poses.

Freud, in his essay, sets up a tripartite schema for understanding issues of subjecthood and objecthood in masochistic practice. According to this schema, there is a distinct moment between sadism (in which an individual "exercise[s] violence or power upon some other person as object") and what could be called masochism proper (in which active physical participation is solicited from "an extraneous person [who] is once more sought as object . . . to take over the role of subject"). The in-between moment is reflexive masochism, conducted by a solo operator not seeking direct physical interaction on the part of any other individual; at this moment, "the object is given up and replaced by the subject's self."[5] By performing solo, Acconci exemplified the first portion of Freud's description of this interstitial moment. And by biting into his own body, he seemed to illustrate the second part—Freud's dismissal of the objecthood of the body. But in fact it is this last portion of Freud's description with which Acconci took issue. The image of Acconci's bite mark actually complicates Freud's dismissive gesture, for the bite mark is a sign of the circular ability of the body to acknowledge its material presence—its objecthood—through its own consumption, and vice versa.[6]

Acconci further challenged Freud's theory by demanding recognition as a speaking subject—an *actively* speaking subject. Freud suggests that the reflexive masochist uses only a "reflexive, middle" voice and not an "active" or "passive" one.[7] Acconci refuted this definition by including text in his piece. This obligates the viewer to interrelate two forms of communication—photos and text, which function as stand-ins for body and voice. As this task is carried out, the viewer is reminded of the delicate balancing act that takes place during the early moments of the mirror stage, juxtaposing the notions that one's body is both a subject and an object, an entity that simultaneously sees and hears, is seen and is heard. It is precisely this kind of indeterminate thinking, retrievable through reminiscences of the mirror stage and the concept of the "split self," that can break up rigid perceptions of the body acquired during the oedipal scenario.

But recalling such a crisis in the perception of one's body would not be possible were it not for Acconci's strong emphasis on typical oral-stage ambivalences. The end of Acconci's text for *Trademarks* underscores the spatial dimensions of these ambivalences while providing "reasons" for moving on to the next stage of psychic development:

Reasons to move: move into myself—
move around myself—move in order to
close a system.

Reasons to move: show myself to
myself—show myself through myself—
show myself outside.

Make my own outside—send my inside
outside (I can slip outside, then, because
I am still moving inside).[8]

Acconci culminates his *Trademarks* text by directing attention to the mirror, where it is
possible to "show [one]self to / [one]self," as well as to show oneself to others located
spatially "outside" that self. What Acconci seems to be stressing in the last stanza is that
the mirror stage, by introducing the individual to the world of language, provides the
opportunity to take command of what is outside oneself.

Acconci's pointed use of the term "outside" is significant here. With it, he evokes
an environmental connotation, thereby producing a crucial link between the spatial
aspects of psychic separation and the material space or environment in which that sep-
aration takes place—what psychoanalyst Didier Anzieu calls the "mothering environ-
ment."[9] This is the domestic space, not only the site of all stages of psychic develop-
ment but also the paradigm for all other social institutions one might encounter in life.
Acconci's "trademark" of masochism helps him critique the social institutions of art
and the economy specifically. Metaphorically, he refers to the commercial practice of
identifying ("marking") a product for purposes of exchange ("trade"). By "making
[his] own outside," Acconci questions the meaning of the brand name or trademark.
In so doing, he also introduces another meaning of "outside"—the body's exterior, or
skin. But even this outside has an institutional connotation, for as Acconci bit into his
flesh, he was attempting (as he states in the *Trademarks* text) to "stake a claim on what
I have." He proclaims his own body, in other words, to be an object with exchange
value. Yet the force with which he makes this assertion suggests that he is critical of the
concept.[10]

Anzieu's theory of the "mothering environment" hinges on the belief that skin plays an
important metaphoric role in psychic development. In fact, the mothering environ-
ment, the functions of the skin, and the role of metaphor are interlocking but virtually
invisible elements that form the foundation of masochism. Examining Anzieu's theory
in detail will make these various elements clearer.

Skin, according to Anzieu, serves the purposes of containment, protection, and
communication:

The primary function of the skin is as the sac which contains and retains in-
side it the goodness and fullness accumulating there through feeding, care,
the bathing in words. Its second function is as the interface which marks the
boundary with the outside and keeps that outside out; it is the barrier which
protects against penetration by the aggression and greed emanating from
others, whether people or objects. Finally, the third function—which the
skin shares with the mouth and which it performs at least as often—is as a

site and a primary means of communicating with others, of establishing signifying relations; it is, moreover, an "inscribing surface" for the marks left by those others.[11]

When Anzieu speaks of the skin's function as a boundary or as a medium for sending messages, he is speaking of the metaphoric character of flesh, not its physical properties. But the crucial metaphor for him is that of the "skin ego," an image that is similar to but different from flesh. "By Skin Ego," Anzieu explains, "I mean a mental image of which the Ego of the child makes use during the early phases of its development to represent itself as an Ego containing psychic contents, on the basis of its experience of the surface of the body."[12]

The "early phases" that Anzieu refers to are the elemental psychic stages which, when taken together, constitute the oral stage. What Anzieu has to say about this stage foregrounds both the skin (of the mothering figure) and the mouth (of the child) and always takes into consideration the institutionalized context of the mothering environment. The latter is the space in which maternal caregiving is performed, especially that care referred to in psychoanalytic theory as anaclisis—the propping up of the child against the skin of the caregiver.[13] In the oral stage, "skin" typically means the skin of the mother's breast, but not always. Anzieu implies that much of the typically gendered activity of the oral stage can in fact be performed by male figures in the mothering environment. In other words, *his skin* may fulfill oral-stage needs for physical support as adequately as *her skin*; the notion of mothering, then, is tied more to a relation to skin and to the activity of caregiving than to the gender of the caregiver.[14]

Central to Anzieu's theory is the notion of the "attachment drive," which holds that a child forms attachments to the mothering figure during the oral stage by relying on her (or his) skin to the point of feeling that the skin is shared. If the attachment drive is satisfied "sufficiently and at an early enough stage," Anzieu argues, then the skin's containment, protection, and communication functions will be internalized by the child after separating from the mothering figure and her environment.[15] But there are many ways in which this internalization process can be disturbed, because each distancing moment evokes anxiety-ridden fantasies that may not be overcome. Anything from genetic deficiencies to inadequate parental attention can produce failure-inducing disturbances. One such disturbance, "primary masochism," is described by Anzieu as "a sudden, repeated and quasi-traumatic alternation, occurring before walking, the mirror stage, or the acquisition of language, between overstimulation by the mother or her substitutes and deprivation of physical contact with her, and thus between satisfaction and frustration of the need for attachment."[16]

All of these anxieties and fantasies—their repetition as well as their interruption—follow a particular developmental pattern, which Anzieu charts. Before the fantasy of sharing a "common skin" with the maternal object materializes in the early oral stage, the child is caught up in what Anzieu terms the "intra-uterine phantasy," which

includes a refusal to be born and a desire to return to the "phenomenon of mutual in-clusion." If anxieties regarding *this* fantasy are not resolved, one simply does not move on to the fantasy of the common skin, procured through anaclisis, and thereby risks undergoing versions of autistic development in which the individual "withdraws into a closed system, that of an egg which will not hatch out."[17]

The common-skin fantasy marks the beginning, Anzieu believes, of an individ-ual's ability to "open out" into the world while still understanding that world through "mutual symbiotic dependency" on the mothering figure. This dependency is sur-passed only as the fantasy of the common skin is suppressed.[18] It is the struggle inher-ent in this passage that many masochistic performance artists, especially those focus-ing on the mnemonic device of the mouth, address in their work.

The intensity of the struggle is symbolically illustrated by Acconci in *Trademarks* and is further articulated in an especially poignant text he published a few years later. Alongside a string of tiny black-and-white photographs of his mother in his 1973 limited-edition book titled *pulse (for my mother) (pour sa mère)*, Acconci writes:

> You couldn't understand why I took these
> photographs
> You'd tremble if you saw this, you'd stay alive to
> think about dying
> I'm fading away from you, I'll bring you back
> You'd say this will bring bad luck, but I won't believe
> you
> I'll keep you alive, you won't die, I'll wish harder
> When I turn away from you, I'll be sure to come
> back. . . .
> I've got to come closer to you than ever before
> You're always ahead of me
> I'll stay on you, keep up with you
> I'm slipping past you, it's only human to drift away
> You'll stay alive to see that I'm watching you, talking
> to you
> I'll push my luck, push past superstition
> No one can pull me away, I'll start again, toward
> you.[19]

Acconci's text metaphorically articulates Anzieu's notion of common-skin suppression and its attendant anxiety, just as *Trademarks* enacts it. The anxiety this suppression produces is, according to Anzieu, manifested in feelings of pain and concomitant fan-tasies of assault on the very skin that previously bound the fantasizer and the mother together. Anzieu claims that "it is at this point that phantasies of the flayed skin, the

stolen skin, the bruised or murderous skin exert their influence."[20] If one does not move beyond this point smoothly but instead fixates on these fantasies, he or she may experience masochistic impulses. It is precisely this moment that masochistic performance artists such as Acconci feel compelled to replay, or so it would appear.

Certainly, I do not mean to argue that this is the only moment in psychic development reiterated by Acconci or the other artists being discussed. Nor do I mean to claim literally that any of these artists were given inadequate attention as children. Such psychobiographical contentions would be reductive, forever debatable, and truly beside the point. To get at the deeper meanings of masochistic performance, it is far more useful, I believe, to continue questioning the function of skin as a spatial metaphor and to examine the ties between the mothering environment and social institutions modeled after it. In particular, this investigation warrants a close look at how Anzieu developed the notion of anaclisis, beginning with the question, What type of interaction is entailed in *smooth* psychic development?

According to Anzieu, a "dual process of interiorization" needs to occur for the skin's functions of containment, protection, and communication to operate successfully. That is, *two* spatial aspects of the skin need to be internalized: first, the interface between the bodies of the child and the mothering figure (what Anzieu calls a "psychic envelope"); and, second, the mothering environment itself with all its verbal, visual, and emotional properties.[21] Together, these aspects form the spatial background of the skin ego against which the ego as we know it develops. Said another way, it is in the oral stage of attachment to the mothering figure's body that the psyche prepares its own spatialized metaphor, its defensive barrier that will monitor input and filter exchanges with both the external forces of the world and the internal forces of the id and superego.[22] But equally important in the skin ego's formation is the mothering environment, which serves as a spatial metaphor for institutional support.

Throughout his discussion of the skin ego, Anzieu insists that these two internalized spatial aspects of the skin should be seen as both natural and cultural. To emphasize this point, he expands the psychoanalytic terminology of anaclisis by coining the term "*double* anaclisis."[23] To explain this new phrase, Anzieu offers an example of how severe psychosis can be treated by using both natural (biological) and cultural (social) props. In a technique called "the pack," a patient is encased in damp sheets (to replicate the mother's biological skin to help the patient regress to common-skin fantasies) and encircled by hospital attendants (to provide a social metaphor for the mothering environment).[24] Anzieu thus implies that a new functional formation of the social component of double anaclisis can contribute to curing masochistic impulses retroactively. Moreover, the implication is that a new functional formation can counteract, or at least elucidate, the *mal*function of the very social component that was responsible for triggering masochistic impulses in the first place.

The social component can be understood here as any social institution modeled after the mothering environment or the oedipalized domestic site.[25] It is precisely this

concept of the social that the masochistic performance artists being considered in this book seem most concerned with—in regard to both the cause of masochism and its possible "cure." If they were not so concerned, why would they encircle themselves with an audience of "attendants"? And why would they choose to deal with masochism in the arena of representation rather than, say, carry out their actions in secret (where, incidentally, it is believed that the most extreme versions of masochistic practice flourish)?[26] Even in the cases of Acconci's *Trademarks* or Burden's *Shoot*, for which audience participation was nonexistent or minimal, photographic documents of the pieces create an infinite number of "attendants."

Before moving on to other performances featuring his/her mouth and his/her skin, it is important to clarify the difference between Anzieu's notion of primary masochism and Freud's. In Freud's work, masochism was labeled primary or secondary according to its position relative to sadism. Primary masochism described the will to make oneself endure pain, even to the extent of risking death. It was termed primary because it had greater force than the will to cause another person pain, pain that might even include homicide (or so Freud began to claim after his 1920 publication of "Beyond the Pleasure Principle"). Freud linked primary masochism to the death drive, whereas primary sadism had more to do with the survival instinct—the desire, enacted literally or metaphorically, to kill rather than be killed.[27]

Before he began his performance piece titled *Velvet Water* at the School of the Art Institute of Chicago in 1974, Chris Burden announced, "Today I am going to breathe water, which is the opposite of drowning, because when you breathe water, you believe water to be a richer, thicker oxygen capable of sustaining life."[28] He then proceeded to plunge his head into a basin of water, keeping it underwater as long as possible, intermittently jerking it back up, gasping violently for air, and starting all over again (fig. 5). This repetitive action was performed offstage, just beyond a wall of lockers separating Burden from audience members who watched his actions on video monitors and listened to his words and the sounds of his performance through amplifiers (although one could also hear through the wall) (fig. 6).[29] The performance ended after five minutes, when Burden collapsed, choking.[30]

Burden's performance raises issues concerning Anzieu's notion of primary masochism as well as Freud's notion of primary sadism, especially the latter's relation to the survival instinct. After all, as part of the piece, Burden proclaimed that breathing water is the opposite of drowning. But, as critic Dorothy Seiberling pointed out, "psychologists might find it difficult to accept [Burden's] distinction. On an unconscious level, children tend to identify drowning with prenatal life in the womb, where the enveloping liquid does indeed 'sustain life.'"[31] Seiberling supported her case with a quotation from psychologist Karl Menninger, who claimed that "the significance of drowning fantasies was one of the earliest of psychoanalytic discoveries. . . . When sub-

jected to psychoanalytic investigation, such fantasies seem to relate quite definitely to the wish to return to the undisturbed bliss of intrauterine existence."[32]

Certainly, Burden demonstrated in *Velvet Water* a desire for "undisturbed bliss," especially when he voiced his interest in sustaining a richer life. And such interest is foundational to Freud's ideas regarding the survival instinct and the urge to obliterate disturbances inherent in primary sadism. But, of course, Burden did not go so far as to carry out truly sadistic acts in his quest for an undisturbed state. Rather, his repetitive attempts to breathe water situate *Velvet Water* more squarely in the domain of Anzieu's primary masochism, where one experiences "satisfaction and frustration of the need for attachment."

The focal point of *Velvet Water* was Burden's mouth—a metaphor for the oral stage, where the developmental need for attachment is most acutely felt. Water may be an unconvincing substitute for the skin of the mothering figure during the oral stage. But perhaps this is simply not the right analogy. If one concurs with Anzieu's theory that skin functions as a protective barrier between the self and others, then the real substitute for the skin here is the wall behind which Burden performs. Moreover, the wall is also representative of Anzieu's notion of common-skin experiences, for both Burden and the audience share this wall as part of their environment, even as it keeps them apart.

Seiberling's interpretation of this work may point toward ways in which Burden touched on Freudian notions of primary sadism, but her implication that he wished to regress exclusively to intrauterine experiences does not hold. *Velvet Water* is as much, if not more, about oral-stage experiences than about intrauterine ones. The photographic images of Burden's contorted mouth emitting a mixture of water and saliva as he repeatedly jerked his head out of the basin of water reinforce connections to the oral stage of psychic development. Meanwhile, the wall (or skin) between the artist and the audience metaphorically represents the ambivalent process of attachment and separation inherent in the late phases of the oral stage.

By staying focused on reminiscences of the oral stage, Burden, like Acconci, recalls the terms of the masochistic contract. He emphasizes the body's simultaneous identity as subject and object by compelling the audience to watch a *re*presentation of his body on the video monitor and to listen to an aural *re*presentation of his sounds, while also hearing the live *pre*sentation of the action only a few feet away. But, as in *Trademarks*, the audience has to settle for the terms being offered.[33]

Although the most troubling part of Gina Pane's 1975 performance *Discours mou et mat* at de Appel in Amsterdam was her dramatic smashing of mirrors, the action also highlighted her mouth.[34] The performance began with Pane's appearing before the audience dressed in white, wearing dark glasses, and playing cymbals that had been completely covered with cotton so that the sound was indeed *mou* and *mat* (French for "soft" and "dull"). In a tape-recorded text that accompanied this first segment of

the performance, Pane played with another meaning of these terms. She described various parts of her mother's body, referring to her mother's breasts as *mous* and *mats* (French for "flabby" and "flat"). Nostalgic references to her mother and grandmother were interwoven on the tape with classical music, and slides were shown almost continuously throughout the performance, sometimes foreshadowing Pane's actions and sometimes reflecting them. The last slide in the performance showed two elderly women walking in a city, wearing dark glasses.[35]

After she described her mother's body in terms recalling oral-stage aspects of anaclisis, Pane turned to two mirrors lying on the floor. On one was drawn a mouth. On the other was written the word "alienation." Using the sides of her bare fists, Pane smashed the first mirror, then the second. Next, she played with a tennis ball hanging from the ceiling, hitting it with a racket and letting it bounce against her forehead. Her breathing, amplified by a microphone, was labored. On the verge of hyperventilation, she crawled back to the first mirror and, using the palms of her hands, fists, and arms, smashed it once again, violently this time, shattering the pieces to smithereens. Breathing like an overly exercised animal, she first lay down, then sat up. Facing the audience, she lifted her left hand to her cheek with controlled slowness and lightly rested her fingertips below her eye and nose. Steadied in this position, she took a razor blade in her right hand and with great precision made a small incision in her lower lip (fig. 13).

Her body trembling now, Pane lay down again for a few moments, then moved to the side of the performance area, where a naked woman had been lying on a black cloth throughout the piece, her back to the action. Pane stretched out next to the woman and placed her arm over the woman's body. The performance ended when Pane turned over onto her back, picked up a pair of binoculars, and held them up to her dark glasses, appearing to look up at the ceiling in a gesture of impeded visual transcendence.

The dark (almost opaque) glasses Pane wore in *Discours mou et mat* suggest that there is more to masochism than meets the eye. Her key point in this piece, in fact, seems to be that the discourse of masochism needs to be as much about touch as about vision, as much about the sensate body as about its visual aspects. She even hints at this point in her title, because *mou* and *mat* have double meanings that are both tactile and visual. Certainly by virtue of its siting in an art context, Pane's performance was about vision and visual impact. And even though her dark glasses may have minimized her own ability to see her image in the mirror, others could see her reflection clearly. At the same time, Pane drew attention to the power of touch by illustrating oral-stage tactile reflexivity (she was the subject touching herself and the object being touched), which in turn emphasized the vulnerability of her body as an object.

The interdependence of an individual's objecthood and subjecthood is often eclipsed in the privileging of subjectivity. Freud's dismissal of the object in his theory of reflexive masochism is an example. Pane referred to this favoring of the subject as a process of "mental prosthetics." In 1988, she wrote:

[The body is] the irreducible core of the human being, its most fragile part.
This is how it has always been, under all social systems, at any given moment
of history. And the wound is the memory of the body; it memorizes its
fragility, its pain, thus its "real" existence. It is a defense against the object and
against the mental prosthesis.[36]

Pane makes a notable distinction in this quotation: the object to which she refers has to
do with socialized conceptions of the body, conceptions that tend to obscure the
body's vulnerability as a natural entity. What Pane wishes to explore here is the body's
preprosthetic (or preoedipalized) status, when the vulnerability of the child (the not
yet socialized, natural body-*object*) is the express charge of the caregivers in the moth-
ering environment.

 This environment, safe as it may sound, is marked by pain—the anxiety of separa-
tion from oral-stage experiences of oneness with the mothering figure (what Anzieu
called common-skin experiences) and the discomfort of the mirror stage. In the mir-
ror stage, this unease is experienced visually, in the form of reflected or fragmented
versions of the self. At this point, the self has finally detached from the mothering fig-
ure, but has not yet been bound by the oedipal-stage law of the father. In the late oral
stage and, especially, the early mirror stage, one is located between hierarchical orders
ruled, respectively, by maternal and paternal figures of power. In this liminal zone, the
individual is alone, alienated and torn from the mothering environment, but paradox-
ically free, if only in theory and only fleetingly. This is precisely the zone that Pane oc-
cupied in this performance. Perhaps this is not surprising, given that she later told
Antje von Graevenitz that she had performed *Discours mou et mat* to "get her father-
mother relationship under control."[37]

 Interestingly, Pane shielded from her own vision her reflection in the mirror,
thereby highlighting the importance of touch. She did this, I believe, to demonstrate
how the fleeting freedom attainable in the early mirror stage does not come without
suffering. To prove this point, she smashed the mirrors, literalizing the pain of mirror-
stage fragmentation as well as one's unconscious memories of being torn away from
the mothering figure in the late oral stage. The images of the hand-drawn mouth and
the word "alienation" on the surfaces of the mirrors before they were smashed (appear-
ing there as if they had arisen from the unconscious) were reminders of the typically
repressed, oral-stage origins of these memories.

 One photograph of *Discours mou et mat* shows Pane's face drawn up close to her
fragmented reflection in one of the shattered mirrors (fig. 14). No matter how close
she is to her image, however, her dark glasses prevent her from fantasizing that the two
bodies (material and reflected) are one. Similarly, no matter how close we, as viewers,
get to the image, we are always kept at a distance. Pane draws us close by accentuating
the invitation to touch the photograph; included within the frame is an image of her
own hand touching the mirror. Touching the photograph of Pane touching the mirror,

one may begin to feel a pull toward her, toward "slipping inside her skin." This impulse is encouraged by Pane's placement of her own head just inside the frame, precisely where the viewer's would logically be. But the viewer is simultaneously distanced by the reminder that this is, in reality, just a piece of paper on which a photograph is printed.

Pane was keenly aware that a performance may ultimately be defined by its photographic image. In response to an interviewer's comment that one of her performance photographs could bear the caption "This is not a cut," Pane said that performance documentation

> can never express the same thing [as a performance], that is impossible. The same is true when a book is written. . . . [But] in my case photography is introduced even before the action begins, as a sort of *means to an end*. It has what we might call a conceptual function. It *creates* the work the audience will be seeing afterwards. So the photographer is not an external factor, he is positioned inside the action space with me, just a few centimeters away. There were times when he obstructed the view! This related directly to the theoretical and conceptual reading of the work. I did nothing to deceive them; the audience understood very clearly that they would have this photographic reading afterwards.[38]

Pane's method for documenting performances, then, kept even the viewers of the original event at a distance, inasmuch as the photographer sometimes stood in their line of vision. As with the work of all the other artists being discussed, Pane's performance work was virtually equivalent to its representations.

Through the denotative solicitation of touch, Pane made it possible for viewers to recognize the capacity of representation to draw them close. At the same time, she showed how photographs could also distance viewers. It is only by taking this distance, Pane seems to say, that one can come to understand how identity is formed, how it is contracted through negotiations with others in institutional settings imbued with pain.

The domestic site—the social institution framing the family relationship Pane addressed in *Discours mou et mat*—is precisely where contract-type operations begin. It is the site to which one must return to uncover the psychic structural elements worthy of critique in all other social institutions modeled after it. By struggling with psychic issues, Pane points toward the underlying concept at work in all masochistic performance: the only alternative to alienation is a fragile balancing of identification between the body as subject and the body as object.

In the video documentation of Pane's performance, there is a striking moment when the camera halts its pan across the room and focuses on a woman in the first row. As Pane slices her lip with the razor, the woman appears paralyzed, her hand pressed

over her own mouth. With this unconscious gesture, the woman brings together the two parts of the body that Pane had most violated. It is as if the woman were seeking to remind herself, through touch, of the power of skin to contain and protect the body, just as Anzieu theorizes. Pane herself prompted this response by showing the power of the body to destroy the sureties of containment and protection. In so doing, Pane offered up the terms of the masochistic contract—"mouthed" them, if you will—all the while demonstrating the risks involved in dealing with them at all.

M Y

MIRROR

3

IN A 1976 performance by Ulay/Abramović titled *Talking about Similarity*, Ulay sat down, stared at the audience, opened his mouth wide, closed it, then took a needle and thread and methodically sewed his lower and upper lips together. After he did this, Abramović took questions from the audience, responding as she imagined Ulay would if he could speak (figs. 7–12). The piece ended when Abramović sensed that her answers had become less similar to Ulay's views than to her own.[1]

Talking about Similarity raises questions about the formation of individual identity in psychoanalytic terms—its impossibility during the oral stage (metaphorically suggested by Ulay's suturing of his mouth) and its possibility in the oedipal scenario or Lacanian symbolic (metaphorically suggested by Abramović's use of language). But for all the seeming emphasis on those two psychic phenomena, Abramović's attempts to mirror Ulay's identity suggest that the real corollary for this performance is the mirror stage. As Lacan makes clear, the mirror stage, especially its early moments, does not necessitate an actual mirror. For example, echoed sounds can suffice to introduce rudimentary notions of self-identity.[2] The key point is that one knows oneself through representations, and at the mirror stage the child realizes that representations of the self, whether they be images or sounds, are not the same thing *as* the self.

Lacan describes the mirror stage as "a drama whose internal thrust is precipitated from insufficiency to anticipation—and which manufactures for the

subject, caught up in the lure of spatial identification, the succession of phantasies that extends from a fragmented body-image to a form of its totality."[3] In other words, the mirror stage itself comes in stages. In the early moments, the child discovers that he or she is fragmented into two parts—the body standing in front of the mirror and the representation of the body seen in the mirror. In the latter moments, the child adopts the fantasy that these two parts equal a whole being. In essence, the child is involved in a drama headed toward a mythical ending. *Talking about Similarity* is, in effect, a test of that ending. When Abramović could no longer convince herself that her own thoughts were equivalent to Ulay's, the notion of a unified identity was exposed as a myth, and the artists' drama of the mirror stage was over.

Significantly, however, for several minutes Abramović *was* able to "talk about similarity," showing that the mirror stage does, in some respects, allow for a shuttling back and forth between identities. *Her* mirror and *his* mirror were temporarily interchangeable. In other words, the artists' perceptions of what each of them might have thought of as *my* mirror were made ambiguous.[4] It is only in the early moments of the mirror stage, when the first inkling of an "I" (or "my") is introduced to the psyche, that these differences and similarities can be held momentarily in equilibrium (rather than repressed by myth or stultified by language). *Talking about Similarity* is about both these aspects of the mirror stage—the indeterminacy of identificatory processes and the myth of indeterminacy's nonexistence.

That Ulay is a man and Abramović a woman emphasizes the complexity of the gender-related aspects of these processes. Feminist art historians of the last few decades have analyzed at length the dynamics of the viewer-and-viewed relationship, starting with the conventional conceptualization of viewed objects as female and viewing subjects as male.[5] These traditional identifications have been maintained most easily during historical periods in which male artists have rendered images of female bodies for a predominantly male set of patrons, judges, or potential collectors.[6] Whether this identificatory process is so embedded in Western culture that it carries over to the viewing of all other types of subject matter is debatable. Less arguable, though, is the idea that the interpretation of an artwork hinges on a symbiotic collusion between economic factors of possession (art is, after all, subject to trade, as Acconci reminds his viewers in *Trademarks*) and the psychological-epistemological activity of the unconscious mind. Early gender-inflected encounters with the world in the oral, mirror, and oedipal stages of psychic development are often explored in masochistic performance in ways that expose issues that are repressed in viewers' experiences of more conventional art. In a formal sense, Ulay's act of sewing his mouth shut symbolizes this process of repression, and Abramović's words symbolize an attempt to cast light on the process from her position as a viewer.

Consider two typical experiences of conventional art viewing: one in which the work of art emphasizes perspective, and one in which it emphasizes surface. One could argue that perspectival art is repressive in that it seduces the viewer into an illusory re-

lation with the composition; it promotes a denial of the viewer's body in favor of the represented space. Conversely, art that asserts surface so strongly that access to virtual space beyond the surface of a painting or sculpture is denied produces a double repression; that is, the more familiar denial of bodily presence is now itself denied. In both cases, viewers realize the presence of their bodies but do not really know what to do with that recognition in relation to the object in front of them or to other objects around them. In these cases, there is almost too much difference. This may account for the sense of disconnectedness from art reported by so many individuals—except those trained to deal with it. But then, the intellectualization enmeshed in such training can itself become a way of transcending the psychodynamics of differentiation, including the complexity of gender.

In masochistic performances such as Ulay/Abramović's, these dynamics are literalized and can hardly be overlooked. To be sure, learning about the psychodynamics of conventional art viewing by analyzing the literalization of such dynamics in masochistic performance art will not automatically rein in tendencies toward transcendence inspired by more conventional art or by intellectualizing about art. Nor will it automatically cut down on a variant of transcendence—alienation. However, a consideration of the psychodynamics of masochistic performance art may elucidate one paradoxical value of alienation, namely, the possibility of recognizing difference.

The typical distantiation of the viewer from the artist in masochistic performance helps make it possible to understand the complexity of difference and to develop a critique of it. More precisely, the establishment of distance, which is facilitated by photodocumentation (note that Ulay and Abramović are not even pictured together in any of their self-published photographs documenting this piece), makes it possible to deconstruct alienation; this might be thought of as "constructive alienation."[7] The most remarkable thing about this brand of alienation is that it allows difference to be acknowledged respectfully rather than manipulated for purposes of marginalization. The conventional process of marginalization tends to cast individuals as *so* different that they are put at a disadvantage in terms of power. But most masochistic performance art fosters a respectful acknowledgment of difference in a way that prevents falsely comforting, absolutist conceptions of it. For, as *Talking about Similarity* so clearly shows, one's acknowledgment of difference always abuts and is complicated by a desire for sameness.

Exploring masochistic performance art from a psychoanalytic perspective also helps illuminate ways in which the performing body serves as a metaphor for the subjects of violence. In fact, this approach can be useful in the analysis of all modern art, because all modern art entails some innately violent psychological functions—artistic *mastery* and visual *domination*, to name just two.[8] But it is often difficult to draw attention to these functions, because their terms belong to the discourse of masochism. The mere mention of masochism in critical analysis usually causes silence or a dead stare. There is a tendency to repress discussions of masochism despite the fact that it riddles

everyday life. Everyone performs within its structure, but few feel comfortable designating as masochistic their seemingly harmless acts of self-deprecation, denial of hunger in the name of beauty, suppression of anger for the sake of peace, and so on. Yet these practices are, in effect, "everyday masochisms."

Though stereotypically gendered, acts such as self-deprecation, the pursuit of beauty, and peace seeking are not exclusively the province of women. Throughout most of *Talking about Similarity*, Abramović carries out a subtle form of everyday masochism often seen among women—self-effacement.[9] She denies difference from her male partner, resisting constructive alienation between herself and Ulay. But *Talking about Similarity* ends when Abramović feels her ventriloquism slip and she begins to formulate her own answers to questions posed by the audience. Moreover, her effort to use linguistic tools of the symbolic order to talk about similarity proves that everyone, male or female, operates simultaneously from both the conscious mind, where actual words get formed and uttered, and the unconscious, where masochism takes root and where language is constructed in response to the recognition of difference.[10] Inevitably, Abramović speaks from and about difference, thereby opening a trapdoor onto what might be thought of as a vast "force field of language" making up the subterranean world of the unconscious mind.

Ulay's efforts in the performance tend in the opposite direction. With great precision, he directs viewers' perceptions from the grand, seemingly obdurate objecthood of the performing body to the specific entity of the skin. In short, he gathers the force field of language into a single sign. As he reduces language in this manner, he forces viewers to limit their perceptions of the body to skin and its communicative function—one of the three "skin functions," besides protection and containment, outlined by Anzieu.

At this juncture, Ulay's efforts collide and even collude with those of Abramović, leading the viewer to conclude that the body can be understood only through the differentiating terms of language. But the artists' collusion also demonstrates that this understanding of the body is inextricably linked to an awareness that only language can deliver a practical and potentially beneficial assumption of sameness between individuals. This link, then, forms a paradox—one that can be most substantively understood and problematized by tapping into the early moments of the mirror stage, as Ulay/Abramović do. For it is there that individuals learn firsthand that similarity *and/or* difference is founded on the vulnerability of the body as an object *and/or* subject. Ulay/Abramović poignantly chart that vulnerability.

Together, the artists take the viewer to the depths of the performance's meaning by drawing attention to the surface of the skin. Their actions suggest that the body, from its roots in the psychologized institution of the domestic site, is operating in a similarly institutionalized context in everyday life. By attending to issues not only of the body but also of space, Ulay/Abramović drive this point home, literally and figuratively.

Ulay/Abramović's emphasis on the paradox of the mirror stage points to the only

way to bring clarity to "meant-said" distinctions: through the recognition of *both* similarities and differences. In legal terms, this is a recognition that takes place in the "acceptance" phase of contractual proceedings where similarities and differences (in opinions, thoughts, and wishes) are negotiated. By default, Ulay/Abramović actualized a metaphoric version of negotiation all their own in *Talking about Similarity*.

As Ulay/Abramović showed, Lacan's notion of the mirror stage is integral to its successor, the oedipal scenario, where gender plays a central role. Understanding more about the oedipal scenario—especially its economic implications in regard to the theoretical possession of woman by man—will help clarify this explanation of the mirror stage and the performances that deal with its subtleties.

Lacan builds on Freud's theories of what takes place in the oedipal scenario, distinguishing between what happens for male and female children. In Lacan's view, as the little boy observes that his mother's body does not have what his does—namely, the penis—he understands her to be different, ultimately thinking of her as the "other." Thinking and describing take place with the help of a symbolic means of representation (language) to which the child is introduced in the oedipal scenario, or what Lacan calls the realm of the symbolic. The conclusion the child articulates in response to his mother's difference, along with his ability to understand and express this difference, is facilitated—actually enforced—by the entrance of the father, who claims possession of the mother, demarcating her as his territory. His possessive enunciation is made both verbally (through language) and physically (by his inherently phallic presence). Language and phallic power are, then, united.

Once this phallic presence is in place, it is no longer possible for the little boy to claim the mother as the chief entity in the environment (Anzieu's "mothering environment") to which he was earlier attached during the oral stage. It was in those pre-oedipal, oral-stage moments that Lacan's notion of the imaginary was most powerfully at work (even though he considers the realm of the imaginary to include both the oral and mirror stages). The child actually *imagined* himself to be merged with his environment during the oral stage. The child's desire for attachment and his subsequent frustration over separation in the latter moments of the oral stage are known only to the unconscious mind at this point. Activated in the oedipal moment, the unconscious is constructed, according to Lacan, by the very language that allows for the patriarchal takeover and the articulation of difference between genders.

Like the little boy in the oedipal scenario, the girl child is no longer able to rely on processes of attachment to the mother figure or on boundariless merging with her environment. But unlike the little boy, the girl continues to identify with the mother on a psychophysiological level of similarity. Nonetheless, this sameness can be expressed only—as for the male child—within the limitations of language imposed by the father. So, the little girl's recognition of sameness is transferred to the perception of herself, like her mother, as "other."[11]

This transition from the oral mother to the oedipalized symbolic is a very big move for the child, but the movement takes place gradually, in increments, like a pendulum marking off minutes and hours in its swing.[12] In the middle of this swing, somewhere between the ages of six months and eighteen months, according to Lacan, the mirror stage takes place. Functioning as a termination of the imaginary and an introduction to the symbolic, the mirror stage constitutes a "threshold" between the two realms.[13]

Masochistic performance artists often return to this threshold. Even when the mouth or bed (metaphors for the oral and oedipal stages) is the focal point in a performance, the mirror stage is generally alluded to as well. In Pane's *Discours mou et mat*, for instance, her mouth served as a prominent image, but so did the mirrors she shattered. And in *Talking about Similarity*, Ulay's mouth appeared to be the focal point, but it was Abramović's attempt to mirror Ulay's thoughts that was ultimately central to the meaning of the piece. These efforts by artists to connect to the dynamics of the mirror stage constitute the greatest contribution of masochistic performance: the attempt to deconstruct the very notion of identity that oedipalization tries to render inflexible. By concentrating especially on the early moments of the mirror stage, these artists expose the masochistic pain inherent in the transition to the symbolic (a pain that is paradoxically simultaneous with flexible notions of identity). Finally, their performances introduce a possible alternative to this pain: a compromise known in contract making as "acceptance," or what I am calling "negotiation." For all of Abramović's attempts to show her similarity to Ulay, she wound up having to accept her differences. The process of negotiation is just this: the act of dealing with both similarities and differences.

Psychically, negotiation begins when a child undergoes what Lacan calls "functional fragmentation." Standing in front of the mirror, recognizing itself for the first time as both the same as and different from its reflected image, the child comes to know *itself* as "other," or, as Lacan says, as a "split self."[14] Lacan hints at the power of this painful splitting process when he speaks of the "price" exacted by the mirror stage—a price not fully recognized until oedipalization is complete. In "The Meaning of the Phallus," he writes that the subject "speaks in the Other . . . because it is there that the subject . . . finds his signifying place. The discovery of what he articulates in that place, that is, in the unconscious, enables us to grasp the price of the division (*Spaltung*) [the split that takes place at the mirror] through which he is thus constituted."[15]

The child's knowledge that its mirror image is not a three-dimensional volume but a two-dimensional surface ushers the child into the world of representation. Crossing this threshold involves intense experiences of both sight and touch, inasmuch as the child actually watches itself touching its image in the mirror. But this is not the only act of touching experienced by the child in front of the mirror. Anyone who has ever watched a child gaze at its reflection has seen the child reach out and smack the hard surface of the mirror with the palm of its hand. To my mind, this gesture constitutes the first symbolic act of self-attack in an individual's psychic development.[16]

My claim should not confuse the fact that experiences of masochism are multi-

temporal. As Anzieu's theories and the performances described in chapter 2 indicate, the first moments of masochism (which Anzieu groups under "primary masochism") take place toward the end of the oral stage when the child begins the painful process of detaching from common-skin fantasies. But it is the mirror that gives a literal picture of this process, presenting the child with an illustration of what it means that the oral stage is over and that the realm of the imaginary is about to draw to a close as well. Although the child does not yet have access to language (which he or she will acquire in the oedipal scenario and will use to articulate sameness and difference on the basis of gendered rights of possession), the mirror nonetheless introduces a fundamentally and fortuitously nongendered concept of sameness and difference located at the site of the child's own body. It is here, in other words, that the notion of *my mirror* is initiated and the gendered meaning of the possessive pronoun is made temporarily transferable. Ulay/Abramović's *Talking about Similarity* highlighted this concept even without the use of an actual mirror. The twinlike nature of the artists' relationship, manifested in Abramović's echoing or mirroring of Ulay's identity, satisfied the need for a symbolic device.

For a child, the split experienced at the mirror constitutes a final, violent disruption of his or her oral-stage merger with his or her environment. The child's seeming oneness with an unterritorialized world begins to be shaken in the late oral stage. But this shake-up is gentle and rolling in comparison to the dramatic severing initiated at the mirror. The mirror stage really constitutes a second moment of masochism, a moment at which (or from which) three things may happen.

First, there might be an effort to return nostalgically to the gentler rumblings of ambivalence in the late moments of the oral stage (or even to a complete recapturing of oneness with the oral mother). One might try to make the mirror go away, to deny its presence, to duck beneath its reflection, to deal directly with the pliable, warm body as if that is all there is, as if the *re*presentation of the body does not exist, or at least does not matter. Second, an individual might accept completely the realm to which the mirror has introduced him or her: the symbolic. In part, the function of the symbolic is to help heal the initial violence experienced in front of the mirror. The symbolic helps repress desires and frustrations centered on separating from the mother that commence in the late oral stage, rise through the mirror stage, and peak in the oedipal scenario. Language is ostensibly that healing agent—albeit one that requires, as Lacan points out, a special price in the form of hierarchized gender designations.[17] Third, one might return, again and again, to the sliver of silvered glass, experiencing the body simultaneously as something to be felt as well as seen; to be experienced directly as well as indirectly, as presentable and representable; to be known as subject and object, same and different, self and other, active and passive, mobile and frozen. In other words, returning to the dynamics of the mirror stage affords the individual a way of thinking about the body in which these vastly different perceptions might tenuously, but advantageously, coexist.

In the performances discussed in this chapter, these three options are constantly traversed, but it is the last option that figures most prominently. Indeed, although Abramović tried to duck beneath the mirror's reflection by "merging mirrors," so to speak, and although she accepted language as a tool with which to disavow difference, in the end, *Talking about Similarity* is much more about the indeterminacy offered by the early moments of the mirror stage.

Given the attraction of masochistic artists to this aspect of the mirror stage, I would like to pose an intentionally provocative question: Are the extremes to which artists go in discovering the utopian potential of the mirror stage proportionate to the degree of patriarchal control? If so, studying artists who use their own bodies to literalize the fragmentation experienced at the mirror and to illustrate the way in which the mirror metaphorically cuts through myths of wholeness could reveal a great deal about the sometimes destructive, and sometimes sadistic, nature of power.[18]

In Vito Acconci's *See Through*, filmed in the fall of 1969, he performed a boxing match with his image reflected in a mirror, punching at the glass until it broke.[19] It is the earliest work in the cluster of performances I am discussing that indicates a trend toward masochism. And as with *Trademarks*, there was no audience. I am trying to suggest that such works responded to the tenuous position of the body in society at the time, specifically in terms of what was being said and what was being meant about bodies and violence. In the midst of the Vietnam War, Acconci tacitly challenged viewers to take a look at the psychodynamics of the mirror stage as he jousted with his reflection in an actual mirror.

A photograph of *See Through* (a still from the film) and an accompanying text were published in the same issue of *Avalanche* in which *Trademarks* appeared (fig. 15). The text ends with a forthright declaration of the body's possessibility, suggesting that the institutions into which the body is contracted are often economic in nature. This exchange value of the body is made even more apparent when one performs or, as Acconci says, "moves." Acconci writes:

> Reasons to move: move toward what
> belongs to me—move to have what
> belongs to me.[20]

Acconci's near repetition of phrases indicates his complex understanding of one's mirrored identity as a possessible object. But recognizing the body as a possessible entity ("*what* / belongs to me") is not exactly the same as taking possession of it ("*hav[ing]* what / belongs to me").

This distinction recalls sociologist Bryan S. Turner's fundamental observation that we both *are* and *have* bodies. "Our embodiment is a necessary requirement of our social identification," he argues, "so that it would be ludicrous to say 'I have arrived and

I have brought my body with me.'"[21] Turner also speaks about alienation. In a discussion of the body's conflicted status as "a natural environment" that is "socially constituted," he asserts:

> Despite the sovereignty we exercise over our bodies, we often experience embodiment as alienation as when we have cancer or gout. Our bodies are an environment which can become anarchic, regardless of our subjective experience of our government of the body. The importance of embodiment for our sense of the self is threatened by disease but also by social stigmatization.... The body is a material organism, but also a metaphor; it is the trunk apart from head and limbs, but also the person (as in "anybody" and "somebody")....The body is at once the most solid, the most elusive, illusory, concrete, metaphorical, ever present and ever distant thing—a site, an instrument, an environment, a singularity and a multiplicity.[22]

Like most masochistic artists, Acconci suggests that a sustained indeterminate perception of the body, in which all the seemingly mutually exclusive aspects Turner outlines are taken into account, may be the only alternative to alienation (that is, the only viable form of constructive alienation). Such delicately balanced thinking about the body—a mode of internalized communication that is externalized in institutionalized contractual negotiation—is first initiated by the cooperative functions of sight and touch in the mirror stage.[23]

Acconci speaks of these functions in his text for *See Through* and ties them directly to the material object of the mirror in his performance. Printed alongside the photograph of Acconci holding his fist up to the surface of the mirror are the first three stanzas of his text:

> Facing a mirror: punching at the mirror:
> punching at my image in the mirror until
> the mirror breaks and my image
> disappears.

> Get to me—get at me—get into me—get
> through me—get through to me.

> Talking to myself—talking myself into
> myself—talking myself out of myself—
> taking myself—taking to myself—taking
> up myself—taking myself on—taking
> myself through—taking myself off—
> touching myself—touching on myself
> (touching lightly and passing myself by).[24]

Here, Acconci's compelling descriptions of "facing" and "touching" are mediated by an internalized use of language ("talking to myself") for purposes of negotiating the space between ("into," "out of") different aspects of identity and their respective psychic states. Those differences are outlined in the fourth stanza:

> This is a way to get rid of myself. No,
> this is a way to get rid of an image and
> so be able to stand on my own. No, this
> is a way to get rid of a necessary
> support. No, this is a way to get rid of a
> nagging shadow. No, this is a way to get
> out of a closed circle and so have room
> to move. No, this is a way to get rid of
> deep space, so that I have to bang my
> head against the wall.[25]

In this case, Acconci draws contrasts between *pre*sentation ("stand[ing] on my own") and *re*presentation ("an image") of his body, and attachment to an oral-stage prop ("necessary / support") and separation from it ("hav[ing] room / to move"). He punctuates these contrasts with what at first appears to be a term of negation. But the word "no" becomes Acconci's rhetorical tool for negotiating among these apparent opposites. With that word, he simultaneously announces the impossibility of resolution and the necessity of sustaining (or entering into contractual acceptance of) difference.

The last set of differences that Acconci mentions are deep space and the wall, broad metaphors for the institutional conflicts in which he, his viewers, and his readers were situated at the time *See Through* was filmed. This is a conflict between nature and culture, between the deep space (nature) inhabited by the physical body and the wall (culture) of restrictive social structures. Acconci offers as one response to this dilemma a classic example of masochism—banging his head against the wall. This action is an extreme example of contractual negotiation and personifies Gilmore's desire for a "meeting of the minds" in contractual practices of the 1960s and 1970s.

Acconci makes no overt reference to contemporary political conditions or to the Vietnam War in this or any other of his performances during this period. But he was involved in antiwar demonstrations, and he has said that he would never

> have thought of this kind of live stuff without the context of that time,
> without the context of demonstrations against American involvement in
> the Vietnam War. Demonstrations against the Vietnam War are the reasons
> why a lot of us could ever do single-person pieces then, because at that time
> it didn't seem like we were pointing out the grandiosity of the self. It was
> more about instrumentality of "person," about the way in which person
> could be effective.[26]

One way to be effective then, as Acconci showed, was to enact a need for negotiation—a need intensified in the sociopolitical sphere by a war in which (like any war) negotiatory possibilities were continually eclipsed by the either/or terms of opposition, of either winning or losing.

To balance seemingly opposite aspects of identification was Ulay/Abramović's chief concern in *Balance Proof*, which was presented at the Musée d'Art et d'Histoire in Geneva in 1977. Not surprisingly, a mirror played a prominent role in the performance. Ulay and Abramović, each naked, stood face to face. Less than one inch separated them, but they could not see each other because sandwiched between them was a thin, seven-foot-high, three-foot-wide mirror (fig. 16). The artists held the mirror in place by pressing the fronts of their bodies up against it. The mirror was reflective on both sides, so the audience saw not only the artists' actual bodies but also the reflections of their bodies, which were partially flattened against the glass. Ulay/Abramović's goal was to stand in this position as long as they could or desired. The piece lasted thirty minutes, with Abramović retiring first. The mirror stayed upright (figs. 17–18) until Ulay eventually also stepped back from it (fig. 19). It then fell to the floor. Amazingly, it did not break (fig. 20).

A text and a series of five photographs documenting the performance (all reproduced here) were published in the artists' book *Relation Work and Detour*.[27] As with the use of the term "proof" in the title of the work, the artists' text alludes to legal processes. It begins with a clear explanation of the terms of the performance (the equivalent of a contractual offer) and then proceeds to articulate the limits of their negotiation (their acceptance of the offered terms). The core of the text reads as follows:

> In a given space.
> We are standing holding a double-sided mirror between our bodies.
> *Marina Abramović*
> I am leaving
> *Ulay*
> I am leaving[28]

The accompanying photographs illustrate the contractual process. That is, they picture the content of the negotiation that took place as the artists approached mutually accepted limits. The photographs also demonstrate that the "consideration" here, as usual in contracts, is the human body.

In the first photograph (fig. 16), the viewer sees the artists pressed up against opposite sides of the double-sided mirror. The mirror appears in the middle of the photograph, bifurcating the image and formally duplicating the function of the mirror in psychic development. What Lacan referred to as the mirror-stage confrontation with the "split self" is precisely what Ulay/Abramović are symbolically experiencing. But in

this case, unlike many of the masochistic performances I have discussed, the artists' visual and haptic exploration of mirror-stage pain is not literalized. Rather than producing a physical mark on their bodies, some metaphoric exteriorization of the psychic mark of the mirror stage, Ulay/Abramović chose to illustrate poetically that which gets introduced in the early moments of the mirror stage—the balance between multiple aspects of individual identity.

One might even consider *Balance Proof* as an extrautopian alternative to the more intense practices of masochism through which artists had previously explored identificatory processes, including Ulay's piercing of his own lips and Abramović's self-effacement the year before. But this is not to say that *Balance Proof* is not masochistic in nature. Indeed, Ulay/Abramović fulfill all the Reikian/Deleuzean criteria for the enactment of masochism here. They keep themselves in a state of *suspense* by not moving for thirty minutes. They engage in a *provocation* of each other (to stand as long as the other) and of the audience (to either help sustain the suspense or stop the piece). They stimulate *fantasy* in themselves, each other, and the audience as everyone tries to imagine how the performance will proceed, when it will end, and what it means. They have a predetermined *contract* with each other (to stand as long as possible) and with the audience members (who are in agreement with these terms if they watch in silence).[29] Finally, the performing of all these aspects of masochism constitutes the artists' *demonstration* and allows for a deconstructive critique of social institutions that perpetuate masochism in everyday life.

Some of the institutions that most shape everyday life are not addressed here, however. The economy, for example, is addressed more directly in other performances. But the institution that Ulay/Abramović *do* foreground is foundational—heterosexual partnership, which is presumed to be the basis of all domestic scenarios. This institution, after which most social institutions are patterned, is addressed in *Balance Proof* in a more specific way than in almost any other performance of this type. But Ulay/Abramović's efforts are far from a ratification of this stereotype. Although they make their biosexual differences the focal point of this performance, they also tamper with them. They stage a scenario in which the mirror draws a line between their identities as "male" and "female." In so doing, they also tap the capacity of the mirror stage to render gender identifications ambiguous. This is clearly illustrated in the first photograph (fig. 16), in which one sees not only Abramović's obviously female body but also an ambiguous image of Ulay's. The line formed by the edge of the mirror makes Ulay's body appear to have frontal "attachments"—mirrored reflections of Abramović's breasts and belly. This conglomerate image dramatically reorients the viewer's perceptions of Ulay's gender as male. Moreover, the lack of a visual match between the reflection of Abramović's face and Ulay's nearly faceless head emphasizes that the denaturalizing processes of representation are at work here. Conclusions regarding Ulay's gender are as constructed, then, as many other aspects of identity are.[30] In the next two photographs in the series, Ulay stands alone at the mirror (figs. 17–18). With all sexual

signifiers now removed, his gender identification slips even further into the domain of ambiguity.

Gender issues are important to Ulay/Abramović, as is implied in *Talking about Similarity* and made explicit in *Balance Proof*. In an interview published in the year after *Balance Proof* was performed, Ulay said:

> I think people are always thinking of us as a symbol for man and woman:
> and of course in a biological way we are. . . . Of course there is a difference
> between Marina and me, but equally there is a difference between one man
> and another. So we negate the general idea of man and woman. I think the
> two of us are more liberated than feminist or non-feminist artists, or any
> single artist. Because a single artist, a single person can't get the results we
> do. We have two impulses of two people, and there is one result.[31]

Although this statement may hint at a tendency toward a totalizing conception of gender ("one result") capable of eradicating a more complicated notion of sexual difference, Ulay/Abramović's photographs disallow such a reading. In the penultimate photograph, the mirror tips toward the floor as Ulay's foot disappears across the right-hand edge of the picture (fig. 19). Between the observer of the photograph and the audience members pictured against the far wall, the thin edge of the mirror seems to float in space. Running a finger over this delicate line in the photograph, the viewer is tempted to try to balance it, imaginatively, on the tip of his or her finger. This instinctive, visual-haptic gesture yields the performance's most useful metaphor: that the ground on which identification is based is not fixed.

The fact that the mirror remains unbroken after its fall at the end of *Balance Proof*—as shown in the fifth and final photograph (fig. 20)—is poetically appropriate. The artists seem to suggest that the early moments of the mirror stage can be explored without shattering or fragmenting the persona. Nor do such explorations necessarily involve scars etched across the surface of the body.

THEIR
BEDS

4

G I N A
Pane lay on her back, fully clothed, on a bedlike iron structure. Beneath this bed were fifteen tall burning candles, the tips of their flames rising to within inches of her prone body (fig. 21). For thirty minutes, Pane's only activity was slowly wringing her hands. "Needless to say, the pain started right away and was very difficult to dominate," Pane later said.

> The public understood my
> suffering from the way I wrang
> my hands much more than
> from my face, so it was actually
> a very primitive mode of com-
> munication. But I feel I suc-
> ceeded in making the public
> understand right off that my
> body is my artistic material.
> When, half an hour later, I was
> able to get up, I caressed my
> body very gently. There was
> no violence; my body hurt but
> I could still feel my touch.[1]

Pane highlighted her own haptic experience in this first segment of her three-part performance titled *Autoportrait(s)*, held at the Stadler Gallery in Paris in 1973. These haptic references recall Anzieu's theories of "tactile reflexivity," the simultaneous experience of "being a piece of skin that touches" and "being a piece of skin that is touched," for as Pane said, she caressed herself *and* she felt the sensation of touch involved in that act.[2] Moreover, Pane's insistence that her body be seen as "artistic material" is a reminder that what is truly at stake in masochistic performance is the human body.

The specific way the body is positioned in this first segment, titled "The Conditioning," reflects the structure of contract, particularly the consideration phase of contract proceedings, during which benefits or detriments are clarified. In contract negotiations, what is being exchanged or "considered" is often the human body or its services. Historically, the term "consideration" was ushered into the vocabulary of contract along with market capitalism. "Since the market was the measure of all things," legal theorists Peter Gabel and Jay M. Feinman explain, "only those promises were enforceable that represented market transactions—those for which the person making the promise received something, a 'consideration,' in return."[3] Although this "something" clearly had economic meaning, it was not exclusively about money. Increasingly in the modern period, money and the human body became interchangeable. This modernist phenomenon is clearly represented in Frank Norris's 1899 novel *McTeague*.

Written during the explosion of modern capitalism in the United States at the end of the nineteenth century, *McTeague* was perhaps the first piece of fiction to deal with the issue of domestic masochism and its curious entanglement with money.[4] Indeed, literary theorist Walter Benn Michaels argues that the key to the novel is this truth: masochism personifies modernity in that it thrives on the tension between owning and being owned.[5] Michaels shows how McTeague's masochistic wife, Trina, uses her body to pay for her marriage contract, and her savings to buy a modicum of independence within that partnership. She allows McTeague, an out-of-work dentist, to pursue his kinky desire to chew maniacally on her fingertips; but she also refuses to share her five-thousand-dollar lottery windfall with him. After separating from the impoverished McTeague, Trina pours her treasured gold pieces onto her bed in her newly rented single room, lies down, and with sunlight streaming through the window, pulls the money in around her body, covers her face with coins, and exhales "long sighs of unspeakable delight."[6] In this telling tableau, Trina both demonstrates the terms of the modern masochistic contract and defies them. By virtually engulfing herself in gold, she merges body and money, suggesting their equity. Acknowledging that her body was barter in the original marriage contract, she now more fully reclaims it with money, the entity for which it was symbolically exchanged in the first place. There may be no way out of modern masochism's equation between body and money, Norris seems to say, but at least with her *own* money Trina can begin to repossess her life.

Of key importance in Norris's sunlit tableau, as in Pane's candlelit one, is the bed on which Trina lies. The bed serves as a compelling metaphor for the oedipal scenario, in part because the father's role in the oedipal scenario is that of claiming territorial rights—particularly sexual rights—over the mother, and because the site most symbolically invested with sexuality is the bed. Lacan argues that the father figure's extension of territorial rights over the mother figure constitutes the "law of the father." Because these rights are imbued with economic connotations of bodily possession, they are directly linked to rights that are finalized in the contractual process of considera-

tion. Deleuze, in his analysis of Sacher-Masoch's novels and contracts, makes a similar connection:

> The situation that the masochist establishes by contract, at a specific moment and for a specific period, is already fully contained timelessly and ritually in the symbolic order of masochism. For the masochist, the modern contract as it is elaborated in the bedroom corresponds to the oldest rites once enacted in the swamps and the steppes. The novels of Masoch reflect this twofold history and bring out the identity between its most modern and its most ancient forms.[7]

Despite his historical generalizations, Deleuze makes a specific correlation here between the bedroom and the elaboration of the modern contract; for it is in the bedroom that the tripartite contractual process reaches its denouement, when consideration is cast in the metaphoric form of the body, which is possessed by the father.

In her *Autoportrait(s)*, Pane started at the end of these narratives, first announcing the consideration of her body as artistic material and then moving backward. The three segments of *Autoportrait(s)*, then, were a study-in-reverse of the building of subjectivity. The second and third segments highlighted aspects of the mirror and oral stages, respectively, and the corresponding acceptance and offer stages of contract development. This backward movement through psychic memory accomplished two things. First, it showed how oedipalization affects the memory of earlier stages of psychic development. In other words, once an individual is oedipalized, there is no going back to a pure, full mirror-stage or oral-stage experience; such regression would be only partial and would always be informed by the problematics of the oedipal scenario.[8] But second, as Pane seemed eager to show, the partiality of this regression can be useful, if mined selectively. Therein lay the "moral" of Pane's story: the *natural* sensation of touch can be mobilized effectively in *cultural* (i.e., oedipalized) environments where prohibitions on touching typically limit one's life experiences. Moreover, touch can even mediate such prohibitions.

To emphasize this moral, Pane continually pointed to both the natural and cultural powers of the body throughout *Autoportrait(s)*. For example, in the first segment of the piece, "The Conditioning," her body functioned as a linguistic entity—that is, her hand-wringing was a kind of sign language that the audience "understood." Like any understanding, this interpretation stemmed from prior participation in the systems of representation that make up culture. But Pane was quick to note that this "mode of communication" was quite "primitive," which in this context meant basic or natural. Pane seemed to stress that the terms of nature and culture were not fixed; rather, she seemed to want to keep them mobile, showing how they are always implicated in one another and that they can problematize one another in useful ways. This was especially clear in the second and third segments of her performance.

In the second segment, titled "Contraction," Pane stood facing a wall onto which slides of women painting their fingernails were projected. With her back to the audience and her hands covered with a white handkerchief, she made tiny incisions with a razor blade in the skin around her fingernails as well as in her lip. A microphone, positioned at mouth level, amplified her whispered words: "They won't see anything." Pane later referred to this segment as "a total refusal to communicate."[9] But it seems clear that she was using irony here for the specific purpose of problematizing biocultural dualities. The natural color of the blood ironically duplicated the artificial color of the nail polish. Her denial of audience members' ability to see what she was doing was made ironic by her simultaneous presentation of slides, which were used to entice the audience's desire to see everything, including that which she was hiding. Finally, she made her own "refusal to communicate" ironic by prearranging with the camera-person to turn the camera on female audience members, thereby forcing them not only to observe the projected images of feminized aesthetics but also to apprehend their own reactions. So, in fact, Pane did communicate, and in a very sophisticated way. That is, she transferred the work of communication to the audience members, pressing them to negotiate the meaning of the piece for themselves.

On both the psychic and the contractual levels, it is significant that the audience members negotiated the meaning of Pane's piece while they gazed at mirror images of themselves on the video monitors. This both stimulated their own memories of the mirror stage and mobilized Pane's key question regarding contractual processes of acceptance. By cutting her body, Pane highlighted the vulnerability that is suppressed by a simplistic, nonnegotiated acceptance of the conditions of masquerade. This vulnerability is first experienced in the process of separating from the mothering figure, but it is manifested even more intensely in the mirror stage when one recognizes his or her identity as a "split self." This heightened awareness of vulnerability is conveyed by the reflexivity of touch working in tandem with vision—that is, by the once-experienced and now reimagined look and feel of one's representation in the mirror. As I noted earlier, one can touch the mirror's hard, cold, impenetrable surface at the same time as being able to touch one's pliable, warm, penetrable flesh. Pane's masochism, then, can be seen as a warning to women not to accept automatically predetermined cultural *or* biological identities but to take command over them. This process begins by recognizing one's identity as simultaneously vulnerable *and* impenetrable.

In "Rejection," the third segment of *Autoportrait(s),* Pane knelt before the audience. After taking a few swallows of milk from a liter bottle, she repeatedly took milk into her mouth, gargled it, and spit it out into a bowl in front of her. She did this with increasing ferocity until the cut in her lip reopened and her blood started to mix with the milk, at which point she ended the performance. Reflecting on "Rejection," Pane later explained its symbolism as "related to childhood in general and thus the family. . . . It means that in my artistic work I reject the memory relationship of my childhood

and the past. I want to assume my adult responsibilities and be responsible for the liberty of my actions. Thus blood becomes an element that replaces milk."[10]

Pane's rejection of her "memory relationship" demonstrates how difficult—even undesirable—it is to recapture previous moments of psychic development in their totality. This rejection is the ultimate irony of *Autoportrait(s)*, for despite the self-alienation from the oral stage of psychic development that she maneuvered by symbolically detaching from the mother as a source of nurturance and support, Pane actually drew attention to a key aspect of the oral stage: the "mothering environment." Although Pane's deliberate forgetting may shove the symbolic mother out of the picture, this very act makes the place she once occupied all the more clear. The mothering environment—the domestic paradigm for all sociocultural institutions—is vivified. It is these institutions that Pane ultimately wants to critique.

One of the institutions targeted in "Rejection" was women's fashion. Others were represented in the five small installations that lined the walls of the gallery where *Autoportrait(s)* was staged. For instance, there were photographs of forests and circus arenas in one section, and in another were some artist's paintbrushes and jar covers. Another section featured the story of a provincial French village that had opposed real estate developers by isolating itself as a self-sufficient economic structure and refusing to use any hazardous chemicals, such as defoliants. Also shown was an artwork by Pane called *Posthumous Work* (1972), which consisted of six tombstonelike constructions fabricated to accommodate photographs of the artist taken at ten-year intervals. She said that her purpose in this work was to document the "deterioration of [her] body."[11] After Pane's death, her posthumous portrait was to be placed in the last gravestone; if the owner of the work were to die first, however, then his or her portrait would be placed there instead.[12] And finally, there was an installation of tampons allegedly used by Pane during the week preceding the performance.

By intercutting references to nature (forests, the processes of aging and menstruating) with references to culture (popular entertainment, high art, and Western attitudes toward death), Pane refused to present the body as solely biological or wholly cultural. Instead, she showed the body caught up in systems of representation involving both natural and cultural characteristics, yet capable of being reshaped. This, I believe, was Pane's mission: to demonstrate not only the role of the body in social relations but also the ways the body can become more effective as a tool for change.[13]

Recalling Pane's earlier remarks regarding the preservation of the reflexive sensation of touch after enduring the pain of "The Conditioning," it seems she was suggesting that this potentially interactive phenomenon—touch, which is first experienced in the oral stage—is capable of being called upon as a mitigator of pain in an adult's forever oedipalized state. Haptic experience, in other words, warrants preservation and nurturing throughout one's entire life. Perhaps it is this phenomenon of touch that Pane was advocating as an alternative to, or a constructive mediation of, the dominating pressure that the hierarchical system of representation (which privileges vision)

exerts in the oedipal scenario. In this way she recaptured touch as the mitigator of pain in oedipal symbolism.

Pane said of "The Conditioning" that "the pain . . . was very difficult to dominate." This pain must be understood as a metaphor for the oppressive level of institutional and political domination in the early 1970s. Both the Vietnam War and the post–May 1968 political changes in Pane's home base of France were alluded to in *Auto-portrait(s)*.[14] Pane's masochistic attempt to dominate self-imposed pain symbolized for her observers the pain of their own social domination.[15] And, even more importantly, it suggested methods for alternative social change that were not as extreme as those to which she pushed herself.

These methods, Pane emphasized, require the maintenance of a constructive tension between two tasks: to stay *in touch* with oneself and to remain engaged with the problem-ridden social institutions for which the "mothering environment" stands as a metaphor. Interestingly, Pane found it most effective to demonstrate these methods using a psychic scenario in which the structure of the institution gets rigidified. Thus, her iron bed symbolized much more than the torture instrument it initially resembled. And it was tied much more directly to the political climate of the 1970s than to Deleuze's transhistorical notion of timeless behavior in the swamps and steppes of ancient times. In the end, it was a bed that served the needs of others rather than her own in the psycholegalistic terminology of territorial rights. It was, indeed, *their* bed.

Deleuze's ideas about the masochistic contract are the most substantive and useful to date, but many of his points are still open to debate. In his discussion of nature and culture in relation to both conventional contract and the masochistic contract, for instance, Deleuze writes, "Contract may indeed be said to exemplify the very type of a culture-bound relationship that is artificial, Apollonian and virile, as opposed to the natural, chthonian relationship which binds us to the mother and the woman." But, he argues, "the contract in masochism reverses this state of affairs by making the woman into the party with whom the contract is entered into."[16] At first, this reversal of gendered power may sound like a promising de-essentializing of the status of woman, but it is not.

In Sacher-Masoch's writings, from which Deleuze extrapolates his theories of masochism and the masochistic contract, the woman-mother becomes master of a male slave. Consequently, she stands for the possibility of female empowerment against all the odds constructed by patriarchy. Deleuze even states, "The masochistic contract excludes the father and displaces onto the mother the task of exercising and applying the paternal law."[17] This shift he sees as the "most radical transformation of the law."[18] But it could also be argued that such a schema, which depends on contract's inversion of patriarchal hierarchy and subsequent investiture of woman with power, depends on woman's *dis*empowerment. Simple reversals of power do not necessarily improve woman's position in patriarchal society, because any reversal can all too easily

be re-reversed. To Deleuze's mind, woman is elevated to high command through masochism. But how high can her position be when it is constituted solely in terms of a power to inflict pain? And does this notion of elevation do anything to transform the fundamentally patriarchal concept of hierarchy itself?

This leads to another argument—one that pertains specifically to masochistic performance of the 1970s and also points to the genuinely radical message in Deleuze's analysis. In an interesting way, the schema proposed by Deleuze (by way of Sacher-Masoch) attempts to level patriarchal hierarchies by confusing gendered roles. Deleuze argues that Sacher-Masoch's male slave is actually liberated by means of a very particular type of "rebirth" or regeneration called parthenogenesis. Parthenogenesis requires no biological parents for birth, or at least no father or "uterine mother" is required, according to Deleuze, who reserves a place for the "oral mother" and her empowerment.[19] This interpretation of Sacher-Masoch's writings radically reconfigures the terms of Freud's oedipal scenario, because parthenogenesis facilitates the male's psychic separation from (at least one version of) a mother as well as from a father. But why should this phenomenon be restricted to males? Since parthenogenesis already tampers with the functions of traditional gender roles, could the position of the parthenogenetically reborn son be taken up by anyone—for instance, a daughter, or even an individual of unspecified gender? If so, one could see Deleuze's interpretation of Sacher-Masoch's written contracts as proffering an opposition to the blind spots inherent in the very inversion theory both writers embrace. For this to take place, however, one must heed Deleuze's warning regarding the world of law and, beyond that, must consider an even more nuanced version of his warning.

To Deleuze, the masochistic contract is a sort of cartoon version of conventional contract, a caricature that calls attention to the place of the contract in the legal world. He defines contract according to its promotion of certain entitlements, all of which are compromised as the contract accedes to law:

> [W]hile the contract implies in principle certain conditions like the free acceptance of the parties, a limited duration and the preservation of inalienable rights, the law it generates always tends to forget its own origins and annul these restrictive conditions. . . . To imagine that a contract or quasi-contract is at the origin of society is to invoke conditions which are necessarily invalidated as soon as the law comes into being. For the law, once established, violates the contract in that it can apply to a third party, is valid for an indeterminate period and recognizes no inalienable rights.[20]

The warning Deleuze issues here concerns the way the law can drastically alter the contract, even swallow it up. Deleuze suggests that the masochistic contract averts this possibility by turning patriarchy, which rules the law, on its head. This power reversal certainly has potential for promoting new readings of gender. But I believe that its real significance lies in the subtle *in potentia* motion, before the reversal is complete.

Any reversal involves a transitory dynamic: nothing is stable; nothing is determined. Indeterminacy in regard to issues of gender or anything else affecting identity first becomes apparent in the early moments of the mirror stage. If revisited and mined thoughtfully, as Pane demonstrated in *Autoportrait(s)*, memories of this psychic stage can keep such issues mobile and negotiable. If not mined with care, however, the indeterminacy of this moment can devolve into rigidification under oedipalized law (which is in part what Deleuze actually warns against) or simplistic reversal (which Deleuze supports but which in the end does not really challenge the rigidity of the structure).

For all his advocacy of a parthenogenetic rebirth, which would theoretically diminish an individual's oedipal experience, Deleuze's theories continually expose the oedipal scenario and its enactment in the home. There, language is bestowed on a child (male or female) by the law of the father, and expectations of obedience to this law (in all its institutional permutations) are established. It is in this light, however, that Deleuze makes his most valuable claim: "[The masochist's] apparent obedience conceals a criticism and a provocation."[21] The performance artists I have been discussing are indeed critical and provocative. But their efforts are far from concealed. In fact, a very clear trajectory of provocation can be traced and multiple targets revealed, from the art world to the domestic site. In every instance, though, the trajectory of critique passes through the institution of law.

Chris Burden is the only artist considered in this book whose masochistic performances led to a literal confrontation with the law. For *Deadman*, presented in 1972 under the auspices of the Mizuno Gallery in Los Angeles, Burden lay on the street in front of the gallery, next to a car parked on La Cienega Boulevard (fig. 22). For viewers observing the inert body lying on a city street, within inches of traffic, flanked by red flares, and entirely covered with a tarpaulin, the scene unquestionably conjured up an image of death. Yet the audience members also knew that the body was a living artist, so the scene evoked images of pulling the covers up over one's head, sleep, beds, and all the attendant psycholegalistic issues.

Within minutes the police arrived, having been notified by a passerby that an accident had occurred. The LAPD had also summoned paramedics and other rescue units to the site. When the police learned there was no emergency (when a policeman asked Burden if he was all right, the artist tried to explain that he was doing a "piece"), the police canceled the emergency calls. They then arrested Burden for what critic Peter Plagens termed "a 1968 (year of the riots) law for [the] knowledgeable causing-to-be-reported of a false emergency (e.g., a bomb threat)."[22] After Burden was booked, released on bail, and summoned for three days of court proceedings, the trial resulted in a hung jury (they were deadlocked at nine to three in favor of prosecution). The case was dismissed by the judge.[23]

One of the most notable aspects of *Deadman* was the "silent acceptance" with

which Burden's body was viewed by audience members and by most of the passersby. The phrase "silent acceptance" is defined in legal theory as a circumstance in which "the offeror has stated or given the offeree reason to understand that assent may be manifested by silence or inaction, and the offeree in remaining silent and inactive intends to accept the offer."[24] These are precisely the circumstances demonstrated in most 1970s masochistic performances. Very few of these performances were ever halted or interrupted by audience members. Rather, the events were accepted and allowed to occur by observers who remained silent. Although such acceptance by silence is a feature of almost all performed works of art, its implications are particularly poignant when a performance such as Burden's involves an inert body in a dangerous public situation.[25]

Yet for all the "silent acceptance" of *Deadman* by viewers, subsequent commentary about the piece incited intense—and divided—public response. One particularly telling group of responses was initiated by Barbara Smith, a Los Angeles artist and friend of Burden who attended the performance. In three consecutive issues of *Artweek*, Smith addressed many of the theoretical and philosophical issues raised by *Deadman*. In her first article, Smith asked a series of rhetorical questions and called for support for Burden. His "benign-to-society risks," Smith argued, yielded "social consequences," foreclosing on what she implied was the metaphoric value of Burden's risk taking. This value benefits not only the viewer, she claimed, but also all artists who take risks to develop new artworks.[26]

Smith even addressed the concept of silent acceptance, though not in a legal context. "Among the interesting aspects of this piece," she wrote, "is the fact that after Burden had placed himself under the car and set the scene, and before the crowd came out of the gallery to see it, several persons walked by and saw the 'accident' but seemed neither curious nor alarmed."[27] It is precisely this sort of passive acceptance by onlookers going about their own daily lives that Burden felt most compelled to address. Converting his body into a limit-text of dependency on others, Burden concretized the structure of contract and its base in mutual understanding. For individuals to be confronted with this situation and to figure out the parts they play in the ongoing agreements constituting their own everyday lives and those of others is unsettling. Not surprisingly, then, Smith's observation regarding the silent acceptance of passersby got lost amid subsequent debates about more manageable questions of innocence and guilt, right and wrong.

Three fascinating letters published in response to Smith's original article focused on these ethical issues and were markedly fearful and hostile. One writer opposed the piece by drawing on historical fears, comparing both Burden's work and Smith's defense of it to "the conceptual art of Himmler . . . [who] had lots of bodies lying around."[28] Another writer, a fellow artist, called for artists' self-censorship, claiming that "if we do not regulate ourselves you can be sure someone else will do it for us. . . . We had as a community better set up some guidelines as to what is legal

and . . . we should not condone or try to protect any artist who disregards any law made to protect society as a whole in public places."[29] The third writer packed several commonly uttered critical clichés about performance art into four short, hostile paragraphs, referring to Burden's works as "bullshit," "half-demented stunts," "fatuous," and "self-indulgent."[30]

But Burden's piece did not in and of itself encourage a complicated discussion of its pros and cons, or admixtures of value and detriment. These are issues that tend to emerge when mirror-stage elements of fragmentation and partial truth trigger analysis of equally fragmented elements of the self and others. Burden's piece focused instead on the metaphor of the bed. On the evening of the performance, silent acceptance reigned. Given the lack of immediate stimulation of mirror-stage negotiation within the performance, the only logical options for audience members were to watch the show like polite theatergoers or to leave. Passersby could either walk on by or call on the only institution they knew to restore order—the law. Oddly, this latter response ultimately revealed the disempowered status of individuals in their everyday lives. Unwilling to get involved or to get details that would have explained the situation and exposed the metaphor at work, one viewer fell back on the dominant belief that institutions of law and order can solve all mysteries and make everything right.

On the one hand, then, Burden's piece seems to illustrate Deleuze's warning that the value of a contract can be drastically compromised by the law. On the other hand, the published critical remarks by Smith and the letter writers set up the same sort of back-and-forth exchange that is typical of contractual negotiation. One final response by Smith contains crucial points about the historical context in which Burden and others were performing. Smith said that every artist

> tends to deal with his own feelings and concerns about this, his *life*. It would
> be naive to say that all artists find our times easy or rosy. So what is he to do?
> It is not news to say that a great many artists find it very difficult to make
> paintings or sculpture when there is no viable architecture—upon which
> these media depend—that adequately represents either our needs or times.
> So we can cite many names other than Burden's that show there is a body of
> work being done in this area of, simply stated, what it feels like to BE now.

Smith then cited several artists (including Acconci) who "show how they feel in their own being and/or in alternative ways, formalized into event-like occurrences that transcend their personal dilemmas." Finally, Smith addressed the one respondent's reference to Himmler:

> [I]t seems there is an obvious distinction between Himmler and Chris Burden. Chris does us the service of pointing to issues, situations and feelings, with no desire to carry his own observations into a personal power trip. He is

merely signaling to us as if to say "pay attention!" or we might have a Himm-
ler or other disaster and be duped, all too unwittingly.[31]

As Smith points out, many performance artists of the 1970s were, like Burden, sig-
naling viewers to "pay attention!"[32] Using their own bodies as artistic material, artists
could look at why times were not so "easy and rosy." Smith's specific use of the term
"architecture" draws a connection between the body and the institutional frameworks
in which it operates. Artists of this era saw problems in the oppressive frameworks that
shaped their lives as artists and citizens—problems that ran far deeper and were more
complicated than previously thought. In response, masochism provided an appropri-
ate methodology, because, as Deleuze rightly argues, masochism always embodies a
critique. Masochism blows the whistle on institutional frameworks that trigger it and
within which it is practiced. Given the historical context of these performances, then,
artists such as Burden seemed to be urging their viewers to pay attention to these facts:
battles cannot be waged without sadists and masochists; soldiers at war in Vietnam are
merely sadists and masochists by other names; and the military is an institution estab-
lished to train, sanction, and glorify sadists and masochists. Burden and others acted
out of a desperate lack of other viable means to critique these institutionalized facts.

Institutional issues were also important to Vito Acconci's *Reception Room*, which was
performed in Naples in 1973 at the Modern Art Agency. After walking through a corri-
dor where an audiotape played Acconci's voice reciting lines such as, "I should have
been here to greet you," audience members arrived in a room equipped with a few
stools drawn close to a spotlighted table (fig. 23). What they viewed for the duration of
the performance was a bedlike tableau: Acconci lay on a mattress-covered table, under-
neath a white sheet, rolling periodically from his back to his stomach, exposing parts of
his naked body (fig. 24). "The whole revelation might be a ploy," reads the text appear-
ing alongside documentation photographs published later in a group exhibition cata-
log. "And all I'm doing is making myself passive, I'm taking the easy way out, I'm
avoiding the real exposure of face-to-face contact with viewers in the gallery."[33]

An audiotape was played inside the "reception room" as well. "What I'm really
ashamed of is the size of my prick . . . but I won't show them that," Acconci said on the
tape.[34] Upon first hearing or reading this statement, one might conclude that Acconci
was preoccupied with his penis and its ability to serve as a purely biological signifier of
his sexual identity. But when the performance is considered as a whole, one realizes
that he was more interested in repeatedly delaying and confounding the audience's
view of his body and thereby paving the way for his anatomy to be read as a metaphor.

Acconci introduced the viewer to the piece through the oedipalized substitution
of language for the actual presence of his body. He thereby prepared the observer to
consider the soon-to-appear body in a more conceptual context, one having to do with
the gendered legacy of psychic development. Once inside the room, the viewer could

not see the "prick that is not shown" as anything other than the phallus: the invisible signifying device around which the oedipal scenario takes place and around which the legacy of the paternalistic symbolic realm is constructed. In this performance, the phallus was the entity that was not seen but that formed one's interpretation of the performance.[35] The phallus was as potent, in other words, in its invisibility as it would have been had it been on "display," to use art historian Amelia Jones's term. Jones addresses other performances by Acconci, but her points are relevant to *Reception Room* as well. She writes that "male body artists [such as Acconci] 'play' the phallus, exploiting its conventional alignment with the male body to reinforce their own artistic authority and/or they 'display' its anatomical corollary, the penis, to potentially deconstructive ends."[36]

Acconci enacted both these strategies in *Reception Room* but nicely confused them, too. He used language as a stand-in for the "anatomical corollary" of the phallus from the beginning of the piece. By Jones's definition, then, he engaged in "display." Of course, this was carried out in a metaphoric sense, but it was precisely *in* this sense that Acconci simultaneously "played" the phallus. Most important (and here he departs from Jones's model), Acconci marshaled *both* his activities of display and play toward deconstructive ends. His deliberate ambiguity about the size of his penis (which is to say, the power of the phallus) both referred to and attempted to destabilize (which is to say, to *deconstruct*) the idea that the symbolic realm has a spatial orientation that is hierarchical. Yet the phallus purposely remains the unmistakable high point or centerpiece of his performance.

In the photographs documenting the performance, viewers can be seen with their stools pulled up close to the bed/table, and one might assume that the key question on their minds as they peer at Acconci's partially covered body is whether or not his maleness will be fully exposed. This central focus on the phallus gets turned into something else, however, if one reads (and reads between) Acconci's spoken lines, where he reveals his interest in performance art's potential for referring to institutional constructs and for offering up the possibility of critiquing them—all of which is obliquely hinted at in the title *Reception Room*. Through the formal arrangement of his body on a bedlike surface, Acconci directed the viewers' attention to the title's institutional referent. With a glaring spotlight hovering over his sheet-covered body, the arrangement assumed a very clinical look. He looked as if he were on an operating table, a hospital bed in a recovery room, or, given the historical context, perhaps even in an emergency medical unit in a battle zone. Whatever the interpretation, viewers were positioned as if they were in some sort of reception room without walls, waiting for the outcome of a clinical procedure.

Through Acconci's use of language, the institutionality of the clinical world was brought together with the institutionality of the domestic world. Acconci used language almost obsessively in this piece, as if to purge his unconscious homeopathically. He used it both to criticize himself masochistically (in statements beginning with

phrases such as, "I should have been . . ." and "I'm really ashamed . . .") and to demonstrate how language is the only source of full communication. Such communication, which is part and parcel of contractual negotiation, can be encouraged by a replay of the mirror stage. But Acconci preferred to trigger reminiscences of the oedipal scenario in this case as he gathered his viewers around its potent central image, the bed. Focusing viewers' attention in this manner did not mean that the psycholegalistic activity of negotiation was altogether discouraged, but it was compromised. This compromise was invoked spatially in *Reception Room* by the almost claustrophobic proximity of the audience to the "bed." But even this attenuation of the distance typically required for negotiation still did not eradicate its theoretical possibility. For Acconci's bed piece, like Pane's and Burden's, declared the necessity of recognizing the primacy of the body, whether it is visible or invisible, in systems of representation—especially language. And this is crucial to any negotiation process.

Acconci wrapped language around his body just as he did his white sheet, generally hiding meaning, sometimes (almost) exposing it. In so doing, he showed that what is really at stake, what constitutes the greatest consideration—in masochism as in the proceedings of contract—is, in fact, the human body. The body and the domestic world were inextricably linked metaphors for such masochistic performance artists in the early 1970s. Acconci became acutely aware of this fact by about 1970, when he decided he had to discontinue the type of performances he had been conducting—performances in the street. "It was as if I had left home too quickly," he recalls. "I had to come back home—whatever work I would do as an artist [after that] had to begin with what I could assume I knew at least something about. (Had to begin with my own body, had to begin at home.)"[37]

HOME
AGAIN

5

P A N E ' S
Nourriture, actualités télévisées, feu
(1971) took place in the Paris home of M.
and Mme Fregnac. To attend, audience
members had to agree to the contractlike
terms printed on their invitations: "A
sum equivalent to 2% at least of your
salary will have to be deposited in a safe
at the entrance of the place where I will
be performing."[1] After depositing the
prescribed sums in a small metal coffer
located at the door of the apartment, the
audience observed a three-part perfor-
mance in which Pane shoved nearly a
pound and a half of raw ground beef
into her mouth and then spit it out,
watched the evening news on television
while sitting in an uncomfortable posi-
tion with a bright light shining in her
eyes, and used her bare hands and feet to
put out patches of fire set in a mound of
sand (fig. 3).

The fact that audience members had
paid a specific part of their salaries for
admission drew attention to this action as
a *trans*action. Viewers were made aware
of their contracted partnership with
Pane—that is to say, of their investment
in the ideology of the human being as
possessible, as a contractible entity of ex-
change. Walter Benn Michaels examines
this ideology in his analysis of Trina's
masochism in Frank Norris's *McTeague*,
arguing that "if the masochist's desire to
be owned is perverse, it is nevertheless a
perversion made possible only by the
bourgeois identification of the self as
property."[2]

The logic of the body's serving as an
object of contractual exchange and the
acceptance of that logic as normal in the

early 1970s were two points that Pane specifically disallowed in this work. Reflecting on the performance, she later wrote that "at the end of twenty minutes, everyone there remarked: 'It's strange, we never felt or heard the news before. There's actually a war going on in Vietnam, unemployment everywhere.' . . . Until this moment, they were anesthetized in the face of world news."[3] Once the structure of the masochistic contract was exposed, however, it became difficult for viewers to remain numb or to consider normal the social dynamic that positioned individuals in masochistic roles. Pane's three-part performance was a sort of wake-up call that worked through the evolutionary stages of contract formation and the corresponding stages of psychic development. Her main focus, finally, was the site where that development originally takes place—the home. That the performance took place in an apartment and not a bona fide art space helped tighten the focus.

In the first segment of the piece, Pane enacted a symbolic rejection (a double rejection, actually) of the oral stage. By ingesting raw ground beef (the body of a mammal, an analogue for the mammalian mother), she substituted dead flesh for a living body (the mothering figure who provides bodily support, sometimes lactational). In making this substitution, Pane seemed to dismiss the nostalgic fantasy of the maternal body's functioning as a nurturing, anaclitic prop. Then, spitting out the meat, she seemed to question any need whatsoever for this prop.

In the second segment, the audience joined Pane in watching the evening news through the glare of a bare lightbulb. The glare had a paradoxical function: it drew attention to the power of vision by hampering it. In a similar way, the mirror stage also emphasizes the power of vision by occluding it. The viewer sees only a partial body in the mirror, never the whole. The televised news in Pane's performance was likewise fragmented, partial, and distant.

If there was any doubt that Pane's television watching was meant to emphasize the concept of the home, her use of fire in the third segment made this point crystal clear. Extinguishing patches of flames (set in small mounds of sand) with her bare hands and feet, she enacted yet another rejection. Here, she symbolically spurned the alleged comforts of oedipalization, represented in the work by the clichéd warmth of hearth and home.[4] Familial unity imitates unity with the oral mother, but with this added feature: family members are subjugated to the law of the oedipal father. Pane's masochism in this segment clarified that it is the body that truly is at stake in the oedipal stage.

Pane's rejection of nostalgic reminiscences of this stage echoed her rejection of the oral stage and suggested thereby that it is only what lies in between that is worthy of *not* being rejected. In between are the mirror stage and its contractual corollary, acceptance. Pane, then, challenged her audience to accept (which entails examining, questioning, and negotiating) what was transpiring before their eyes. But this challenge was aimed less at the masochistic actions themselves than at larger issues for which the burned flesh served as a powerful metaphor. When asked about the audience's reaction to this last segment of the work, Pane reported that "the atmosphere was at first

filled with curiosity, then astonishment, then a curious floating. Nobody said any-thing—the silence was terrifying. I don't think they received what I call the 'perturbing' or 'disturbing' element. That came much later when they returned to their routine environments."[5]

These responses suggest that the audience was affected on an unconscious level, precisely the stratum probed by Pane's metaphoric replay of the masochism inherent in psychic development. Through strategies of fragmentation and distantiation, Pane prepared viewers to be consciously perturbed and disturbed as they reentered their routine environments—that is, as they arrived *home again*. Presumably, what these viewers would be disturbed by was the "it's me" experience of their bodies relative to Pane's in the performance and to the wounded bodies represented on the news. Pane also alluded to the time and distance required for critical thinking. Upon returning home, one could consider the value of distance itself.

The opening of critical space was initiated in this piece by the distancing interplay between presentation and representation. But it is the inherently alienating dynamic of masochism that ultimately imbues distantiation with critical potential—in other words, masochism is what converts distantiation into constructive alienation. Bertolt Brecht explained this process in his own theory of alienation, what he dubbed the "so-called A-effect":

> What is involved here [in the "so-called A-effect"] is, briefly, a technique of
> taking the human social incidents to be portrayed and labelling them as
> something *striking*, something that calls for *explanation*, is not to be taken for
> granted, not just *natural*. The object of this "effect" is to allow the spectator
> to criticize constructively from a social point of view.[6]

Pane's acts of self-induced regurgitation, exposure to glaring light, and interaction with fire qualify as *striking* in Brecht's sense. The photographic images resulting from these acts beg for explanation and critique, inasmuch as they document uncomfort-able, unnatural events. But, again, what is important to see in Pane's performance pho-tographs is that the critique they foster has as much to do with distant pains (met-aphorically, war wounds or poverty) as the pain one sees and feels up close. By bringing attention to the distance between "here" and "there," these photographs im-plicitly invite viewers to question how much distance is appropriate. Is one's proximity to others beneficial (as in mass protests against a war, for example) or detrimental (as in a coalition or group that can be subjugated)? Pane's piece thus suggests that the evaluation of distance can be broadened into a critique of oedipalized institutions based on their tendency to encourage or discourage similarity among individuals for purposes of control. These extrapolated concerns constitute the constructive potential of masochistic processes and tie viewers more consciously to their own sociopolitical environments.

Pane concludes her observations about this piece by claiming, "I attack their [the viewers'] habitual comfort—which if they allowed to be penetrated would automatically be modified. But the simple fact I cause a momentary struggle inside them is important for me."[7] This conclusion situates Pane's performance in a wider historical context than the early 1970s, specifically the Vietnam War. In 1971, when Pane staged this performance, protests against the Vietnam War were becoming less frequent. The time for analysis and critique had begun. And this reflection had to begin at the site of the viewers' "habitual comfort." This site was the home: the very home into which the representations of fragmented, injured bodies were still being channeled on a daily basis; the very site in which Pane chose to present her piece; the very location to which audience members retired at the end of the evening to further examine, question, and negotiate that which they had seen; the very place where patriarchal power is first established.

It is easy to overlook the fact that when Freud chose to name that moment when patriarchal hierarchy gets established, he turned to a classical drama, Sophocles' *Oedipus Rex*.[8] He thereby linked in psychoanalytic theory the spaces of domestic and theatrical performance. Like Pane, masochistic performance artists of the 1970s literalized Freud's link by showing how the experience one has in the institutional framework of performance art can be compared to the institutional framework of the home in which one experiences the oedipal scenario.

Another link exists between the home and the historical foundations of the contract: Jean-Jacques Rousseau's eighteenth-century theory of the social contract is founded on his belief that "the family is the first model of political societies."[9] Law and contract begin at home, then, in both psychoanalytic and legal terms. Of course, this legalistic concept of the home—which is "another aspect of the concept of the family," according to Philippe Ariès in his *Centuries of Childhood: A Social History of Family Life*—is unique to the modern period (defined by Ariès as the eighteenth century and beyond).[10] But the legal instrument of contract has existed far longer than the modern concept of the home. In *The Evolution of Law*, one of the most thorough histories of contract for the layperson, Alan Watson locates the beginnings of contract in the Roman Empire, where five different types were operative.[11] Despite this long history, it was really not until the 1870s that anyone attempted to theorize how a contract actually functions and, especially, how it differs from what is called "tort."

In simple terms, "tort" can be defined as "a wrong . . . done to one person by another for which the law provides a remedy."[12] With tort, in other words, there is no mediating document such as a contract in relation to which the nature of a wrong can be assessed. Oliver Wendell Holmes Jr. and others set down hard-and-fast differences between contract and tort in the 1870s, and they also standardized the tripartite stages of contractual development (offer, acceptance, and consideration). But, as Grant Gilmore points out in *The Death of Contract*, the judicial system found ways to soften its own

rules. Judges increasingly exercised what is called "estoppel," which is "a way of saying that, for reasons which the court does not care to discuss, there must be judgment for plaintiff."[13] Estoppel seemed to function as a strategy for complicating the distinctions between signifier and referent on which contract had come to rely since the late nineteenth century. This is precisely the sort of semiological confusion that Gilmore refers to when he speaks of being able to hear "what was meant" in an agreement along with "what was said"—that is, along with that which was formally offered, accepted, and considered.[14] Significantly, Gilmore sees this kind of softening of rules as an illustration of a "basic coming together of contract and tort, as well as the 'instinctive, almost *unconscious*' level on which the process has been working itself out."[15] As was mentioned earlier, Gilmore characterizes this shift as a reactivation of "the meeting of the minds."[16] His reference to the psychic domain of the unconscious, however unintentional, situates this "meeting" as much in the home as in the courtroom.

I have been arguing that masochistic performance artists of the 1970s (the same era in which Gilmore was writing) also wanted to reactivate a meeting of the minds, specifically in the form of a negotiation of differences between individuals or a negotiation among the various identities inherent in one's own being. Although these artists metaphorically pointed to the ills of various social institutions that affected their lives, they appeared to understand that it was the social origin of these institutions—the home—that required special attention if a more substantive form of negotiation were to be mobilized.

Eleven audience members for Ulay/Abramović's *Communist Body/Capitalist Body* were invited to arrive at the artists' temporary living space, a loft in Amsterdam, at 11:45 P.M. on November 29, the night before the artists' joint birthday in 1979. The arrival of the viewers and their activities over the next few hours were recorded on super-8mm film. (Stills from this film appear in the artists' self-published documentation.)[17] Upon entering, viewers encountered a homelike scenario: a desk, two small tables, and the artists lying in a bed situated on the floor against a far wall (fig. 25). A white sheet and bright red blanket covered their bodies. On the two tables were displays of food, drinks, and utensils from the artists' native countries: on one table was champagne from Yugoslavia, where Abramović was born; on the other was beer from Germany, where Ulay was born. On the desk nearby were both artists' identification papers, delicately joined together with tape—Ulay's birth certificate and Abramović's 1962 student identification, which included information regarding her birth (fig. 26).

Ulay and Abramović appeared to sleep throughout the nightlong performance, never rising from the bed while the guests were present nor communicating with them in any way. This mildly masochistic gesture—enduring a position of suspended activity (one of the Reikian elements of masochism is suspense) in an environment ostensibly created for their active, pleasurable participation—perpetuated a different kind of suspense in the viewers, who were left to question what would happen next. After

about thirty minutes, having concluded that the artists might well sleep indefinitely, one audience member uncorked the champagne. Socializing ensued. The guests celebrated the mutual birthday of the artists, who were virtually absent. Most visitors left after a few hours. Some lingered. One friend stayed and slept on the floor at the foot of the artists' bed.

In reviewing documentation of the performance (which includes the artists' "contract," their identification papers, stills from the film shot at the performance, and interviews by the artists with the eleven guests, recorded a few weeks after the performance), it becomes evident that the artists' identification papers hold the key to *Communist Body/Capitalist Body*. This simple assemblage of documents, which could easily have been missed or misinterpreted by the viewers, given its subtlety and marginal placement in the space, constitutes a rich and multileveled emblem of sustained identificatory tension having to do with gender, nationality, politics, and economics. Specifically, the papers highlight the following differences: Ulay's gender is male and Abramović's is female; Ulay's birthright is German and Abramović's is Yugoslavian; and West Germany was, in 1979, predominantly capitalist, whereas Yugoslavia was communist.

There were shared traits, too. After all, Ulay and Abramović were a couple, a fact symbolized by the joining of their identification papers. Ulay was known for keeping his national origins vague, and Abramović had been exiled from Yugoslavia.[18] Together, they had underscored their uprootedness by declaring that they had "no fixed living-place" (proclaimed in their frequently published artists' statement), although they maintained a home in the Netherlands for business purposes.[19] The Netherlands itself, like the artists, was ideologically neutral, seeing cold war capitalism and communism as more or less compatible views that shared at least some common political and economic elements. The title of this performance would seem to indicate that Ulay/Abramović supported this general position.

Perhaps the most compelling aspect of the performance was the way the artists forced viewers to confront dualistic notions of identity. They did this by manipulating the viewers' sense of distance. This was made clear later in audience responses. "The birth-certificates really stole my heart," one woman reflected. "Mine is exactly like Uwe's, with a sort of swastika still on it and words like 'Gottglaubig' [believer in God], which you don't use anymore."[20] For her, the identification papers functioned as a sort of historical mirror, reflecting bad memories of an institutionalized frame of nationalist politics and politicized religion. In the specific case she recalled, the context of Nazi Germany, difference in politics or religion could be a matter of life or death. Paradoxically, the actual distance she felt from the artists ("I didn't dare . . . to come near the bed") allowed her to feel close to them. Her link to Ulay's body, in particular, resonated conceptually in the difference between the histories represented by the artist's birth certificate (Hitler's Germany) and the viewer's position (the present moment). These distances and differences, then, were experienced in delicate balance with the sense of closeness and the recognition of similarities to the artist.

Another viewer's experiences were less personal but nonetheless also testify to the function of distance in the piece. He described the performance space in which the artists lay in bed as a "vast open area." Here, too, the formal distantiation from the artists spawned a kind of conceptual space. He found himself "wondering . . . about all sorts of things, asking questions, without having to give a definite answer, which kept you mentally on the move. . . . Those questions had to do with all sorts of things. Also with the people who were there. Who is he? And who is she?, things like that."[21] The viewer's questioning expanded to broader issues:

> Why this thing in this way? Because then the whole of life becomes art-like—life is made into art then. Or is it the other way round? Maybe even the question is irrelevant. . . . There always is a problem there . . . [with] this kind of relation between art and life, because I never got the impression that you [Ulay/Abramović] were really aesthetes in the sense of stylizing your whole life. So there was no . . . no chance that it'd turn out to be that way.[22]

This statement indicates the viewer's frustration in trying to resolve notions of difference and similarity with regard to such abstract categories as art and life. He seemed to have found a resolution in the performance itself, but he was still interested in examining what he called "conventions." The performance, he concluded, was "something which happened in the stream of time, to quote Bergson. . . . Sometimes it crystallizes and then is made conscious by way of dropping all existing conventions and putting no new ones in their place, but only offering possibilities to establish new conventions."[23]

The possibility of establishing new conventions, of revamping institutionalized structures, is a valuable outgrowth of sustaining a tenuous balance among identificatory meanings as they fluctuate indeterminately. This is the possibility that all masochistic performances evoke. The second viewer corroborated this notion of fluctuation by remarking how "things kept on shifting" in the performance: "[The] protagonists weren't there, but the thing shifted to the people themselves," and audience members' "communication [constituted] a crazy shifting. . . . You could make up an infinite number of interpretations, but I think you can't make up one, because the perspective is always changing."[24] For both these viewers, then, indeterminate thinking was activated because the artists provided a space in which processes of negotiation over new conventions having to do with issues such as gender, nationality, politics, and economics could take place.

Although this type of thinking is triggered most readily by performances that revisit the mirror stage, it also seems to be stimulated by masochistic performances in general, particularly if distance is established for purposes of negotiation. Ulay/Abramović's focus on the bed as a mnemonic device in *Communist Body/Capitalist Body* took the viewer *home again*. But their manipulation of distance also took the

viewer beyond the home, toward issues concerning other institutions that are modeled after it. The specificity of materials in the performance—especially the artists' identification papers—helped pinpoint these issues. The documents not only stimulated awareness of the institutionalized parameters into which the body is powerlessly born, but also drew attention to the mitigation of those ostensibly fixed rules by means of contractual processes that empower individuals to critique and possibly even change those structures.

In *Communist Body/Capitalist Body*, the distance between Ulay/Abramović and their viewers was highly charged, domestic and institutional reminiscences proliferated, and indeterminate thinking was successfully mobilized. But what if the performance had been constructed differently? Is the mere provision of formal and conceptual distance powerful enough for masochistic performance that does not focus on the mirror to generate a useful practice of identificatory equivocation? Or is it the quality and quantity of distance that count?

Chris Burden focused more heavily on bed imagery in his performances than did any of the other artists I have discussed. Between 1972 and 1975, he performed five works in which a bed or bedlike equivalent was used. These were *Bed Piece* (February–March 1972), in which he lay on a cot in a gallery for twenty-two days; *Oh, Dracula* (October 1974), in which he hung in a cocoon-type apparatus at the Utah Museum of Art in Salt Lake City for eight hours; *White Light/White Heat* (February–March 1975), in which he lay on a ten-foot-high platform in the Ronald Feldman Gallery in New York for twenty-two days; *Doomed* (April 1975), in which he lay inert at the Museum of Contemporary Art in Chicago for almost two days straight; and *Oracle* (May 1975), in which he delivered a monologue reflecting on the piece he had done at the Feldman Gallery a few months earlier.

These five works by Burden challenge my argument that all masochistic performances trigger, in one way or another, reminiscences of the mirror stage through the presentation or representation of the artist's body. Questions of identity, which are initiated in an individual's first moments before a mirror, arise again in masochistic performance as the figurative split experienced in those moments is literalized and made metaphoric. Of all the performances discussed thus far, these five by Burden least stimulated such reminiscences. At the same time, they featured a home-sited mnemonic device and a manipulation of distance. On the one hand, then, it would seem that Burden contradicted the tendencies I have identified in masochistic performance. On the other hand, by focusing almost exclusively on reminiscences of the oedipal scenario, he was able to direct attention toward specific social institutions that emanate from that scenario. But this choice of focus did not come without a price.

Perhaps the two clearest examples of works in which Burden targeted specific institutional issues are *Oh, Dracula* and *Doomed*. For *Oh, Dracula*, Burden had himself hung in a cocoonlike harness on a wall, precisely where a Renaissance painting was

usually exhibited, in the Utah Museum of Art in Salt Lake City (fig. 27).[25] In place of the wall label describing the painting was a plaque with Burden's name, the title of the performance, and the date. He remained suspended on the wall for eight hours—the number of hours the museum was open to the public and the number of hours an individual typically sleeps. The piece was a virtuoso combination of compliance and critique. Burden complied with the conventional exhibition practice that requires artworks to be hung on a wall. But he also critiqued the museumgoer's expectations (which are founded on a tacit contractual agreement with the institution and its traditions) that art function as an object of transcendent meditation. Candles placed below Burden emphasized these expectations.

For *Doomed*, Burden lay motionless behind a large pane of glass that was leaned at a forty-five-degree angle against a wall at the Museum of Contemporary Art in Chicago for forty-five hours and ten minutes (fig. 28).[26] The duration of the performance was based on conditions known only to Burden, who had decided that the piece would last until someone altered in any way the arrangement of his body and/or the pane of glass. Finally, a glass of water was placed near him. Burden then leaped up and stopped the clock to document the elapsed time. Guards had to work overtime to supervise the performance. Thus, Burden subtly tampered with the institutional logistics and economics of the museum.[27]

In these performances, Burden emphasized two of the chief aspects of masochism outlined by Reik and Deleuze: suspense and contract. As with almost all bed performances, Burden's primary action was inaction. He waited, and he made the audience wait, for his points to be made. Suspended, Burden demonstrated that the body is always on the line in institutionalized constructs and, more specifically, in the contractual agreements that sustain them. One of the staff members at the Chicago Museum of Contemporary Art said, "We could have ended it anytime we wanted to, and here we thought we had a contract with him that we couldn't break unless he died."[28] This remark clarifies a scarcely observed tautology: the stakes of the stakes of contract are truly life-and-death.

On a more predictable level, *Oh, Dracula* and *Doomed* raise complicated issues about our perceptions of traditional art. In each case, Burden substituted his own body for a work of art. In *Oh, Dracula*, he appeared in lieu of a Renaissance painting; in *Doomed*, he appeared behind a pane of glass—as would most paintings exhibited in a museum. All masochistic performance work comments on traditional art by confounding patterns of repression experienced in viewing traditional art. But these patterns are not restricted to the viewing of art. They also involve its history and, especially, the way in which art and art history construct one another. At least one purpose of this repression—advanced in the very period in which the painting for which Burden substituted himself in *Oh, Dracula* was produced—is to set up conditions for the transcendence of the viewer. Masochistic performance has the potential to deconstruct these conditions and the art forms for which they exist by making viewer relations ob-

vious—*painfully* obvious. The possibility of transcending to a fictional space beyond the obvious materiality of that which is being viewed is thereby compromised.

It could be argued that once a viewer has experienced a performance piece in which transcendence is so clearly *not* an option, traditional art forms that tend to evoke such a response never look quite the same again. But a performance falls short of its richest deconstructive potential if it takes up a stance solely in opposition to traditional art forms or the institutional frameworks that represent them, or if it uses a method of simply uncovering the formerly repressed agreement in which the viewer participates. Masochistic performance is capable of going beyond illusions of liberation resulting from this type of opposition, to lodge a substantive critique of that which is opposed. The strongest performance accomplishes just this. It cannot help but promote a critique of institutional frameworks in that it activates, in an inescapably and tellingly painful manner, the *structure* of contract that is itself institutionally born and perpetuated.

Art historian Donald Kuspit has also explored the workings of contract in performances by Burden. Although his arguments have influenced my own, Kuspit's view of deconstruction seems more tied to the virtues of oppositional strategies. In an essay for the catalog of Burden's 1988 retrospective, Kuspit observed what he called a "social contract" functioning in Burden's oeuvre, originating in the artist's "early self-destructive actings-out."[29] Here Kuspit is drawing on sociologist Talcott Parsons's definition of social contract, meaning, broadly and simply, power.[30] Kuspit argues that Burden deconstructs the social contract. But to him this means that the artist uncovers the problems of institutionalized power that "blind" and "bind" an individual, which, in turn, allows Burden to discover his "true self." More specifically, Kuspit claims that in "disobeying the social contract" Burden not only is freed from a "false sense of the body the social contract gives us," but also demonstrates the social contract's own "inherent falseness." Further, Kuspit shows how Burden's dealings with the social contract affect the functions of traditional art:

> Traditional art persuades the viewer of the goodness of the social contract, drawing him blindly into it and giving it complete power over him. Traditional art acts to make us unconscious of the powers that control us—to which we are contracted—in part by theatricalizing them as "divine," that is, inevitable. The power of Burden's critical art . . . is that it deconstructs . . . the social contract; it calls it into question, reminds us that it has many problematic features, and puts us in a position to be able to consider its hold on us, a position which already half frees us of that hold. . . . Burden has given the increasingly empty idea of "critical art" fresh credibility by showing that the social contract—symbolized by the museum—which gives art its reality is not binding.[31]

Although I agree with many of Kuspit's claims (especially the idea that traditional art engages the viewer in a controlling bond), I am surprised that he overlooks the extraordinary potential of naming that bond "masochistic." By not doing so, Kuspit is unable to go beyond arguing in absolutist terms of truth and falsehood, beyond showing how Burden indicts contractual arrangements through simple disobedience.[32] A more extended argument might allow for an exploration of the *structure* of contracts and an interrogation of whether or how Burden grappled with its complexities and whether or how his actions motivated a change in institutions driven by this structure. I believe the only way that change can be mobilized—that is to say, the only way deconstructive practice can point toward a solid alternative to that which is being deconstructed—is for access to the practice of negotiation, with its basis in the structure of contract, to be provided. On this point, Burden's bed pieces, with their inexorable emphasis on issues of oedipalization in lieu of any guiding reference to mirror-stage (hence negotiatory) dynamics, actually fall short of playing the richest deconstructive role possible—either in Kuspit's terms or in mine.

In *Doomed*, Burden pointed to the possibility of negotiation but denied its practice, a fact pointed out by the staff member who understood that such an interaction was out of the question. The terms of the agreement had been established as absolutes. The issue was maintaining or breaking the agreement, not negotiating its terms. And in *Oh, Dracula*, despite the way attention was drawn to institutionalized directives about how to view art, Burden did not set up the conditions that would allow a negotiation to take place between the viewer and the artist, or even among viewers, concerning the structural concepts of the masochistic contract at work in the performance.

The problem in these performances, I believe, the way in which they fall short of their deconstructive potential, has to do with the distance factor. Burden showed that it was possible to leave both too much and not enough distance between himself and the viewer. The placement of the candles in *Oh, Dracula*, for example, succeeded only in duplicating the measure of distance set up in conventional art-viewing practices, suggesting that the viewer should stay at bay. If someone were to violate this directive and approach the cocoon, he or she would discover only the mute fact that Burden was inside it. In both *Oh, Dracula* and *Doomed*, the temptation is simply to acknowledge the "one-liner" quality of the jokelike substitution of the artist's body for a work of high art and, once humored, to disengage.

In the bed performances by Ulay/Abramović, Pane, and Acconci (or even Burden's own *Deadman*, owing to the dialogue published in its aftermath), peripheral references were provided so that viewers could access at least an indirect communication with the artists and thus "fill in the blanks" of the formal and conceptual distance between them. But in his bed performances, Burden manipulated distance so totally that viewers could only violate it or not. He halted criticality at the point of a non sequitur display of that which needs to be questioned, negotiated, and sustained in delicate balance, not simply opposed.

Another problematic feature of these pieces is the way their deadpan, empty qual-
ity evokes a sense of melancholia. This, in fact, is the price Burden paid for the exclu-
sivity with which he focuses on the bed. It is also the price exacted by the psycholegal-
istic movement away from the mirror and toward oedipalization.[33] As the painful early
mirror-stage experience of splitting is healed, it is also blocked, first by the late mirror
stage, in which the process of what Lacan called "orthopaedic armouring" creates in
the individual a mythically unified identity, and then by the oedipal scenario, in which
the individual is assigned a gendered role.[34] In both cases, the result is loss—not only
of the object of the mothering figure once known in the oral stage but also of the ob-
ject of the self, experienced as one side of the split identity encountered at the mirror.

Freud's attitude toward the object in his theories of melancholia helps deepen our
understanding of the problematic of Burden's bed pieces. In his 1917 essay "Mourning
and Melancholia," Freud argues that the "loss suffered by the melancholiac is that of an
object; according to what he says the loss is one in himself."[35] More precisely, the
process of melancholia begins with what Freud calls the loss of an "object-choice"—a
loss not only related causally to the natural event of death but also, as he implies in his
comparison of melancholia to mourning, related to any set of cultural circumstances
as well (such as a sociopolitical or economic catastrophe).

Whatever the cause, Freud says, loss results in melancholia when it fails to inspire
withdrawal of one's libidinal investment from the lost object and transference of that
investment to a new one. In this scenario of failure, the melancholiac identifies with
the lost object, and "[t]hus the shadow of the object [falls] upon the ego, so that the
latter could henceforth be criticized by a special mental faculty like an object, like the
forsaken object."[36] The language Freud uses here comes close to that used in his obser-
vations of masochism, but he resists the use of the term "masochism" in his theories of
melancholia. In keeping with his theories of masochism in "Instincts and Their Vicissi-
tudes" (published two years earlier), he concentrates more on the "sadistic" aspects of
turning onto the self the criticism one really wishes to aim at a lost love object. The
benefit of this detour for melancholiacs, besides what Freud calls "sadistic gratifica-
tion,"[37] is the ability to "avoid the necessity of openly expressing . . . hostility against the
loved ones."[38]

Freud's theory of the melancholiac's avoidance of a seemingly greater wrong—
hostility toward a loved one—bears a similarity to the conclusions reached by Reik in
his study "Masochism in Modern Man" (1949). At the end of this essay, Reik first as-
serts that masochism "endangers the progress of civilization because it imposes need-
less sacrifices and too great psychic burdens on the ego and on communities." But then
he resigns himself to the fact that masochism "undoubtedly constitutes a cultural step
ahead when the masochist, faced with the necessity to choose, prefers to be hit rather
than to hit."[39] It would seem that melancholia serves the same purpose in Freud's
schema.

Bringing Freud's observations on melancholia and masochism together with the

cumulative views of theorists such as Reik, Deleuze, Anzieu, and Lacan, it becomes clear how the masochistic performances I have been discussing aim at retrieving the sense of one's objecthood and all its potential. This sense of objecthood is first gained in the early moments before the mirror and then lost when the oedipal scenario raises the stakes to include the body and invests that body with a subjecthood fashioned around traditional gender identifications. Retrieving a flexible, nongendered sense of objecthood (*and* subjecthood) stands a better chance, though, when processes of negotiation between ostensibly opposite identifications of the self experienced at the mirror are made possible—that is, when the link between psychic and legal dynamics is made evident.

Interestingly, Freud himself made connections between the world of the psyche and the world of law. For example, the melancholiac's criticisms or "complaints," he writes, "are really 'plaints' in the legal sense of the word . . . because everything derogatory that they say of themselves at bottom relates to someone else."[40] By integrating Freud's observations with those of other theorists, it also becomes clear how even the melancholiac is attempting to critique something outside the self. In reaction to this, his or her attention (or, in the case of the masochist, his or her action) is trained on the very body that is at stake in the institutional systems that shape the conditions of suffering and loss.[41]

If an individual falls short of this critical goal, however, his or her efforts can easily slip into a melancholic abyss, providing only an all too ephemeral hint as to what those institutionalized systems and the specific problems within them actually are. By refusing to provide the possibility of a negotiatory process, which might return the individual to the point in psychic development (or vice versa) where the "lost object" can be retrieved for the purpose of balancing it against one's perception of subjecthood, the slide into the abyss—culminating in inertia and silence—is inevitable.

Nowhere in Burden's oeuvre is there less possibility for negotiation than in his bed performances. In the first one, *Bed Piece* (1972), Burden lay in a bed at one end of the Market Street Program Gallery in Venice, California, for twenty-two days (fig. 29). He was silent throughout. He ate food left for him by the gallery staff and relieved himself only during the night. However, as he revealed to writer Robert Horvitz, the staff often forgot to leave food, because "in their minds I had become an object."[42]

Although Burden's response indicates that the performance may have satisfied his own quest for lost objecthood, an equivalent result for the viewer was denied. Any mirroring onto the viewer was occluded by the enormous distance between viewer and artist. But it was not only a question of the quantity of distance; quality played a role, too. At first glance, there is nothing strange about someone lying in a bed, but there *is* something strange about someone lying in a bed in an art gallery. And so, one felt compelled to stay at a discreet distance from Burden—an unfamiliar position, given the ostensibly familiar nature of the bedside scenario.

Yet, as Burden himself said, he functioned in this performance as a "repulsive

magnet."[43] Indeed, it was the initial familiarity of this arrangement that would have attracted the viewer, offering an avenue of identification (just as the bed, food, and drink in Ulay/Abramović's *Communist Body/Capitalist Body* made the setting seem more intimate and prompted the viewers to examine the artists' identification papers). But the instant this familiarity turned strange, the viewer would have moved away, and exposure of the institutions responsible for the sense of the artist's body as a vulnerable object would have stopped. Burden's bed then alluded only to the identity-fixing dynamics of the oedipal scenario. In the end, there was no contractual agreement (as was evidenced by the gallery staff's lapses of memory and duty) and no mirroring. The overdetermination of formal distance in the piece, then, coupled with Burden's silence, foreclosed any possibility of negotiation.

What Burden did accomplish in *Bed Piece*, however, was to locate an issue so central to his work that he staged a different version of the piece three years later. Of that later work, *White Light/White Heat* (1975), Burden said, "The shift from beginning to end [of *Bed Piece*] was pretty mysterious to me and that's why I'm reinvestigating it. I'm trying to get to the crux of it."[44] In *White Light/White Heat*, which also lasted twenty-two days, Burden positioned himself ten feet above the floor on a plain, white, triangular platform in one corner of the all-white gallery space (fig. 30).[45] Unlike *Bed Piece*, Burden fasted throughout this performance, and although he slept intermittently, he was often awake, participating, as he said, "like a ghost" in the comings and goings of viewers and in the everyday business of the gallery.[46] Melancholia, Freud observed, is marked by "sleeplessness and refusal of nourishment, and by an overthrow, psychologically very remarkable, of that instinct which constrains every living thing to cling to life."[47] Perhaps the "crux" of these bed pieces that Burden discovered was, as Freud implies, simply a psychological dead end.

Burden brought this discovery to light in *Oracle*. Performed just months after *White Light/White Heat*, *Oracle* was a self-conscious response to the previous piece. Inasmuch as *White Light/White Heat* was itself a response to *Bed Piece*, *Oracle* can be seen as the artist's conclusion to both. Moreover, *Oracle* is the last performance of Burden's career to deal directly with the topic of masochism. So, it serves as a conclusion not only to the five pieces discussed here but also to Burden's investigation of masochism in general.

After the audience had entered the Schema Gallery in Florence, Italy, where *Oracle* was presented, the door was locked. Viewers were seated facing three large, spotlighted windows covered with scrims. Burden's shadow was projected onto one of these scrims as he delivered a long statement (fig. 31). He first reviewed the logistic details of *White Light/White Heat*. Then he recounted this story:

> After I had been there for three weeks, on the last night, I had a dream—a
> sort of a nightmare. In the dream, I was doing a piece on a large bunk bed.
> I was high on the top bunk, and nobody could see me. I was always worried

that the sheets were coming untucked, hanging down, spoiling the piece by making it look messy. I couldn't look to see if the sheets were really hanging down, because then someone would see me. All I could do was lie there and worry. Then in the dream, the piece was over and I was down from the bed. I was sitting in a bar with two friends. It was the first time I had seen anyone. . . . I could talk . . . but I didn't have anything to say. Nothing interested me. I knew that I was physically all right, but spiritually something had happened to me. It was as if I didn't need anything anymore, it wasn't just that I didn't want it. And it wasn't like I was crazy—it wasn't like that. It was like serenity. If there was ever a time when I should have been happy and relieved and wanted to talk, this should have been it. But it wasn't. It was like ennui or boredom, when nothing you think about is interesting or fun. I knew that people expected me to be happy, and they expected me to be glad to see them. I knew that it would be obvious that I was distant, and I couldn't hide the way I was feeling. It was like something had evaporated from me. I was sad and frightened. I realized what was wrong. I no longer had any desire to be part of the real world.[48]

After the story of the dream was finished, Burden's shadow faded and the audience departed.

Burden's closing remarks regarding his sense of detachment and self-evaporation recall Freud's descriptions of the "distinguishing mental features" of melancholia, including "abrogation of interest in the outside world" and "inhibition of all activity."[49] Burden's remarks also echo Freud's contrast between mourning and melancholia. "In grief," Freud writes, "the world becomes poor and empty; in melancholia it is the ego itself [that becomes poor and empty]."[50] Through ever-increasing increments, Burden's bed pieces overdetermined the formal and conceptual factors of distantiation necessary to the task of effectively negotiating dualistic aspects of identity. As Burden catapulted his body out of its position as "repulsive magnet" in *Bed Piece* to complete visual absence in *White Light/White Heat* and, further, to the faraway dreamworld expressed in *Oracle*, he protracted alienation to such an extent that he obliterated any possibility of what Gilmore called a "meeting of the minds."

On the positive side, Burden's concentration on the use of bed imagery indeed brings one's attention *home again*. And his manipulation of formal and conceptual elements suggests, again in ever-increasing increments, the hierarchies established there. The bed and the body suspended on it are lifted higher and higher, to a location far above the viewer's head, to a position well beyond presence in the everyday world. This literal elevation of the body not only hints at the notion of hierarchy inherent in the oedipal scenario but also suggests that within that scenario, the body is of primary consideration.

Still, by not providing access to a discursive negotiation of this oedipalized hier-

archy, Burden's bed pieces stop short at activating the masochistic contract. The mechanism of contract itself—its structure—is never fully exposed or explored. Through his references to suspense and contract, Burden displays those psycholegalistic elements worthy of critique, but he simply lets them evaporate, along with the potential sense of his body as both subject and object. The world then begins to look empty—not only of goodness, but of problems. Allowing masochism to turn into melancholia is a way of undercutting the inherently critical power of masochism to blow the whistle on these problems.

CONCLUSION

6

THE world in which masochistic performance thrived in the 1970s was particularly unbalanced. For more than a decade, the Vietnam War loomed over international affairs, creating political turmoil and psychic divisions in the United States and abroad. Recent scholarship has shown the extent to which this ongoing conflict influenced various artists' work in the 1960s and 1970s.[1] What I have tried to suggest is how masochistic performance artists, in particular, were affected, how they were moved to create metaphors for a type of negotiation—*contractual* negotiation—that might bring balance to the war-induced instability they were experiencing. It is not surprising, therefore, that the last masochistic performances by Acconci and Burden were in 1973 and 1975 respectively, precisely the time span during which the war was winding down.[2] In the summer of 1973, the U.S. Congress prohibited further funding for combat in Vietnam and Cambodia, and in late April 1975, the president of South Vietnam surrendered and U.S. president Gerald Ford ordered the immediate helicopter evacuation of Americans and their Vietnamese assistants from Saigon.[3]

For Acconci and Burden, the war had been close to home—both knew people who had died in the war. For the European artists I have discussed, the situation was less immediate and urgent but no less keenly felt. Pane, who demonstrated an awareness of the war but also was concerned with the May 1968 events in her home country, con-

But maybe did it for 50 or so years because it's so physically taxing.

75

tinued her masochistic actions until 1979, when for the first time she wounded herself seriously enough (in the third version of a piece titled *Mezzogiorno a Alimena*) that she decided to stop performing altogether.[4] Ulay/Abramović sustained their involvement with masochism even longer. Between 1981 and 1986, they logged more than one hundred hours of sitting opposite each other at a table, completely motionless, in a series of performances titled *Nightsea Crossing* (they sat for seven hours a day, several days in a row, at a variety of institutions around the world). They have been quoted as saying that this was the most painful performance they ever conducted.[5] And in 1988, they culminated years of research and planning for *The Great Wall Walk*, in which the artists started at opposite ends of the Great Wall of China and walked toward each other. Because the Great Wall is 3,700 miles long, has been virtually destroyed in some places, and passes through rough terrain, the simultaneous journeys took more than three months and were utterly grueling. This was Ulay and Abramović's final performance together. They had originally planned to meet at the middle of the wall for a marriage ritual, but their relationship deteriorated before they began the walk, converting the end of the performance into a poignant farewell before starting their separate lives.[6]

These later works by Ulay/Abramović are typical of a strain of performances that are regarded as *endurance-oriented* rather than *masochistic.* Yet many of the characteristics of masochism cited by Reik and Deleuze still apply. Both *Nightsea Crossing* and *The Great Wall Walk* involved demonstration (as does any performance piece that proceeds according to a plan of action involving the body), suspense (in that the pieces were laced with a tension-producing uncertainty as to whether they would unfold as planned), provocation of observers (in *Nightsea Crossing*, the audience members were dared to be as silent and motionless as the artists; in China, government officials felt provoked to set strict conditions for *The Great Wall Walk,* such as refusing the artists the right to walk without an official Chinese crew), and fantasy (typified by the disciplined imaginings required to sustain the artists through hour after hour of sitting motionless in *Nightsea Crossing*).

In other words, masochistic performance did not disappear after the 1970s. It did diminish in the United States for a time in the late 1970s, only to reescalate in the 1980s and explode in the early 1990s. Exemplifying this recent redefinition of masochistic performance is the work of Bob Flanagan, who staged events connected to his own lifelong struggle with cystic fibrosis (or CF). Flanagan died in 1995 at the age of forty-three, having lived longer than almost any other individual born with the disease.[7] Throughout his life, Flanagan used art making, "slave/master" games, and other masochistic acts as distractions from his condition.[8] In the 1970s, he started to write poetry and also got involved in the Los Angeles S-M scene. In 1980, after meeting Sheree Rose, the woman who would become his lifelong partner, he began dealing more publicly with his masochism and performing at alternative art spaces. In his performances after 1980, Flanagan would often read his poems, tell jokes, and perform increasingly extreme masochistic acts, which ranged from allowing himself to be pelted

with food substances (at Beyond Baroque in Los Angeles in 1981)[9] to sewing his penis inside his scrotum (at Southern Exposure in San Francisco in 1989).[10]

As his CF-related condition worsened in the early 1990s, Flanagan decided that "it was time to *review*," and he started "developing images from [his] past."[11] One result was the exhibition *Visiting Hours* (Santa Monica Museum of Art, 1992; New Museum of Contemporary Art, New York, 1994). Flanagan called this exhibition "the culmination of all my work. . . . It focuses on where Cystic Fibrosis and SM converge."[12] Among the works in the show was a wall of children's alphabet blocks that featured only the letters *C, F, S,* and *M,* and pictures of medical and S-M equipment. The show also included a child-size reconstruction of a doctor's waiting room, complete with magazines such as *Highlights* (into which Flanagan had inserted S-M magazine images) and a gigantic cruciform of video monitors on which parts of Flanagan's body were shown in states of masochism-induced pain. The most moving aspects of the show, however, were those that opened up the possibility of a dialogue with the viewer. Inscribed onto the walls of the exhibition, for example, were excerpts from Flanagan's poem "Why?" consisting of phrases such as "because I was different . . . because of my genes . . . because of doctors and nurses . . . because it makes me feel invincible . . . because my parents said BE WHAT YOU WANT TO BE . . . because I'm terrible at sports . . . because of Morticia Addams and her black dress with its octopus legs . . . because YOU ALWAYS HURT THE ONE YOU LOVE."[13] These half-serious, half-comical reasons for Flanagan's masochism may have reflected his own thoughts, but the obsessive quality with which they were delivered (there were dozens more) seemed to reflect as well the assumptions of those who do not understand masochism and who frantically search for any easy explanation that will allow them to have no part in it. Because the poem is as much about observers as it is about the artist, it prompted viewers at the exhibition into an inner dialogue with Flanagan and with themselves.

Viewers could also talk to Flanagan directly by entering a small simulated hospital room in the middle of the exhibition space. There the artist lay in bed for certain visiting hours, often with Rose at his side. Many visitors asked questions, and Flanagan concluded that people "seemed to understand that SM pain was a metaphor for the kind of pain they were forced to endure as illness."[14] For Flanagan himself, self-induced pain seemed to be a metaphor mostly for the illness-induced pain he felt on a regular basis. Amelia Jones has pointed out that when Flanagan performed as a masochist he was "attempting to externalize his internal pain," which for him had the pleasurable effect of "reducing the pain of illness to the less ambiguous agony of the definitively physical."[15]

Unlike the work of other artists I have discussed in this book, Flanagan's performed pain seemed to go hand in hand with pleasure. But *like* the other artists' work, Flanagan's masochism, as Jones rightly argues, "constructs him as both acting subject and receptive object of violence, merging subjectivity into objectivity for both Flanagan and his audience and thus confusing the security of either identification."[16] In

other words, Flanagan achieved a useful indeterminacy of identities similar to that witnessed in the 1970s examples I have discussed.

A more historically and culturally specific example of masochistic performance in the United States toward the end of the 1980s is David Wojnarowicz's act of sewing his mouth shut in the film *Silence = Death*.[17] Like Ulay's similar action in *Talking about Similarity*, Wojnarowicz's masochistic gesture had a specific political history, which was related to AIDS and the public response to it.[18] After the AIDS pandemic came to the public's attention in the early 1980s, it was instantly politicized, because the populations that appeared to be most affected initially were gay men and intravenous drug users, both considered by conservative factions as undeserving recipients of federally supported research, treatment, and insurance programs. The stakes involved for both sides in the ensuing debates over health-care funding created a warlike situation. Ideally, the enemy should have been the disease itself, but in the political battles over AIDS this view was often lost. Without the efforts of activist organizations such as ACT-UP (AIDS Coalition to Unleash Power), for which Wojnarowicz participated in this film and for which "Silence = Death" is a key slogan, far less progress would have been made.

By the late 1980s, the commonsense logic of proclaiming a "war on AIDS" had grown to terrifying proportions for the conservative Right, which began to displace its terror onto art. This resulted in what anthropologist Carole S. Vance in 1989 dubbed the "war on culture" to describe the hostile political combat waged by particular individuals in positions of power against artists whose work provoked them.[19] Especially provocative was art that dealt with the topic of sexual orientation, which these individuals often "mistook" for the cause of AIDS instead of the wholly indifferent virus itself. Fortunately, many people recognized that the censorious efforts of individuals such as Senator Jesse Helms and Representative Dana Rohrabacher and organizations such as the American Family Association (AFA) were based on thinly veiled homophobia. Performance art, especially, became a new enemy in this war on culture. Four performance artists (known as the NEA Four) had their 1990 National Endowment for the Arts grants revoked on the charge that their work was "obscene." Three of these artists (Holly Hughes, Tom Fleck, and Tim Miller) were gay, and one (Karen Finley) dealt with AIDS-sensitive issues in her work. Wojnarowicz, a gay man who later died of AIDS, also became a target in the war on culture when AFA head Donald Wildmon accused him of obscenity for including in his photomontages images of gay men having sex.[20]

Masochistic performance models resurfaced in the late 1980s, I would argue, because the need for negotiation became as strong during the war on culture and the war on AIDS as it had been during the Vietnam War. As masochistic performance continued into the 1990s, the intensity of masochistic turns against the self seemed to be proportionate to the intensity of desire for negotiation. This desire was further intensified by the persistent refusal to negotiate by those with the power to solve these crises (for

example, officials at the National Endowment for the Arts and the National Institutes of Health).

At the height of these crises, in 1991 and 1992, Simon Leung presented his performance *Transcrypts: Some Notes between Pricks* at a variety of locations in Los Angeles and New York. Before the audience stood a small, portable film screen (the kind used for home movies, with a single tripod leg) on either side of which was a video monitor. On the left monitor were shown close-up images of a hand making tiny holes in a piece of paper with a pin, intercut with images of a hole in a wall through which an open mouth and the head of a penis alternately appeared. On the right monitor the audience could watch Leung, who was being videotaped behind the film screen (except for his legs, which were visible beneath the screen) as he faced a camera operator standing at the far right of the performance space. Throughout the one-hour performance, Leung read a long poetic text that helped explain the video images. The last letter of Marie Antoinette, Leung noted, was written in pin pricks because she had been deprived of writing materials. He also discussed "glory holes," which are cut through the walls separating the stalls in men's public washrooms ("tearooms") to facilitate gay sexual encounters.[21] As art historian Kelly Dennis has observed, Leung's *Transcrypts* "is a nuanced analysis of the permeability of the body's real and symbolic borders, exacerbated in light of the AIDS epidemic. . . . [T]he architectural site for digestive elimination and sexual emissions becomes a metaphor for HIV-transmission."[22]

Leung concluded the piece by opening his shirt and running his fingertips over a three-and-a-half-inch scar on his chest. Next to the scar he then wrote the letter T in red as he recited, "'T.' T is for truth. Truth which can only stand next to the subject, next to the 'I.' Am I I or am I it. I or it. I confuse the two, the I and the It."[23] Leung's deliberate allusion to the mirror stage here is supported by his references to Lacan in his text, by his use of video to present his mirror image to the audience, and by his interpolation of the act of touching into the visual field. In addition, Leung has stated that the scar is the result of a cut he made in his chest with a knife in 1978, at the age of thirteen, as he stood before a mirror. Leung considers his "playing with the scar" in his performance to be an "enactment of the scar."[24] In other words, the original masochistic act represented by the scar was as real in the *Transcrypts* performance as it had been in 1978.[25] Conversely, the original cut had been as mediated by the mirror in 1978 as it was by the video in 1991-92.

The decade of the 1970s has continued to resonate in Leung's work since *Transcrypts*, in relation not only to the performance history of that era but also to that era's politics. Since 1992, Leung has been working on a trilogy on "the residual space of the Vietnam War."[26] The first segment of the trilogy, *Warren Piece (in the '70s)*, focused on the story of Vietnam draft resister Warren Niesluchowski, who worked at the alternative space P.S. 1 in Long Island City, New York, where the segment was exhibited in 1993. Included in the exhibition was a videotape of an interview Leung conducted with Vito Acconci. In it, Leung addresses what he considers to be the key issues in Ac-

conci's work of the late 1960s and early 1970s: "the construction of masculinity; the political climate of the United States during its engagement in Vietnam; and the rhetoric of war."[27] Leung later wrote that the interview was influenced by "my own subject position as interpolator, who as an immigrant to the United States from Asia in the fall of 1974, was re-situated in my perception of the Vietnam War by American popular media immediately after my arrival [from Hong Kong]."[28] Also included in the exhibition was a copy of a statement by Acconci printed in the catalog for P.S. 1's inaugural exhibition, *Rooms*, in 1976. Leung had blanked out some of Acconci's words and encouraged readers to substitute the word "war." For example, Acconci's line that originally read, "Why did we all jump to be in this show?" would read, "Why did we all jump to be in this war?"[29]

The second segment of the trilogy was titled *Squatting* (1994) and was inspired by a story Leung heard from his brother who had observed Vietnamese immigrants squatting (a culturally specific posture), instead of sitting, while waiting for a bus in California.[30] The third segment, *Surf Vietnam*, is still in development but will address the specific inspiration for the trilogy: a 1992 *New York Times* article about the return of surfers to Vietnam's China Beach, the U.S. military's "R and R" site during the war.[31] Although they do not focus on aspects of masochism, these more recent works are linked to *Transcrypts* in that they also address issues of the 1970s and deal with "borders"—the borders constituted not by skin but by ideologies of national, cultural, and racial difference.[32]

But there is one big difference between Leung's masochistic performances in the 1990s and those of his predecessors—the orientation of the artist's body to the audience. Even though viewers were face-to-face with Leung's *mediated* body during *Transcrypts*, they could see his *un*mediated body (his legs) only beneath the film screen as he stood at a right angle to the audience, facing the camera operator.[33] Leung's ninety-degree turn away from the audience in *Transcrypts* introduces what I consider an important and telling cluster of works produced by other artists in the past five years. In these works, the masochistic body does not face the viewer directly (as in most 1970s or 1980s works) but is turned entirely around. What does this act of turning away from the audience mean in this context?

For her *Self-Portrait* (1993), Catherine Opie photographed her own bare back soon after a friend carved an image into the flesh between her shoulder blades (fig. 32). The picture, of a house and two stick figures, is rendered like a first-grader's drawing of a traditional couple in front of their country home. But the scene has been queered. Both smiling figures wear skirts and they hold hands. A radiant sun peeks out from behind a cloud and shines down on them, signifying approval of their relationship—a response that our pervasively conservative society does not grant automatically. Rather, approval must be constructed within oneself. In the context of rampant homophobia, this self-construction process can be painful, as each razor cut in Opie's back seems to suggest.[34]

In one segment of Ron Athey's 1994 performance *Excerpts from Four Scenes in a Harsh Life* (at Patrick's Cabaret in Minneapolis), Darryl Carlton lay with his back to Athey.[35] Wearing surgical gloves and using a scalpel, Athey carved a pattern into his African American co-performer's back. Intermittently throughout the process, which was based on an African tribal scarification ritual, Athey placed a fresh paper towel over the incision he was making, slapped the towel, pressed on it to cause the blood from Carlton's back to seep through, and thereby created blood prints. Other performers then hung the prints on a clothesline that stretched over the heads of the viewers.[36] In another segment of the performance, Athey pierced his own arm with hypodermic needles (which did not cause bleeding) and inserted needles into his scalp (which did, but the blood was not used for making prints). In his spoken lines, Athey addressed his history as a heroin addict, a gay man, and a person who is HIV-positive.

An expanded version of Athey's performance was presented later that year at Performance Space 122 (P.S. 122) in New York. Titled *Four Scenes in a Harsh Life*, this performance also included the scalp piercing and the scarification of Carlton's back. But there was one significant difference: audience members were required to sign a release form before attending the performance. This was because the Minneapolis version, which had been presented under the aegis of the Walker Art Center and used $150 of NEA funds, had caused a political brouhaha. An audience member felt he had been put at risk of HIV transmission from the bloodied towels hanging over his head. Although actual danger was virtually nil, if not entirely nonexistent, the conservative Right immediately took up the cause.[37] Fears about HIV transmission were quickly extended to larger concerns about homosexuality (and perhaps even race), which were then enacted in challenges to NEA funding of performance and of the arts in general. Athey's decision to hang the towels seemed to be an attempt to "negotiate" with the audience over just how much they knew about HIV and its transmission. Had knowledge been adequate, the bloodied towels overhead would have served as a reminder of basic facts about HIV and would not have induced fear. Because some audience members failed the negotiation test in Minneapolis, when the performance came to New York this process of negotiation was made more obvious through a type of written contract.[38]

Lutz Bacher stayed in bed for three days straight in a room on the sixth floor of the Gramercy Hotel in New York as the 1996 Gramercy Arts Fair raged on the floors below her. On the first evening of the fair, visitors could enter Bacher's room, where they saw only the back of her head, her body covered with a white sheet, and a video camera at the foot of the bed. Thereafter, the door was locked, but a videotape of the performance, which was titled *Sleep*, played in the room on the third floor where Pat Hearn exhibited works by the artists she represented. It showed Bacher's body poking up through an expanse of white, her back intermittently turned toward the viewer. In effect, Bacher turned her back on the glitzy commercialism of the occasion even as she participated in it. The contrast between the two contexts made the ostensibly simple

act of sleeping extremely complex, obviating the possibility of the (mild) masochism of her prolonged inactivity from spilling over into melancholia.[39]

Viewers of Robby Garfinkel's 1997 interactive, computer-based piece *Case 61* sit in front of a computer screen that displays, during one segment, an image of a person's naked back from just below the middle of the back to the base of the skull.[40] Each shoulder is adorned with an ornate tattoo of a dragon. Between the tattoos, where the figure's spine would be, appears a wide zipper. The computer user soon learns that the goal here is not to "point and click" but to depress the computer mouse button while moving the mouse slowly or in quick swipes across the pad. By moving it very slowly from the bottom of the zipper to the top, one virtually unzips the figure's flesh, causing the flesh to pull away from the spine and up toward the sides of the screen. The action is not unlike pushing apart the two segments of a curtain at a window to create a quasi-triangular opening through which to see the outside world. In *Case 61,* what one sees is a triangular expanse of black screen between the pulled-up flaps of splayed skin (fig. 33). This black wedge soon dissolves into an X-ray image of a human rib cage that has been manipulated to make the blacks and grays of the X-ray appear bloodred, as if to infuse the typically cold-looking medical image with vitality. Intermittently, from the very beginning of this segment, when the mouse is swiped quickly across the pad, sounds of a bullwhip being cracked emanate from the computer, and phrases excerpted from Richard von Krafft-Ebing's case number 61, the case study of a masochistic artist, appear across the screen. The excerpts include phrases such as, "He complained of cerebral neurasthenia," "weakness of the mind," "irritability," and "anxiety of mind" (fig. 34).[41] Eventually, as if the "whipping with diagnostic words" not only had torn the flesh from the figure's back but had canceled out vitality altogether, the screen dissolves into a standard black-and-white X-ray image of a rib cage. But this image, too, serves as a backdrop against which the computer user can continue to make Krafft-Ebing's words appear.

Countering arguments that computer technology constructs a sheltered space for users in which they need not feel connected on a personally responsible level to the content with which they are dealing, Garfinkel constructed a situation in which no such shelter exists. To access details concerning the behavior of a "genuine," clinically diagnosed masochist (and the more excerpts from the case study one sees, the more one wants to see, to round out the narrative), the user cannot remain naive about his or her performance of partnership with the image on the screen, or, by extension, with any individual for whom the digital body of case 61 stands as a metaphor.

How does the turned back affect our reception of these pieces? The impulse, I think, is to reach out and turn the person (real, photographed, or computerized) around, to see how the person is reacting to the signs of pain we see before us. Knowing this is impossible, however, we are left with our own painful responses. For we are disallowed the comfort of our reactions' being absorbed by the registration of pain in the eyes of the observed. In a sense, then, what is being set up is a metaphoric mirror-

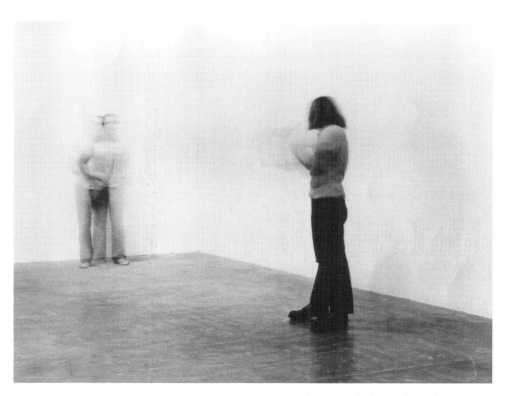

Figs. 1-2. Chris Burden. *Shoot*. 1971.
Photos by Alfred Lutjeans, courtesy of the artist.

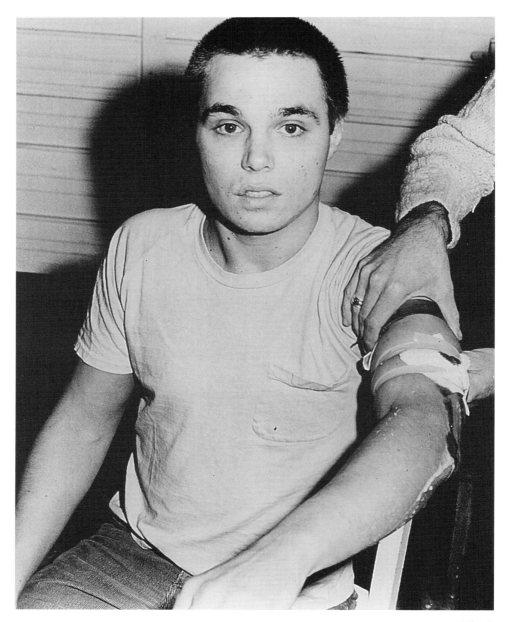

Fig. 2

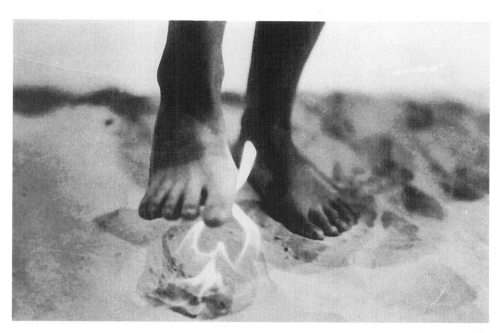

Fig. 3. Gina Pane. *Nourriture, actualités télévisées, feu.* 1971.
Photo courtesy of Galerie Christine et Isy Brachot, Brussels.

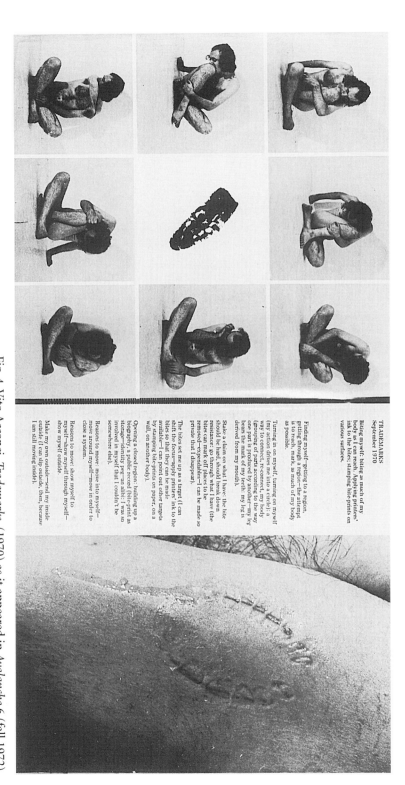

Fig. 4. Vito Acconci, *Trademarks* (1970) as it appeared in *Avalanche* 6 (fall 1972).
Photo by Bill Beckley, courtesy of the artist, *Avalanche Magazine*, and Barbara Gladstone Gallery, New York.

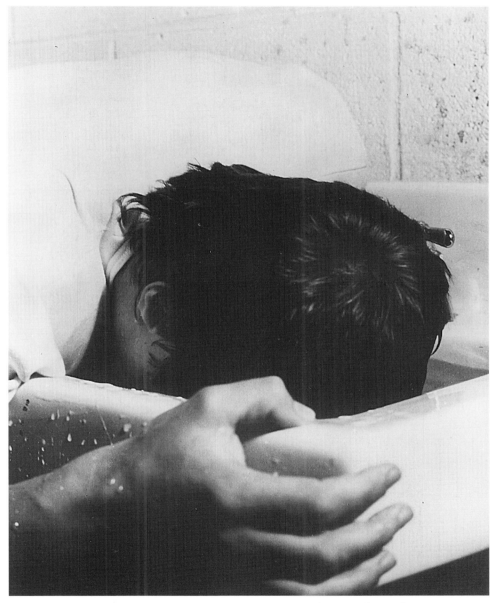

Figs. 5-6. Chris Burden. *Velvet Water*. 1974.
Photos by Chris Burden, courtesy of the artist.

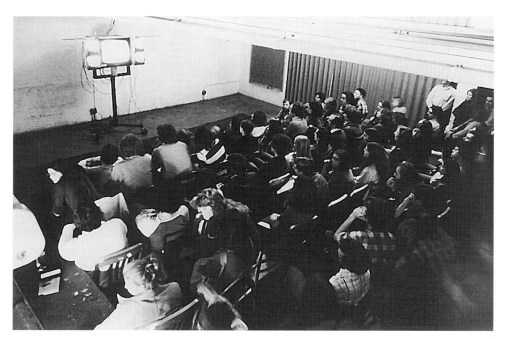

Fig. 6

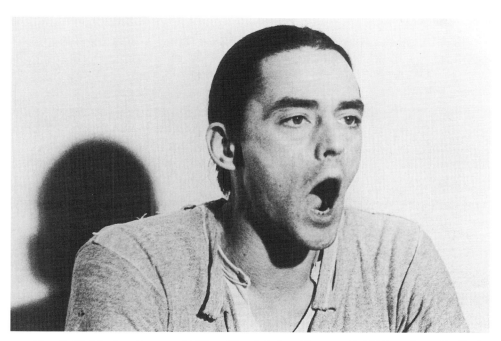

Figs. 7-12. Marina Abramović/Ulay, Ulay/Marina Abramović. *Talking about Similarity* (1976) as documented by the artists in their book *Relation Work and Detour*, 1980.

Photos by Jaap de Graaf, courtesy of the artists and Sean Kelly Gallery, New York.

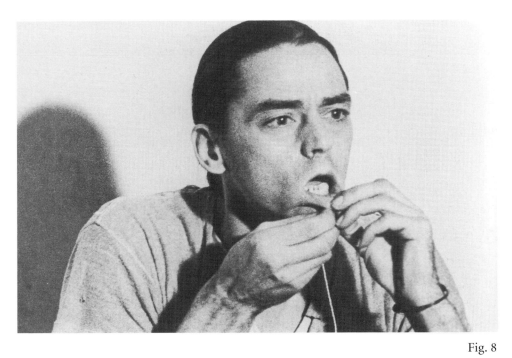

Fig. 8

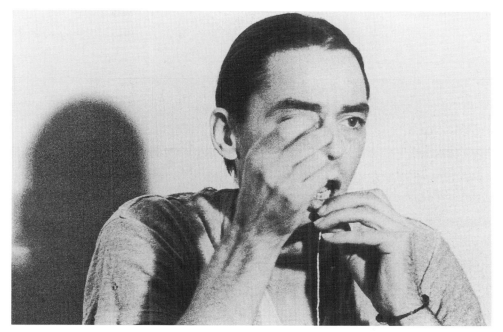

Fig. 9

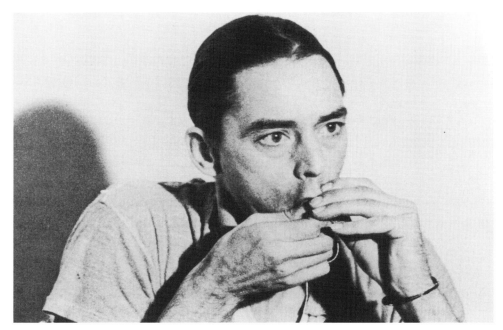

Fig. 10

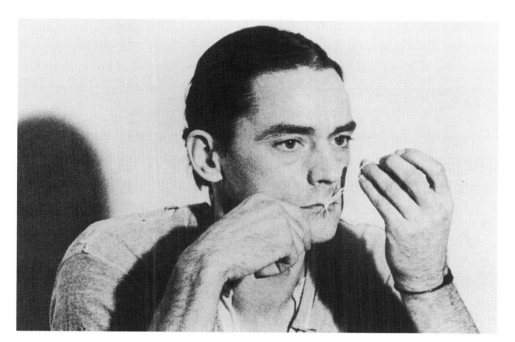

Fig. 11

Fig. 12

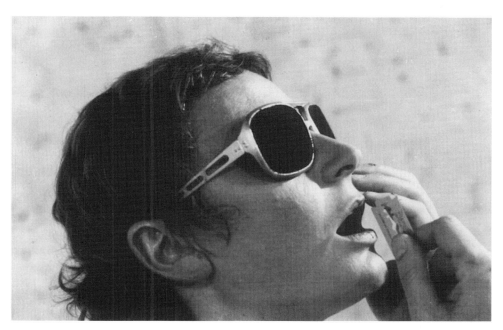

Figs. 13-14. Gina Pane. *Discours mou et mat.* 1975.
Photos courtesy of Galerie Christine et Isy Brachot, Brussels.

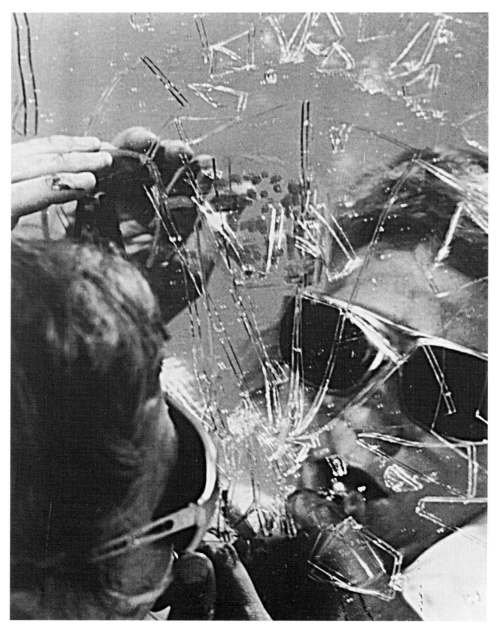

Fig. 14

SEE THROUGH
Super 8 film, color, 5 minutes; October
1969

Facing a mirror: punching at the mirror:
punching at my image in the mirror until
the mirror breaks and my image
disappears.

Get to me—get at me—get into me—get
through me—get through to me.

Talking to myself—talking myself into
myself—talking myself out of myself—
taking myself—taking to myself—taking
up myself—taking myself on—taking
myself through—taking myself off—
touching myself—touching on myself
(touching lightly and passing myself by).

This is a way to get rid of myself. No,
this is a way to get rid of an image and
so be able to stand on my own. No, this
is a way to get rid of a necessary
support. No, this is a way to get rid of a
nagging shadow. No, this is a way to get
out of a closed circle and so have room
to move. No, this is a way to get rid of
deep space, so that I have to bang my
head against the wall.

Reasons to move: move toward what
belongs to me—move to have what
belongs to me.

Fig. 15. Vito Acconci. *See Through* (1969) as it appeared in *Avalanche* 6 (fall 1972).
Photo by Kathy Dillon, courtesy of the artist, *Avalanche Magazine*, and Barbara Gladstone Gallery, New York.

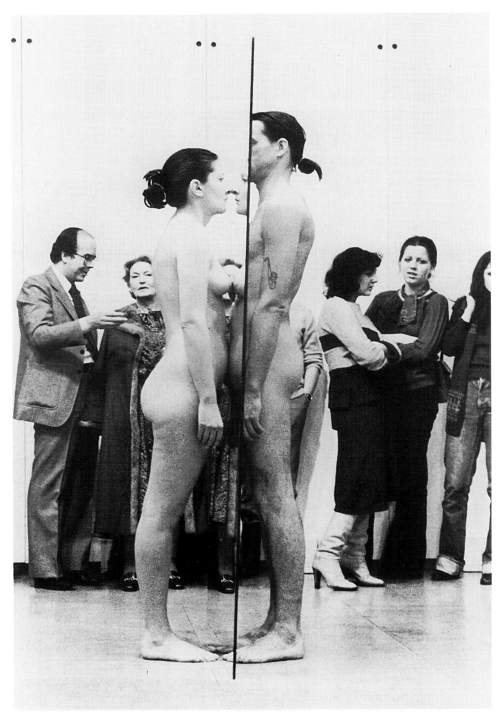

Figs. 16-20. Marina Abramović/Ulay, Ulay/Marina Abramović. *Balance Proof* (1977) as documented by the artists in their self-published book *Relation Work and Detour,* 1980.

Photos by Catherine Duret, courtesy of the artists and Sean Kelly Gallery, New York.

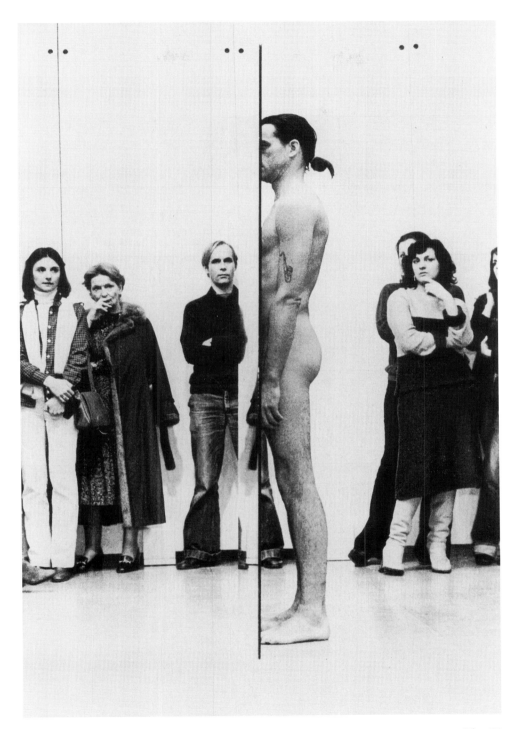

Fig. 17

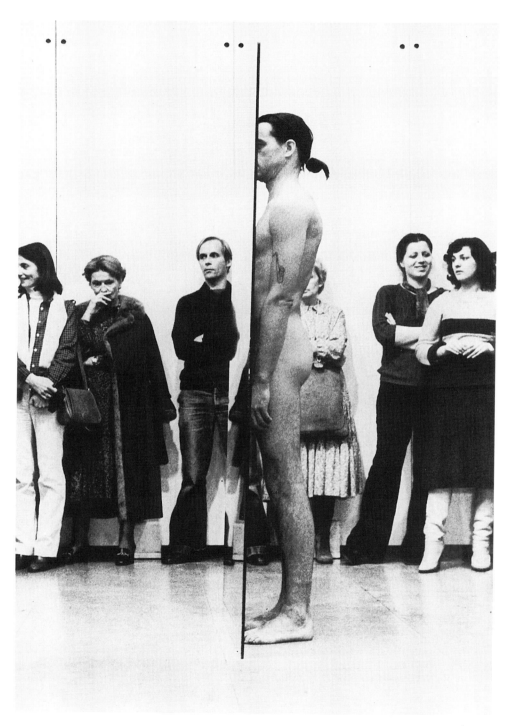

Fig. 18

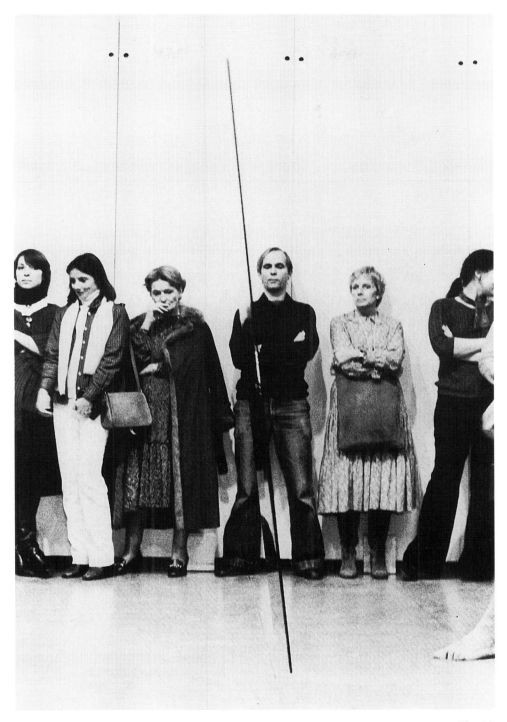

Fig. 19

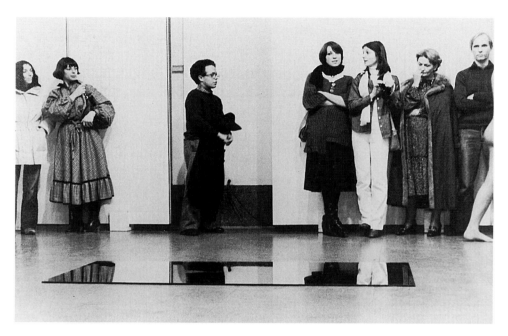

Fig. 20

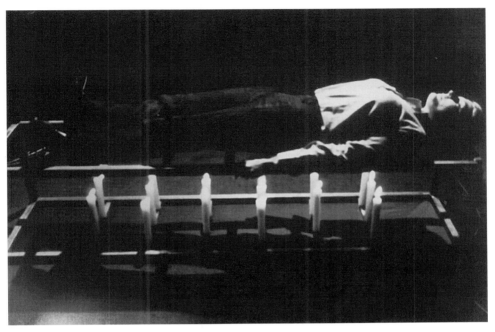

Fig. 21. Gina Pane. "The Conditioning." *Autoportrait(s)*. 1973.
Photo courtesy of Galerie Christine et Isy Brachot, Brussels.

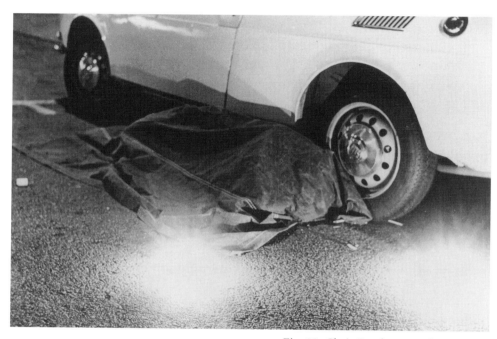

Fig. 22. Chris Burden. *Deadman*. 1972.
Photo by Gary Beydler, courtesy of the artist.

Figs. 23-24. Vito Acconci. *Reception Room*. 1973.
Photos by Fabio Donato, courtesy of the artist and Barbara Gladstone Gallery, New York.

Fig. 24

Figs. 25-26. Marina Abramović/Ulay, Ulay/Marina Abramović.
Communist Body/Capitalist Body. 1979.
Photo by Tomislav Gotovac, courtesy of the artists and Sean Kelly Gallery, New York.

Такса на Тар. бр. 52 Закона о
административним таксама од дин
200 — је наплаћена и прописно
поништена.

Матичар,

ИЗВОД
ИЗ МАТИЧНЕ КЊИГЕ РОЂЕНИХ

НАРОДНОГ ОДБОРА ОПШТИНЕ САВСКИ ВЕНАЦ-БЕОГРАД СРЕЗА СТРАНА

Текући број		

(дан, месец и година уписа)

30. /тридесети/ новембар 194... (место рођења, улица и број)

(дан, месец, година и час (0—24) рођења)

ABRAMOVIĆ MARINA – ženski
(породично и рођено име и пол детета)

ПОДАЦИ О РОДИТЕЉИМА	ОЦА	МАЈКЕ
Породично име (за мајку и девојачко)	Abramović	
Рођено име	Vojin	Danica
Дан, месец и година рођења	2. septembra 1914.	16. ... 1921.
Место рођења	–	–
Држављанство	FNRJ	
Народност	Crnogorci	
Занимање	major JA	student
Место становања	Beograd, Bul. ... Tita 52–	

Накнадни упис и прибелешке

Примедбе и исправке грешака: ... knjigama, na osnovu ... prijave br.3167/46.

Породично и рођено име пријавиоца

Пријавилац

Издато ... 196... год.

Матичар.

Образац бр. 11-32 — (51.322)

Издаје "Савремена администрација" — Београд, Црногорска 1

Fig. 26

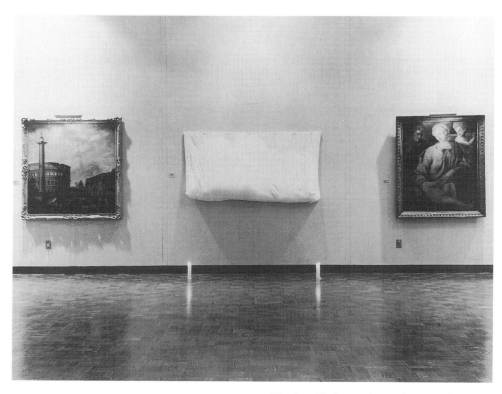

Fig. 27. Chris Burden. *Oh, Dracula.* 1974.
Photo by Barbara Burden, courtesy of the artist.

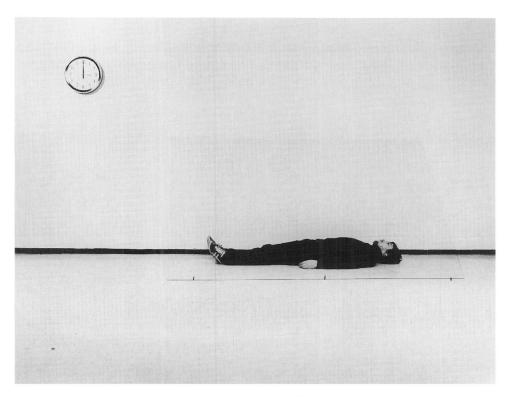

Fig. 28. Chris Burden. *Doomed.* 1975.
Photo by Chris Burden, courtesy of the artist.

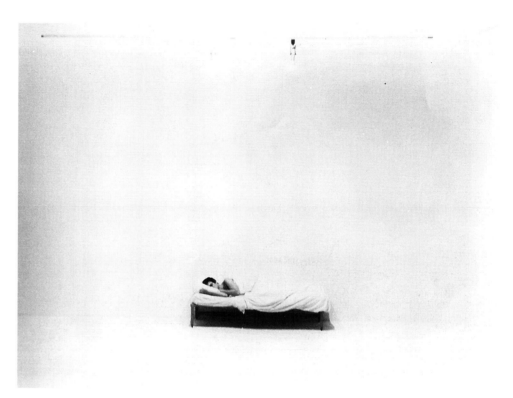

Fig. 29. Chris Burden. *Bed Piece.* 1972.
Photo by Gary Beydler, courtesy of the artist.

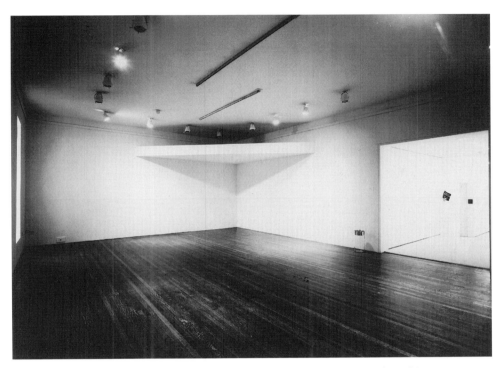

Fig. 30. Chris Burden. *White Light/White Heat.* 1975.
Photo by eeva-inkeri, courtesy of the artist.

Fig. 31. Chris Burden. *Oracle*. 1975.
Photo by Chris Burden, courtesy of the artist.

Fig. 32. Catherine Opie. *Self-Portrait.* 1993.
Photo courtesy of the artist and Regen Projects, Los Angeles.

Figs. 33-34. Robby Garfinkel. *Case 61*. 1997.
Photos courtesy of the artist.

His appearance was undeniably masculine,

...s conduct decent and beyond criticism.

He complained of cerebral neurasthenia

(weakness of the mind,

of will power,

absent mindedness, irritability,

shyness,

anxiety of mind...

Fig. 34

stage experience: by observing the turned back, one recognizes the pain of separation between viewer and viewed; in imagining a different scenario in which the figure *can* be turned around, the identity positions of viewer and viewed shift. Either way, the viewer is implicated in the image, becoming a contracted partner in the performance if only by handling its representations or by seeing aspects of the self mirrored across the skin of another's back. As one swipes the mouse across the digital back of case 61 or as one traces with a fingertip the incisions on Opie's back, vision and touch work in tandem to underscore one's participation in masochistic processes on levels both sensate and intellectual.

More recently, at least since 1995, artists' masochistic gestures have been getting less extreme in the United States. Bacher's and Garfinkel's pieces were literally nonincisive in their masochism. This trend seems to repeat that which took place in American performance art in the 1970s. Acconci went from punching a mirror until it broke (*See Through*, 1969) to rolling back and forth on a mattress for several hours while the audience listened to an audiotape laced with self-deprecating statements (*Reception Room*, 1973). Burden went from having himself shot (*Shoot*, 1971) to simply falling asleep (see his numerous "bed pieces," 1972–75). If moderation in *masochistic performance* by the mid-1970s might be linked to the end of *war* (as two situations that call for contractlike negotiations), what might current trends away from masochistic extremes in performance say about the war on culture and the war on AIDS of the 1990s? To be sure, one cannot claim they are over. But could it be argued that one major battle has been lost, at least partially (given that the NEA's power has been greatly diminished), and one has not, at least not entirely (given that the efficacy of new drug treatments for AIDS such as protease inhibitors is hopeful)? Moreover, *can* it be argued that masochistic performances are tied to something as positive and rational as negotiatory processes?

At first glance, masochism seems to negate any possibility for the reciprocity required of negotiation. In fact, masochism seems downright senseless, off-putting, unsettling, and numbing. But I would argue that we may have to experience these responses in a concentrated form to understand that we all experience that which triggers them on a daily basis. Perhaps we need to experience these responses in order to desire a form of negotiation that can turn senselessness, alienation, imbalance, and numbness into something constructive. To the degree to which there have been victories in the war on culture and the war on AIDS, they have been due entirely to negotiatory successes on the part of artists and AIDS activists. Through demonstrations, publications, letter-writing campaigns, appearances on television, use of the Internet, and so on, they have forced others to question, to recognize, and to alter institutional causes of everyday masochisms.

Masochism in art may be getting less incisive as we move into the twenty-first century, but our status as viewers (of the live performances or their documentation) still constitutes active participation. We are asked to take responsibility for masochism's in-

stitutional causes. And insofar as this institutional process starts at home, artists who create a semblance of the home—in the form of a hotel room that looks like a bedroom, a domestic scene etched into a human back, or even an interactive computer setup that is not unlike the setup of your own PC atop the desk in your living room—are creating reminders of the place where every contract with the skin is initially drafted. Masochistic artists guide viewers on a metaphoric journey back home, and, in doing so, they deliver the important message that nonnegotiable, black-and-white thinking is not effective in the long run. This message becomes clearer—and more crucial—in times of strife, when people tend to fall back on dualisms to simplify situations and to make things more manageable, even if those solutions are temporary or illusory.

Masochistic performance is as complex as the strife to which it responds. And so, many questions remain: How far does masochistic performance go in helping to rectify strife-ridden situations? Is masochism only about desperation in not being able to find a way out of situations traditionally bound by dualistic thinking? What does it mean that masochistic performance in the 1970s was conducted predominantly by white artists? Is masochism an indulgent luxury facilitated by privilege, as it was for the wealthy Léopold von Sacher-Masoch himself?[42]

Such questions probably will not go away. Nor will masochistic performances. But it is hoped that one can meet their challenge: to recognize masochism in one's own life and in others' lives and to consider what it implicitly demands. In this way, masochism's extremes would not have to be enacted by artists to expose its value. Masochistic performance art provokes viewers into examining the *structure of contract* so that certain of its aspects might be appreciated and mined, especially the *value of negotiation*. As Simon Leung has written, "An adequate response to violence necessitates the negotiation of a contract with the future"[43]—and, I might add, with those we meet along the way.

NOTES

1. HE GOT SHOT

1. Chris Burden, *Chris Burden 71–73* (Los Angeles: Chris Burden, 1974), 24.

2. Peter Plagens, "He Got Shot—for His Art," *New York Times,* 2 September 1973, D1, D3.

3. Such responses in the "general public" persist to this day but are, of course, impossible to document, because they are related in informal conversation, classroom discussion, and the like. When recorded in mainstream media of the 1970s, responses often took the form of cynicism, as in Plagens's article, or satire, as in Robert Hughes's "Portrait of the Autist as a Young Man," *Time,* 24 February 1975, 56–57.

4. Lea Vergine, ed., *Il corpo come linguaggio (La "Body-art" e storie simili),* trans. Henry Martin (Milan: Giampaolo Prearo Editore, 1974), 5, 9.

5. Vito Acconci has said that by 1973–74, as his period of performance work was drawing to a close, he began to think of this work as "performing a contract." But he is using this terminology in a slightly different way than I am here. For Acconci, this meant carrying out a promise: "You say you're going to do something; now you have to carry it through . . . you have to live up to it." He also links this notion to what stand-up comedians feel in "being put on the spot." Vito Acconci, interviews with the author, Brooklyn, N.Y., February 1989 and December 1996. See also Vito Acconci, "Performance after the Fact," *Documents (Sur l'art contemporain)* (Paris), March 1992, 44–50.

6. Burden (b. 1946, Boston, Mass.) received a master of fine arts degree from the University of California at Irvine in 1971. Vito Acconci (b. 1940, Bronx, N.Y.) received a master's degree in writing from the University of Iowa in 1964. Gina Pane (b. 1939, Biarritz, France; d. 1990) studied at the École des Beaux-Arts in Paris. Marina Abramović (b. 1946, Belgrade, Yugoslavia) received an advanced degree from the Academy of Fine Arts in Belgrade in 1970. Ulay (b. F. Uwe Laysiepen, 1943, Solingen, Germany) studied photography from 1962 to 1968. (Note: The last two artists will hereafter be referred to in the text as Ulay/Abramović.)

7. For an examination of these types of environments and their impact on the history of performance-based video of the 1970s, see my essay "Performance, Video, and Trouble in the Home," in *Illuminating Video: An Essential Guide to Video Art,* ed. Doug Hall and Sally Jo Fifer (New York: Aperture, in association with Bay Area Video Coalition, 1990), 135–51, 501–5.

8. For example, the Wiener Aktionismus (Viennese Actionism) artists, including Hermann Nitsch, Günther Brus, Otto Mühl, and Rudolf Schwarzkogler, all had ceased their most extreme activities by 1972. Moreover, their use of violence was sometimes simulated, as in Nitsch's and Schwarzkogler's constructed photographs of faked amputations, for which a colleague (Heinz Chibulka) generally served as the model.

9. Deborah Linderman, "Oedipus in Chinatown," *Enclitic* 5–6 (fall 1981–spring 1982): 200. This sort of questioning derives from Michel Foucault's thinking, especially his concerns about sexuality and the social strategies of its deployment, as Linderman points out, based on the dominant power's desire to see that which it feels the need to delimit. See Michel Foucault, *The History of Sexuality,* vol. 1, *An Introduction,* trans. Robert Hurley (New York: Vintage, 1978), 106–7.

10. American Psychiatric Association, "Sexual Masochism," *Diagnostic and Statistical Manual of Mental Disorders,* 4th ed. (Washington, D.C.: American Psychiatric Association, 1994), 529. The rest of the diagnosis described in this text includes "fantasies, sexual urges, or behaviors [that] cause clinically significant distress or impairment in social, occupational, or other important areas of functioning." Another diagnostic source, the *ICD-10 Classification of Mental and Behavioral Disorders,* maintains the same sexual bias toward masochism. The diagnosis for "sadomasochism" (the only time masochism appears in this manual) explains that "sexual sadism is sometimes difficult to distinguish from cruelty in sexual situations *or anger unrelated to eroticism*" (my emphasis); nonetheless, "where violence is necessary for erotic arousal, the diagnosis can be clearly established." World Health Organization, *ICD-10 Classification of Mental and Behavioral Disorders:*

Clinical Descriptions and Diagnostic Guidelines (Geneva: World Health Organization, 1992), 220. Though it merges masochism and sadism (a problem, as I will show), the *ICD-10,* unlike the *DSM-IV,* at least tries to keep open the possibility that the tendency toward such practices might have something to do with extra-sexual issues.

11. Richard von Krafft-Ebing, *Psychopathia Sexualis* (1886; reprint, New York: Pioneer, 1953), 132.

12. Gilles Deleuze, *Masochism: An Interpretation of Coldness and Cruelty,* trans. Jean McNeil (New York: Braziller, 1971); originally published as *Présentation de Sacher-Masoch* (Paris: Editions Minuit, 1967). Also published as *Masochism, Coldness, and Cruelty* (New York: Zone, 1989). Both the Braziller and the Zone editions include a translation of Léopold von Sacher-Masoch's novel *Venus in Furs* (1870) and related contracts. All my references are to the 1971 Braziller edition.

13. Theodor Reik, "Masochism in Modern Man," in *Of Love and Lust: On the Psychoanalysis of Romantic and Sexual Emotions* (1949; reprint, New York: Farrar, Straus & Giroux, 1984), 206–54. Reik actually resisted including provocation in his list of "essential" components, because of its suggestion of sadistic impulses (254). I am including it here because Deleuze cites it as one of the four components characteristic of masochism (*Masochism,* 65–66), and I wish to indicate his dialogue with Reik's text.

14. Deleuze, *Masochism,* 66ff.

15. For Pane's own description of *Nourriture, actualités télévisées, feu,* see Effie Stephano and Gina Pane, "Performance of Concern," *Art and Artists,* April 1973, 22. See also François Pluchart, "Gina Pane's Biological Aggressions," *arTitudes,* December 1971–January 1972, 10.

16. For Acconci's description of *Trademarks,* see Cindy Nemser, "An Interview with Vito Acconci," *Arts Magazine,* March 1971, 20. For a philosophical discussion of the piece, see Germano Celant, "'Dirty Acconci,'" *Artforum,* November 1980, 77–79. For passing but important references to the function of the contract in other 1970s works by Acconci, see Stephen Melville, "How Should Acconci Count for Us? Notes on a Retrospect," *October* 18 (fall 1981): 80, 86. Although Melville's discussion is brief and is not tied to issues of masochism, I believe it constitutes the first attempt by a critic to think about performance in relation to contract and the law.

17. Vito Acconci, "Trademarks," *Avalanche* 6 (fall 1972): 10–11. This issue of *Avalanche* is a special edition on Acconci's work.

18. Leo Bersani, *The Freudian Body: Psychoanalysis and Art* (New York: Columbia University Press, 1986), 74.

19. Bersani's references to "self-shattering" can be found throughout his text, but see especially his chapter titled "Sexuality and Esthetics." Ibid., 29–50.

20. Ibid., 54.

21. For Burden's description of *Velvet Water,* see Chris Burden, *Chris Burden 74–77* (Los Angeles: Chris Burden, 1978), n.p. Also see Robert Horvitz, "Chris Burden," *Artforum,* May 1976, 28.

22. For Ulay/Abramović's description of *Talking about Similarity,* see Marina Abramović/Ulay, Ulay/Marina Abramović, *Relation Work and Detour* (Amsterdam: Ulay/Marina Abramović, 1980), 26. See also C. Carr, "The Art of the Twenty-first Century: Marina Abramović/Ulay," *Village Voice,* 25 February 1986, 45.

23. Indeed, Ulay has said that he was inspired to sew his mouth shut in *Talking about Similarity* by the story that some of the members of the Baader-Meinhof gang, when imprisoned (starting in 1972) for their radical political activities, had sewn their own mouths shut (Ulay, letter to the author, November 1996). One assumes that their act was not only symbolic of their resistance to divulging information but also symbolic of the very types of torture threatened to be used on them if they did not cooperate.

24. For an extensive discussion of political incarceration and torture, as well as the question of freedom in self-engineered situations of eroticized sadomasochism, see Kate Millett, *The Politics of Cruelty: An Essay on the Literature of Political Imprisonment* (New York: Norton, 1994), 113–16. Throughout this book, Millett emphasizes the dual capacity of every human being to be a torturer *and* to be tortured.

25. See Kristine Stiles, "The Destruction in Art Symposium (DIAS): The Radical Cultural Project of

Event-Structured Live Art" (Ph.D. diss., University of California at Berkeley, 1986). For abbreviated versions of the dissertation, see Kristine Stiles, "Synopsis of the Destruction in Art Symposium (DIAS) and Its Theoretical Significance," *The Act* 1, no. 2 (spring 1987): 22–31; and "Sticks and Stones: The Destruction in Art Symposium," *Arts Magazine,* January 1989, 54–60. For Stiles's argument that aspects of earlier destruction-oriented work have operated throughout the post–World War II period, see her essay "Survival Ethos and Destruction Art," *Discourse* 14, no. 2 (spring 1992): 74–102.

26. See Stiles, "Destruction in Art Symposium," "Synopsis," "Sticks and Stones," and "Survival Ethos." For an abbreviated discussion of the destruction-creation dialectic, especially Stiles's important distinction between destruction *in* art and destruction *of* art, see "Synopsis," 22.

27. For a full account of OMT theory, see Hermann Nitsch, *Orgien Mysterien Theater/Orgies Mysteries Theatre* (Darmstadt, Germany: Marz Verlag, 1969).

28. Stiles, "Destruction in Art Symposium," section 3.2, "Metonymy: The Figure Bridging the Space between Subject and Object," 645–66. (The "crown" example is my own.)

29. Robert Rauschenberg, quoted in Dorothy C. Miller, ed., *Sixteen Americans* (New York: Museum of Modern Art, 1959), 58.

30. Allan Kaprow, *Assemblage, Environments, and Happenings* (New York: Abrams, 1966), 188–89.

31. For Stiles's elaboration on the naïveté of the art/life collapse theory, see "Between Water and Stone," in *In the Spirit of Fluxus,* ed. Elizabeth Armstrong and Joan Rothfuss (Minneapolis: Walker Art Center, 1993), 62–99.

32. See Günter Brus, "Notes on the Action *Zereisseprobe,*" in *Aktionsraum I oder 57 Blindenhunde* (Munich: Aktionsraum, 1971), 141–45. Thanks to Kristine Stiles for providing this citation.

33. For more on Ono's *Cut Piece,* see my essay "Fluxus Feminus," *TDR: The Drama Review* 41, no. 1 (T153, spring 1997): 43–60.

34. The term "body art" first appeared as a category heading in *Art Index* in 1971–72, although it had been in common usage for some time before that. "Performance art" first appeared in the following year. See Bruce Barber, "Indexing: Conditionalism and Its Heretical Equivalents," in *Performance by Artists,* ed. AA Bronson and Peggy Gale (Toronto: Art Metropole, 1979), 185. The first general survey book on the subject, by RoseLee Goldberg, was published under the title *Performance: Live Art 1909 to the Present* (New York: Abrams, 1979); the revised edition is titled *Performance Art: From Futurism to the Present* (New York: Abrams, 1988).

I have chosen to use the term "performance art" in this study because I feel it places emphasis on the action and function of the artist. Thus, the instrumentality of the art form's primary material, the body, is highlighted without giving so much weight to the individualistic character of that body that the viewer might not be able to form a useful identification. Other terms can be defended and may even be more precise for clusters of work done in certain periods, such as Stiles's use of "event-structured live art" to describe the destruction-oriented works of the mid- to late 1960s DIAS era (for her discussion of this terminology, see Stiles, "Destruction in Art Symposium," 648). However, I feel that global application of such specific terminology might close off the field from perusal by a broader range of observers who might feel they first need to understand the term before they can understand what it describes. (For a more philosophical argument regarding the use of the term "event," see Stephen C. Foster, "Event Structures and Art Situations," in Stephen C. Foster, ed., *"Event" Arts and Art Events* [Ann Arbor, Mich.: UMI Research Press, 1988], 3–10.)

Recently, Stiles has utilized the more inclusive term "destruction art" as a subsidiary of "performance art." To Stiles, "performance art is the medium that conveys human sentience in the visual arts most directly. Destruction art is the kind of performance art in which the conditions of human emergency are most vividly displayed" ("Survival Ethos," 90). She argues convincingly that destruction art is not circumscribed by the historical period (World War II and the Holocaust) that prompted artist Gustav Metzger to coin the term "auto-destructive art," from which she adapted her own term. Rather, destruction art is produced in any period of "human emergency." It could be argued that Stiles's term applies to the masochistic performances I

am addressing, most of which were done during the period of the Vietnam War. But these performances were simply not as tightly focused on issues of survival. There are other aspects of destruction art that do appear in masochistic performances of the 1970s, and I will point out some of these as I proceed.

Amelia Jones prefers the term "body art" to describe work after 1960 that included the artist's body "in or as the work of art." See her book *Body Art/Performing the Subject* (Minneapolis: University of Minnesota Press, 1998). "Body" itself has been and probably always will be a term that pushes its referent forcefully into the consciousness of observers, listeners, and readers. Thus, I fear that applying it too broadly to performed work by artists could result in the trivialization or vulgarization of the issues for which it is mobilized, by writers less committed to the complexity of the term than Jones.

Having said all this, a certain honoring of artists' own choices of terminology is called for. The first bibliographic pieces I discuss in the text all used some version of the term "body art." They were, in some cases, written by individuals who thought of themselves as active participants in the work they were addressing.

35. Willoughby Sharp, "Body Works," *Avalanche* 1 (fall 1970): 14–17.

36. Michael Fried, "Art and Objecthood," *Artforum,* June 1967, 16.

37. Ibid., 23.

38. Ibid., 20.

39. Subsequently, there has been lively debate about Fried's essay in relation to performance. See Maurice Berger, *Labyrinths: Robert Morris, Minimalism, and the 1960s* (New York: Harper & Row, 1989), 9–10; Nick Kaye, *Postmodernism and Performance* (New York: St. Martin's, 1994), 24–35; Henry M. Sayre, *The Object of Performance: The American Avant-Garde since 1970* (Chicago: University of Chicago Press, 1989), 6–7, 9; and Kristine Stiles, "Performance and Its Objects," *Arts Magazine,* November 1990, 39.

40. Cindy Nemser, "Subject-Object Body Art," *Arts Magazine,* September–October 1971, 42.

41. Ibid. (my emphasis).

42. Recently, subject-object relations have been central to discussions of performance art, especially in regard to how subject-object identities are balanced in performance work—one of my major concerns in this book. See, for example, Kristine Stiles's theory of the function of the performing body as a "metonymic joint." She points out that the sense of wholeness that this connective function implies is not to be construed "in terms of unity" but in Derridean and Nietzschean philosophical terms of "reciprocal being," the end result being a condition in which "[c]ontingency manifests the interdependence of the subject/object distinction" ("Destruction in Art Symposium," 676). See also her comments on the capability of the performing body to "visualize the perpetually shifting but mutually identifiable relations of power and need within the exchange of subject/object relations" ("Survival Ethos," 96).

Of more specific relevance to my discussion of masochistic performance is Amelia Jones, "Dis/Playing the Phallus: Male Artists Perform Their Masculinities," *Art History* 17, no. 4 (December 1994): 546–84. Jones discusses "the ultimate exchangeability and interdependence of . . . oppositional categories of viewer/viewed, male/female, subject/object" in the masochistic performance work of Vito Acconci (564–66). For an in-depth investigation of the historical changes in notions of subjectivity, especially in the contemporary period, and how those changes have manifested themselves in art practices involving the body, see Jones, *Body Art/Performing the Subject.*

43. Nemser, "Subject-Object Body Art," 42.

44. Psychoanalytic theory had been employed, of course, for some time in art history and criticism (Jungian analyses of Jackson Pollock's work and even Sigmund Freud's psychoanalytic assessment of Leonardo are well-known examples). But it was still an underemployed methodology in the early 1970s. This changed by the mid-1970s, as feminist artists, theorists, and critics started to examine the potential of a wide range of psychoanalytic theories to inform their work. Artist-theorist Mary Kelly, filmmaker-theorist Laura Mulvey, and their contemporaries writing for the British journal *Screen* in the 1970s are some of the earliest and strongest examples of this development. Thanks to Ann Reynolds for prompting me to look at earlier uses of psychoanalytic theory in art history.

45. Vergine, *Il corpo come linguaggio*. Also worthy of note from this time period are the catalogs for some of the earliest exhibitions of this art form: François Pluchart, *L'art corporel* (Paris: Editions Rodolphe Stadler, 1975); and Ira Licht, *Bodyworks* (Chicago: Museum of Contemporary Art, 1975).

46. Vergine, *Il corpo come linguaggio,* 5, 9.

47. Ibid., 13.

48. See Stiles's comparative discussion of metonymy and metaphor in "Destruction in Art Symposium," 652, and "Synopsis," 29.

49. Lacan's theories will be dealt with at length in chapter 3. In brief, Lacan believed that it is during a child's initial moments in front of a mirror, discovering another self—flat, cold, and partial rather than fleshy, warm, and full-bodied—that the child experiences an impulse toward symbolizing, toward the use of some kind of language to articulate the "I" it now encounters as split. It is the sensation of actually feeling split in two (into body and image) that is of interest in the discussion of masochistic performance. See Jacques Lacan, "The Mirror Stage as Formative of the Function of the I as Revealed in Psychoanalytic Experience" (1949), in *Écrits: A Selection,* trans. Alan Sheridan (New York: Norton, 1977), 1–7.

50. Citations regarding Freud's theories of oedipalization are too numerous to list, but perhaps the most helpful is his discussion of ego and super-ego development in "The Ego and the Id" (1923), in *A General Selection from the Works of Sigmund Freud,* ed. John Rickman (1937; reprint, Garden City, N.Y.: Doubleday, 1957), 219–21.

51. For the concept of splitting, see Jacques Lacan, "The Meaning of the Phallus" (1958), in his *Feminine Sexuality,* ed. Juliet Mitchell and Jacqueline Rose, trans. Jacqueline Rose (New York: Norton, 1985), 79–83; and "Mirror Stage," 1–7.

52. For an example of contemporary art historical writing that addresses body-related work and organizes it around similar metaphors (mouths, mothers, and beds, in this case), see Mignon Nixon, "Bad Enough Mother," *October* 71 (winter 1995): 70–92. See also my doctoral dissertation, in which I first formulated the organizational schema of the mouth, mirror, and bed: Kathy O'Dell, "Toward a Theory of Performance Art: An Investigation of Its Sites" (Ph.D. diss., City University of New York, 1992).

53. For a discussion of the "law introduced . . . by the father" (I have shortened the phrase to "law of the father"), see Lacan, "Meaning of the Phallus," 83. See also Juliet Mitchell's discussion of Lacan's "law represented by the father," in contrast to Freud's and Melanie Klein's theories of oedipalization, "Introduction-I," in Lacan, *Feminine Sexuality,* 22–23.

54. A definition of "offer" can be drawn from "Restatement, Second, Contracts," as it is cited by legal textbook writers Gordon D. Schaber and Claude D. Rohwer: "a manifestation of willingness to enter into a bargain, so made as to justify another person in understanding that his assent to that bargain is invited and will conclude it." "Acceptance," then, can be described by the way in which assent is granted. Schaber and Rohwer explain that the "manner of acceptance" may consist of a promise or a performance of a requested act, carried out in various "medium(s) of acceptance," including writing, oral consent, or, in the case of more contemporary contracts, silence. See Gordon D. Schaber and Claude D. Rohwer, *Contracts in a Nutshell,* 3d ed. (St. Paul, Minn.: West, 1990), 9, 34, 70.

55. Law theorists Peter Gabel and Jay M. Feinman explain how "the [modern] doctrine of 'consideration' . . . grew out of [nineteenth-century] principles of freedom and equality." They provide this example: "If a person offered to sell his house to another and agreed to give the other person until Friday to decide whether to buy or not, he could change his mind and revoke the promise because it was, like a gift, a gratuity. Conversely, when a bargain had been struck, it was firm, and the courts would not inquire into the 'adequacy of consideration,' *i.e.,* the fairness of the bargain" (Peter Gabel and Jay M. Feinman, "Contract Law as Ideology," in *The Politics of Law: A Progressive Critique,* ed. David Kairys [New York: Pantheon, 1982], 177).

56. Oliver Wendell Holmes Jr., quoted in Grant Gilmore, *The Death of Contract* (Columbus: Ohio State University Press, 1974), 41. See Gilmore's chapter "Origins" (5–34) for how modern contract was concretized between 1874 and 1880. The first attempts at "restating" the nature of contract took place in the

1920s but ended up being "fudged and blurred," producing "schizophrenic" results (65, 60). At the time Gilmore wrote *The Death of Contract,* a major effort was under way to formulate the second "Restatement, Contracts." Between 1964 and 1971, six tentative drafts had been produced.

57. Although no resolution had been reached on the second restatements when Gilmore wrote *The Death of Contract,* there was a tendency toward reinstituting the notion of a "meeting of the minds." For the origins of this concept and the concept of the contract as an abstraction, see *The Death of Contract,* 13, 29.

58. In November 1969, reporter Seymour Hersh broke the news about a U.S. military massacre of hundreds of civilians—mostly old men, women, and children—at My Lai. Despite elaborate cover-ups by the military, it was later learned that General Westmoreland had sent a message reading, "Congratulations to officers and men of Charlie Company, 1st Battalion, 20th Infantry for outstanding action" that "dealt enemy heavy blow" (quoted in Marvin E. Gettleman et al., eds., *Vietnam and America: A Documented History* [New York: Grove, 1985], 404). Because of Hersh's efforts to distinguish between "what was meant" and "what was said" by individuals such as Westmoreland, the world became aware of many such "breaches of contract" carried out by the military.

59. A second example of a "meant-said" distinction during the Vietnam War: In 1971, Congressman Ronald Dellum's unofficial war crime hearings exposed major discrepancies in the tallying of the enemy dead. In those hearings, a captain described the institutional pressure to inflate statistics and gave an example of how it was carried out: "Our . . . [b]attalion . . . had not been getting the body count that the other battalions in the division had, and General Williamson told that battalion commander, Lieutenant Colonel Carmichael, that he had better start producing or we would get a battalion commander in that battalion that could produce. Colonel Carmichael got the message loud and clear." The captain went on to explain how bodies were simply added here and there to the statistics—for example, 100 Vietcong seen moving across a field, possibly toward an ambush, were included in the tally. Thus, the count magically rose from approximately 30 dead bodies actually observed to a fictionalized 312. James William Gibson, *The Perfect War: The War We Couldn't Lose and How We Did* (New York: Vintage, 1986), 125–26.

60. Amelia Jones has challenged my focus on the Vietnam War as an influence on performance art: "O'Dell reduces the historical picture to this one event . . . as *the* motivating factor for performance art— particularly masochistic performance—in the early 1970s." Jones, "Dis/Playing the Phallus," 579 n. 10. To clarify, I do not believe that the Vietnam War was the sole event motivating masochistic performance (and certainly not performance art in general). Rather, I have chosen, for purposes of focus and in-depth inquiry, to circumscribe the Vietnam War as an object of analysis because of the profoundly complex ways in which this war's contractual underpinnings were manipulated. A strong sociohistorical connection was established between the war and masochistic performance artists' tamperings with contract. See Jones's own more expansive, causal approach to performance, masochistic and otherwise, in her book *Body Art/Performing the Subject.* In "Dis/Playing the Phallus," she rightly cites as motivations for body-related artwork from the 1960s to the present the "second wave of feminism and of the civil rights and gay rights movements . . . as well as . . . the development of poststructuralist critiques of modernist conceptions of subjectivity and meaning" (548).

61. Nonetheless, as Elaine Scarry writes, "That the adult human being cannot ordinarily without his consent be physically 'altered' by the verbal imposition of any new political philosophy makes all the more remarkable, genuinely awesome, the fact that he sometimes agrees to go to war, agrees to permit this radical self-alteration to his body." Elaine Scarry, *The Body in Pain: The Making and Unmaking of the World* (New York: Oxford University Press, 1985), 112. It is the nature of such "agreements" that interests me here. For Scarry's more recent views on contract in relation to the body, see her essay "The Merging of Bodies and Artifacts in the Social Contract," in *Culture on the Brink: Ideologies of Technology,* ed. Gretchen Bender and Timothy Druckrey (Seattle: Bay Press, 1994), 85–97, 144–45.

62. Plagens, "He Got Shot," 3.

63. Lebel described his experiences at the Renault factory in an unpublished interview with Kristine

Stiles in 1982. Thanks to Stiles for this information. See also Jean-Jacques Lebel, "On the Necessity of Violation" (1968), in *Happenings and Other Acts,* ed. Mariellen R. Sandford (London and New York: Routledge, 1995), 268–84.

64. Maurice Berger, unpublished statement delivered in discussion at the conference "The Scholar and the Feminist XV," Barnard College, March 1988. According to Berger, Morris often referred to labor issues in performances. For the opening of his 1970 exhibition at the Whitney Museum, for example, Morris worked as part of the installation crew in assembling his own exhibition, a show that one reviewer compared to "a midtown construction site." But this focus was more typical of the preceding decade of Morris's and other artists' work. In 1964, Morris had referred to labor symbolically in *Site,* a performance with Carolee Schneemann in which Morris, wearing work gloves and a mask, moved large pieces of whitewashed plywood to construct a setting around Schneemann, whose reclining pose simulated that in Edouard Manet's *Olympia* (1863). See Berger, *Labyrinths,* 117.

65. Stiles, "Synopsis," 29.

66. Freud established the expectation of a pain-pleasure symbiosis in "Three Contributions to the Theory of Sex" (1905), in *The Basic Writings of Sigmund Freud,* ed. A. A. Brill (1938; reprint, New York: Modern Library, 1966), 570. Here he claims that lurking in every sadist is a masochist, a condition providing the sadist with a promise of double pleasure—the pleasure of dominating one's partner and the pleasure one's hidden self derives from identifying with the dominated. Deleuze refutes this symbiosis in his chapter "Are Sade and Masoch Complementary?" in *Masochism,* 33–41.

In counterpoint to Deleuze's and my own reading, it is important to note that Freud's notion of symbiosis has been useful to other feminist theorists who see how it plays into practices of masquerade (the thinking here is that the masochist masquerades as a sadist). To these theorists, such practices produce a distance from essentialized identifications through masquerade's pronounced artificiality. For art historian Therese Lichtenstein, for example, Freud's theory of a pain-pleasure symbiosis and masquerade's attraction-repulsion dynamic help explain Hans Bellmer's photographs of his multilimbed, grotesquely assembled, doll-like sculptures. Lichtenstein argues that Bellmer's images evoke "feelings that oscillate . . . between empathy and distance, attraction and repulsion . . . the very kinds of contradictions that constitute the s/m dynamic as Freud theorizes it. Thus, the s/m dynamic sets up the impossible place of being simultaneously inside and outside, close and distant, a dynamic that is always, already at a distance through the objectification of the self and the other" (Therese Lichtenstein, "Hans Bellmer's Dolls: Images of Pleasure, Pain, and Perversion," *Sulfur* 26 [spring 1990]: 60). Lichtenstein concludes that Bellmer's doll imagery represents the artist's desire for boundaries through a representation of their annihilation. In the end, he establishes an "alienation of [the] alienation" that was so sharply felt in Germany during the 1930s, when he was working (63). See also Therese Lichtenstein, "Behind Closed Doors: Hans Bellmer," *Artforum,* March 1991, 118–22; and *Behind Closed Doors: Hans Bellmer's Dolls in the Context of Nazi Germany* (Berkeley and Los Angeles: University of California Press, forthcoming).

67. This is not to say that the place of photography in performance art history has been overlooked but, rather, that the special relationship between performer and viewer—a relationship that I am arguing is contractlike and is based on the photographic document—has been elided. For provocative theorizations of performance photography, see Jones, "Dis/Playing the Phallus," especially her compelling comparison of performance photographs and "self-performative advertisements from the late 1960s and early 1970s," 549ff. See also Robert C. Morgan, "Half-Truth: Performance and the Photograph," in *Action/Performance and the Photograph,* ed. Craig Krull (Los Angeles: Turner/Krull Galleries, 1993), n.p.; Peggy Phelan, *Unmarked: The Politics of Performance* (London and New York: Routledge, 1993), especially 34–70; John Pultz, *The Body and the Lens: Photography 1839 to the Present* (New York: Abrams, 1995), especially the chapter titled "1960– 1975: The Body, Photography, and Art in the Era of Vietnam," 113–41; Sayre, *Object of Performance,* especially the chapter titled "The Rhetoric of the Pose: Photography and the Portrait as Performance," 35–65; Stiles, "Performance and Its Objects," especially her critique of Sayre's theories of photography, 35–39; Stiles,

"Synopsis," 26–27; and the important early essay by Lynn Zelevansky, "Is There Life after Performance?" *Flash Art,* December 1981–January 1982, 38–42. A more recent, extremely rich contribution to this bibliography is Jennifer Blessing, *Rrose is a Rose is a Rrose: Gender Performance in Photography* (New York: Guggenheim Museum, 1997). Especially relevant to my topic is Nancy Spector, "Performing the Body in the 1970s," in Blessing, ibid., 156–75.

68. Video documentation has been important to performance art's history since the late 1960s, but it still plays a secondary role to that of the photograph. The reasons are obvious. Photographs lend themselves more easily to distribution, principally in journals, magazines, catalogs, and books. Purchase or rental of videos is costly, leaving this form of representation available mostly to scholars visiting archives and distribution houses that allow on-site screenings, visitors to special (and rare) performance video exhibitions, academics who acquire videotapes for university and college collections, the students of those academics, or funders who screen tapes for decision-making purposes.

69. Thanks to Liz Kotz for conversations on the properties and experience of performance photography.

70. I am using the term "haptic" rather than "tactile" because I believe it makes greater etymological sense in relation to the history of technology, especially the camera. Although both words mean virtually the same thing (having to do with the sense of touch), the earliest recorded use of "haptic" is 1890 and "tactile," 1615 (*Merriam-Webster's Collegiate Dictionary,* 10th ed.). The former term, then, started to be used as the Industrial Revolution was peaking, the use of the camera was becoming more commonplace, and perceptual experiences of the world were being changed dramatically by modern technologies. I believe it is possible that these changes required the adoption of a new term to define the viewer's interaction with inventions such as the photograph. Given the largely intimate use of photography at the time (to record infant death, for example) and related framing practices (the production of small frames that could be held), the viewer's interaction involved not only sight but also touch. I believe this fact has been overlooked in recent scholarship on perceptual changes in modernity, rendering this scholarship ocularcentric. For more on this topic, see my essay "Displacing the Haptic: Performance Art, the Photographic Document, and the 1970s," *Performance Research* (London) 2, no. 1 (spring 1997): 73–81.

71. I am indebted to Kristine Stiles for first stimulating me to consider issues of complicity in performance art in the 1979 seminar she taught on the history of performance art at the University of California at Berkeley (see the preface of this book). See also Amelia Jones's insightful discussion of complicity as "interpretive exchange," a collaboration between the viewer and the documented performer that points to the "performative aspect of interpretation itself." Jones, "Dis/Playing the Phallus," 549ff.

72. The difference between the type of photograph I am discussing and an art photograph by, say, Alfred Stieglitz, Lee Friedlander, or Barbara Kruger rests on issues of context and the relationship of referent to supplement. For Stieglitz, Friedlander, or Kruger, the photograph is an artistic object for which the referential subject matter is supplemental. The designation of "artistic object" comes from the art world context in which the photograph has currency. This context solicits viewer interaction with the artistic object first and foremost, making it difficult to wrench the referent away from a supplemental position. The only way these priorities can be meddled with is through the introduction of text, in particular if the text's purpose is to problematize the imagery by, for example, providing linguistic tropes that engage the viewer in a more personal context (as in Kruger's mobilization of the linguistic shifter to pull viewers into a dialogue with her photomontages).

In performance photography, things are reversed. It is the photograph that functions as supplement to the performance-referent. The performance, having been presented in an art world context, is what bears the designation of artistic "object." Originally, an audience was asked to participate on physical and psychic levels with that "object." The performance photograph, though supplemental, solicits a far stronger bond to that which it represents than does a photograph by Stieglitz, Friedlander, or Kruger, for which audience participation in the represented scene is not necessarily an issue. Understanding the supplemental nature of the performance photograph is crucial. No matter how "primary" the status of the "original" performance might seem, there is no access without the mediating material of the photograph. Moreover, no matter how much

that photograph solicits acts of touching on the part of the viewer, the materiality of that mediating device is never lost. Thus, any question of the photograph being essentialized is moot. The sense of touch is not the basis of essentializing processes unless the scenarios in which it is mobilized are decontextualized. Performance art takes place in a profoundly nonessentialized context and is always reliant, epistemologically, on forms of mediation.

Thanks to Amelia Jones for challenging me on the haptic aspects of my argument and for establishing the work of the three photographer-artists mentioned as points of comparison and contrast. Her comments helped me clarify my views. See Jones, "Dis/Playing the Phallus," 580 n. 14. See also my essay "Displacing the Haptic."

73. Roland Barthes, "Rhetoric of the Image" (1964), in *Image/Music/Text,* trans. Stephen Heath (New York: Hill & Wang, 1977), 44. Barthes's essay is a common reference point in writings on performance art and its documentation. See especially Sayre, *Object of Performance,* 253–64.

74. Barthes, "Rhetoric of the Image," 45.

75. Indeed, this privileging dissolves the rich indeterminacy hinted at in Barthes's essay. This indeterminacy is akin to that inherent in the simultaneous experience of one's subjecthood and objecthood in performance art. Barthes's preliminary conclusion that space and time form an "illogical conjunction" on photography's denotative level of meaning hints at the possibility of the photograph's eliciting a conceptual balancing act, prompting viewers to attend to both the spatial and the temporal aspects of photography. Such different concerns, indeed, operate indeterminately; each threatens to cancel the other but defies that threat by insisting on simultaneous attention.

76. Barthes, "Rhetoric of the Image," 44.

77. Ibid. Barthes seems to allude here to vulnerability, an issue often discussed by writers on performance. See Stiles, "Destruction in Art Symposium," "Synopsis," and "Survival Ethos"; and Jones, "Dis/Playing the Phallus," 564, where she initiates the question whether male masochistic performance artists project and preserve the body's inviolability or undermine it, thus displaying its nonstereotypically "male" vulnerability.

78. Barthes, "Rhetoric of the Image," 44–45.

79. Didier Anzieu, *The Skin Ego: A Psychoanalytic Approach to the Self,* trans. Chris Turner (New Haven: Yale University Press, 1989), 62.

80. My claims to a strain of "universalism" are grounded in the history of modernity. As film theorist E. Ann Kaplan has pointed out, it was in the latter part of the nineteenth century that the burgeoning of industrialism and capitalism prompted enormous changes in social relations and, consequently, in family structures. These historical events, she argues, prompted not only traumas within the home—namely, oedipal traumas, which in turn led to their representation as oedipal themes in literature (and ultimately in film, photography, and art in general)—but also the need for a therapeutic system such as psychoanalysis with which to deal with such traumas. One of the strategies of this system, of course, is to observe stages of psychic development. By relying on historical terms as Kaplan has outlined them, it is possible to say that these stages are experienced universally by all those who live in a culture undergoing the same historical events broadly defined as "industrialization" and "capitalism," although attention must be paid to more specific conditions as well. This also justifies the use of psychoanalytic methodologies in the analysis of cultural production of the modern era as a whole. See E. Ann Kaplan, *Women and Film: Both Sides of the Camera* (New York: Methuen, 1983), 24.

2. HIS MOUTH/HER SKIN

1. Vito Acconci, "Trademarks," *Avalanche* 6 (fall 1972): 10–11.

2. When asked whether he thought of performances such as this as masochistic, Acconci said: "I wanted

to de-emphasize [masochism] because it felt like if I were to emphasize it, I was becoming this kind of Christ figure; I was being this sacrificial . . . van Gogh kind of figure, and I hated that about art. I wanted to de-emphasize that kind of masochism . . . at least in terms of *thinking* about it. But the fact is, it was there. . . . I'm not sure how much I was thinking about this then, but in retrospect what interests me in the masochism of a lot of pieces was [the question whether it was about] trying to get rid of a notion of self, or 'I.' I mean, was it . . . almost like an early version of a deconstructive urge? . . . If that's true, maybe there was something in that. But was it trying to do that? I don't know" (Vito Acconci, interview with the author, Brooklyn, N.Y., February 1989).

For an engaging discussion of Acconci's performances that emphasizes the function of vision but also problematizes it, see Christine Poggi, "Following Acconci or Beholding as Transgressive Performance" (paper presented at the annual meeting of the College Art Association, New York, N.Y., February 1997).

3. Sigmund Freud, "Instincts and Their Vicissitudes" (1915), in *The Standard Edition of the Complete Works of Sigmund Freud,* vol. 14, trans. James Strachey (London: Hogarth, 1957), 127.

4. Acconci, "Trademarks," 11.

5. Freud, "Instincts," 127. For further discussion of the role this interstitial moment plays, see Hal Foster, "Convulsive Identity," *October* 57 (summer 1991): 40–42. Foster's psychoanalytic approach to Max Ernst's collages is of interest to my study, because Foster recognizes the way in which linguistic, visual, and haptic elements can interact in an artwork in a clearly masochistic way. Moreover, his approach contributes to an understanding of how masochism-based works of art can serve as instructive metaphors. But he also rightly warns that the operation of metaphor, though issuing from the unconscious, should not be seen as exposing the "intentional referents or literal origins of . . . art." Rather, the metaphoric substance should be examined for the ways in which it expands an understanding of the art's *structure* as a "working over that is never purely involuntary and symptomatic *or* controlled and curative" (52). See also his discussion of metaphor in contrast to metonymy as operative elements in surrealist imagery and objects, respectively (52). For a reworking of this essay, see Foster, *Compulsive Beauty* (Cambridge: MIT Press, 1993), 87–98.

6. A provocative connection could be made here between the self-bitten body and processes of self-consumption, especially eating disorders, and their place within the psychodynamics of masochism. For two different approaches to one aspect of this disorder, anorexia, see Susie Orbach, *Hunger Strike* (New York: Norton, 1986); and Rudolph M. Bell, *Holy Anorexia* (Chicago: University of Chicago Press, 1985). Orbach argues that the impulse to starve is driven by social and cultural pressures of a given historical period. Bell, although not denying this claim, establishes a history of willed starvation stretching back to the medieval period, thereby somewhat universalizing the disease. Neither author expands the discussion beyond anorexia to bulimia or compulsive overeating. Nor do they approach their topic through a discourse on masochism, which, if one were careful to consider the legalistic construct of contract in such an analysis, could enrich the discourse tremendously, casting light on the unspoken agreements between individuals suffering from eating disorders and others in their environment.

7. Freud, "Instincts," 128.

8. Acconci, "Trademarks," 11.

9. Didier Anzieu, *The Skin Ego: A Psychoanalytic Approach to the Self,* trans. Chris Turner (New Haven: Yale University Press, 1989), 55.

10. Interestingly, Acconci does not deliver his viewers fully into the negotiatory stages of contract that I am suggesting correspond to the mirror stage. His focus is on what is called, in legal terminology, the contractual offer. He offers up the terms by which one comes to understand the body: as an object and a subject, and more specifically, as an object that is subject to being possessed by others or by oneself. He simply marks these aspects of identity for trade, establishing at least the possibility of negotiating their meanings.

11. Anzieu, *Skin Ego,* 40.

12. Ibid. Note that Anzieu specifies at one point that the skin ego is a "product of . . . metaphoro-metonymic oscillation" and cites fellow psychoanalyst Guy Rosolato's work on this dual process (*La relation*

d'inconnu [Paris: Gallimard, 1978]). Anzieu's concerns are ultimately more circumscribed by the function of metaphor, however. He announces that his mission is "to convince the reader that this metaphor [of the skin ego] can generate a coherent set of operational concepts, susceptible of factual verification or theoretical refutation" (*Skin Ego,* 6).

13. For a rich discussion of anaclisis, see Elizabeth Grosz, *Jacques Lacan: A Feminist Introduction* (London and New York: Routledge, 1990), especially "Anaclisis, Narcissism, and Romantic Love," 126–31.

14. I am extrapolating here from Anzieu's rationale for using the term "mothering" as opposed to "maternal": "I prefer 'mothering' to maternal, . . . so as not to limit the environment to the biological mother." *Skin Ego,* 55.

15. Ibid., 40. If there is criticism to be launched against Anzieu's theory, it is that he focuses too intensely on the attachment drive. His own attachment to his theory of attachment has led to at least one error of fact. As an example of the extremes to which an individual might go "to maintain the boundaries of the body and the Ego and to re-establish a sense of being intact and self-cohesive," he cites Viennese Actionism artist Rudolf Schwarzkogler, who, Anzieu writes, "perceived his own body as the object of his art, amputated his own skin, inch by inch, until finally he killed himself. He was photographed throughout the process, and the photographs exhibited at Kassel in Germany" (20).

Kristine Stiles has definitively set the record straight on the myth that Schwarzkogler amputated his own penis and died as a result—a myth, as she points out, first promoted by Robert Hughes in *Time* magazine in 1972. Photographs suggesting self-castration were constructed by Schwarzkogler, using Heinz Chibulka as a model, in the 1960s. Schwarzkogler died in 1969 of still-undetermined causes, none of which included self-amputation, according to Stiles, who conducted in-depth interviews with Schwarzkogler's lover and other friends and colleagues, who speculate that his death may have resulted from "falling, jumping, or attempting to fly from his apartment window in Vienna in a state of extreme agitation and hallucination." See Stiles, "Performance and Its Objects," *Arts Magazine,* November 1990, 35. Stiles's essay is a book review of Henry M. Sayre's *The Object of Performance: The American Avant-Garde since 1970* (Chicago: University of Chicago Press, 1989). Stiles criticizes Sayre for perpetuating the Hughes myth and, moreover, using it to support his own argument (see Sayre, 2ff.) regarding the function of photography in performance—an argument seriously shaken by Stiles's factual insights.

16. Anzieu, *Skin Ego,* 41.

17. Ibid., 63. If anxieties in this intrauterine phase are resolved, however, this stage is constructively recalled in later moments of adult affection, as when lovers embrace and thereby replay the phenomenon of mutual inclusion, according to Anzieu.

18. Ibid.

19. Vito Acconci, *pulse (for my mother) (pour sa mère)* (Paris: Multiplicata, 1973), n.p.

20. Anzieu, *Skin Ego,* 63.

21. Ibid.

22. Ibid., 40.

23. Ibid., 112.

24. Ibid., 111–12. "The pack" technique was first developed, according to Anzieu, by French psychiatrists in the nineteenth century; it was revived in France in the 1960s by way of an American who was responsible for adding to the treatment the practice of institutional attendants surrounding the wrapped body, thereby providing what Anzieu calls a "social prop."

25. I am stressing this point so that it does not appear that I am perpetuating the common psychoanalytic myth of "mother blame." I concur with Anzieu that mothering is not limited to the biological female; hence, malfunctions experienced in one's life are not necessarily traceable to one's biological mother, nor even to the mothering environment, but can just as easily be traced to the institutions modeled on the same kind of *hierarchy* as that environment.

26. The fact that extreme masochistic acts, especially those involving self-mutilation, tend to be isolated

ventures on the part of the masochist contributes to the paucity of information on the topic. One of the more useful texts addressing the issue of secrecy is Barent W. Walsh and Paul M. Rosen, *Self-Mutilation: Theory, Research, and Treatment* (New York: Guilford, 1988). In this study, the authors point out that although the self-mutilator in a family situation (the authors' research area) might carry out his or her action in secret, "there is [often] ambivalence. He or she hopes that the family will come to the emotional rescue" (207). But there are many other instances in which that hope is so minimal that the masochist may stay isolated for years.

A strong contribution toward bringing masochism out of the closet is Teresa Opheim's "Self-Mutilation: Pain to Forget Pain," *Utne Reader,* March–April 1987, 21. However, Opheim claims that self-mutilation is primarily a woman's disease, basing her argument on already published material, such as a letter that appeared in *Lesbian Connection* (September–October 1986). In the full version of that letter (which, as it turns out, was anonymously written), the writer argues that much of the isolation related to the practice is implicitly encouraged by the medical profession. In many mutilators' minds, the world of medicine is the only place to which to turn, but because of its domination by male practitioners, it ends up being no place to turn to at all. Although the sociological aspect of Opheim's explanation is plausible, the premise that extreme masochistic practice is almost exclusively a *woman's* practice is debatable. A high-profile case of male masochism is that of "Mr. H." who, in private, literally cut off his own face with (significantly enough) shards of mirror. Amazingly, he recovered, at least on a physical level; on an emotional level, however, there was far from full recovery. Despite in-depth lab reports to the contrary, Mr. H. persisted in his claim that "his dog did it." See Susan Scheftel et al., "A Case of Radical Facial Self-Mutilation: An Unprecedented Event and Its Impact," *Bulletin of the Menninger Clinic* 50 (November 1986): 525–40.

The numerous bibliographic references cited by Walsh and Rosen (257–63) and Scheftel et al. (539–40) are extremely helpful and remind the reader that there is a vast body of academic work on this topic, especially that inspired by Karl Menninger starting in the 1930s. Only recently has more accessible literature been published, however. Armando R. Favazza's *Bodies under Siege: Self-mutilation and Body Modification in Culture and Psychiatry,* 2d ed. (Baltimore: Johns Hopkins University Press, 1996), and Louise J. Kaplan's chapter titled "Mutilations," in *Female Perversions* (New York: Anchor, 1991), 362–407, are especially notable.

If they accomplished nothing else, the performances discussed in this book blew off the lid of secrecy sealed tight on these practices as of just a few decades ago. The works' relative repression in art history, however, illustrates common reactions of denial on the part of observers of extreme masochism. Scheftel et al. examine the impact of masochists on others in "Staff Members' Reactions to [Mr. H.'s] Self-Mutilation," a segment of their case study. Common reactions included distortion (for example, insisting that the patient was drugged at the time of the laceration, despite proof that this was not the case), avoidance (some staff members asked not to work with Mr. H., and some discouraged him from ambulating so that they would not have to look at him), and morbid curiosity (537–39). These seem to be common reactions to masochistic performance as well.

(As this book went to press, an important report about the rise in treatment-seeking on the part of adolescent self-mutilators appeared in the *New York Times Magazine* [Jennifer Egan, "The Thin Red Line," *New York Times Magazine,* 27 July 1997, 20–25ff.]. Although it is not possible for me to respond fully to this article at this time, I would like to commend the author. In a sensitive, nonsensationalist manner, Egan writes about the prevalence of secrecy among self-mutilators and examines similarities as well as contrasts between adolescent self-mutilators and those who practice self-mutilation in various subcultures in the United States, in other cultures internationally, and in the art world. She briefly addresses [40] the controversial work of Ron Athey, an artist I will discuss in the conclusion of this book. Only here does one wish that Egan had gone into more depth regarding the differences between masochistic performance artists who mutilate themselves in a public, art world context and people who engage in self-mutilation in private. In the former situation, masochism's metaphoric function is more of a "given" [art being virtually synonymous with metaphor], making it more possible [one hopes] for the observer to discover connections to the social circumstances represented by the artists' metaphors and to consider ways of changing those circumstances. Although this

hope also exists in the latter, private situation, secrecy makes the discovery of troubled social circumstances and the pursuit of change far more difficult.)

27. Sigmund Freud, "Beyond the Pleasure Principle" (1920), in *A General Selection from the Works of Sigmund Freud,* ed. John Rickman (1937; reprint, Garden City, N.Y.: Doubleday, 1957), 141–68. For an excellent chronology of the development of Freud's thinking on primary masochism, especially the detection of 1920 as the turning point in this development, see Jean Laplanche, *Life and Death in Psychoanalysis,* trans. Jeffrey Mehlman (Baltimore: Johns Hopkins University Press, 1976), 88–89.

28. Chris Burden, "Velvet Water," in *Chris Burden 74–77* (Los Angeles: Chris Burden, 1978), n.p.

29. It is not entirely clear what constituted the "wall" separating Burden from the audience. In his documentation of *Velvet Water,* which he wrote and published four years after the performance, he refers to a "wall of lockers" (ibid.). More recently, however, he has claimed that "there was no partition between myself and the audience. The audience could see me, but what prevented the audience from seeing me clearly was that there were many lights and equipment around me and the audience was seated facing the front of the room and I was off to one side of the room" (Chris Burden, letter to the author, December 1996). Because the former documentation is more contemporaneous with the actual performance, and short-term memory is typically more reliable than long-term, I have used "wall of lockers" in my text.

30. Burden, "Velvet Water," n.p.

31. Dorothy Seiberling, "The Art-Martyr," *New York,* 24 May 1976, 58.

32. Karl Menninger, quoted in ibid.

33. The possibility of negotiating a fuller understanding of how these aspects of identity can be held in balance—a negotiation linked to the mirror stage—is metaphorically hinted at in *Velvet Water* through the use of the mirrorlike video monitor. Realization of this possibility is forestalled, however, by the skinlike wall.

34. This discussion of Pane's *Discours mou et mat* amplifies points made in my essay "Displacing the Haptic: Performance Art, the Photographic Document, and the 1970s," *Performance Research* (London) 2, no. 1 (spring 1997): 73–81. There I concentrated on the mirror as a focal point in this performance.

35. My description of *Discours mou et mat* is based on my viewing of a video document in the archives of de Appel, Amsterdam. A transcription of the audiotaped text is also in the archives. (Note: Although Pane always called her performances "actions," for consistency I use the term "performances" throughout this book.)

36. Ezio Quarantelli and Gina Pane, "Travels with St. Francis," *Contemporanea,* November–December 1988, 46.

37. Gina Pane, paraphrased in Antje von Graevenitz, "Then and Now: Performance Art in Holland," *Studio International,* July–August 1976, 52.

38. Esther Ferrer and Gina Pane, "The Geography of the Body," *Lapiz,* April 1989, 38, 40. Pane also addresses the relationship between photography and performance in her essay "The Body and Its Support-Image for Non-Linguistic Communication," *arTitudes,* February–March 1973, 10. For what may be a better English translation of this essay, see Gina Pane, "Program Notes," in *Il corpo come linguaggio (La "Body-art" e storie simili),* ed. Lea Vergine, trans. Henry Martin (Milan: Giampaolo Prearo Editore, 1974), n.p.

3. MY MIRROR

1. *Talking about Similarity* was held at Singel 64, an alternative art space in Amsterdam. Ulay recalls that the audience asked questions such as, "When did you decide to sew your mouth?" and "Did it cause you pain?" Marina avoided the latter question (a question Ulay viewed as "pathetic") by responding with, "Can you repeat the question?" This exchange took place three or four times, Ulay remembers, "until the questioner gave up any expectation of getting an answer" (Ulay, letter to the author, November 1996). For docu-

mentation of *Talking about Similarity,* see Marina Abramović/Ulay, Ulay/Marina Abramović, *Relation Work and Detour* (Amsterdam: Ulay/Marina Abramović, 1980), 26–33.

2. See Jacqueline Rose, "Introduction-II," in Jacques Lacan, *Feminine Sexuality,* ed. Juliet Mitchell and Jacqueline Rose, trans. Jacqueline Rose (New York: Norton, 1985). Rose argues that Lacan did not wish his observations to be "restricted to the field of the visible alone: 'the idea of the mirror should be understood as an object which reflects—not just the visible, but also what is heard, touched and willed by the child'" (30). (The original Lacan quotation is from "Cure psychanalytique à l'aide de la poupée fleur," *Revue française de la psychanalyse* 4 [October–December 1949]: 567. Note that this text was written in the same year that Lacan presented his essay "The Mirror Stage as Formative of the Function of the I as Revealed in Psychoanalytic Experience" [1949], in *Écrits: A Selection,* trans. Alan Sheridan [New York: Norton, 1977], 1–7.) In the whole context of Lacan's theory, the quoted passage seems to be a rare de-emphasis of vision; hence, I am choosing to characterize his theory in my own text as vision-privileging.

In his *Life and Death in Psychoanalysis,* Jean Laplanche clarifies Lacan's de-emphasis of the mirror: "Lacan's intention is certainly not to link in any necessary way the appearance of the human ego to the creation of the instrument of a mirror, nor even, for example, to the fact that like Narcissus, the infant can see his reflection on the surface of a body of water" (Jean Laplanche, *Life and Death in Psychoanalysis,* trans. Jeffrey Mehlman [Baltimore: Johns Hopkins University Press, 1976], 81). This is an extremely useful caveat to researchers who are considering objects of representation, for it is important to resist being reductive when discussing art and psychoanalysis, to beware of limiting discussion to works of art involving (in this case) actual mirrors or the like. But just as Laplanche himself places a condition on his caveat when he says that "Lacan's intention is certainly not to link in any *necessary* way" the ego and the material object, so is it reasonable to assume that the material object of the mirror *may* sometimes be utilized in the investigation of the structural aspects of the stage of psychic development inspired by it. Laplanche also provides an implicit link to Anzieu's theory via Freud (indeed, Freud functions as a large part of Anzieu's foundational theory) in this same section of his text, as he goes on to say that "It would be imprecise . . . to say that Freud had not himself focused on the situation of specular identification. For it is present not only in 'Mourning and Melancholia' but above all in an extremely dense passage in *The Ego and the Id,* in which it is specified that 'the ego is first and foremost a body-ego; it is not merely a surface entity, but it is itself the projections of a surface'" (81). These projections, as Laplanche points out, involve visual as well as tactile perceptions based on a reflexive epistemological practice of getting to know the self by touching the self. For Anzieu's acknowledgment of Freud's influence in the development of his own theory of the skin ego, see his chapter "Two Precursors of the Skin Ego: Freud and Federn," in Didier Anzieu, *The Skin Ego: A Psychoanalytic Approach to the Self,* trans. Chris Turner (New Haven: Yale University Press, 1989), 71–95.

3. Lacan, "Mirror Stage," 4.

4. This notion of interchangeability was central to Ulay and Abramović's relationship from the time they met in 1975 until the termination of their work together in 1988. When they met, they were struck by the fact not only that their birthdays were the same (November 30) but also that they both wore their hair in an identical style (pulled up in back and held in place with chopsticks). It was the possible interchangeability of their identities that motivated their "Relation Works" documented in Abramović/Ulay, *Relation Work and Detour.* For an account of their meeting, see pp. 5–17.

5. Sources are too numerous to list. Extremely useful as well as demonstrative of three different decades of feminist thinking on woman as a viewed object are Linda Nochlin, "Why Have There Been No Great Women Artists?" (1971), in *Women, Art, and Power and Other Essays* (New York: Harper & Row, 1988), 145–78; Griselda Pollock, *Vision and Difference: Femininity, Feminism, and the Histories of Art* (London and New York: Routledge, 1988); and various essays in M. Catherine de Zegher, ed., *Inside the Visible: An Elliptical Traverse of Twentieth Century Art in, of, and from the Feminine* (Cambridge: MIT Press, 1996), especially Bracha Lichtenberg Ettinger's "The With-in-Visible Screen" (88–113, including the excellent introduction to Ettinger's essay by Griselda Pollock, 89–92). Ettinger problematizes the gaze, heretofore freighted, in her

view, with patriarchal notions of the symbolic that exclude types of experience outside the phallic order, by positing what she refers to as the "matrixial gaze." Ettinger explains her highly complex theory by comparing the matrixial gaze to "the phallic gaze [which] excites us while threatening to annihilate us." In contrast, "the matrixial gaze thrills us while fragmenting, scattering, . . . and turning us into participatory witnesses" (109). For an understanding of the underlying concept of the matrix, see Pollock's introduction to Ettinger, 89. For another recent challenge to traditional notions of the male gaze, see Mieke Bal, "His Master's Eye," in *Modernity and the Hegemony of Vision,* ed. David Michael Levin (Berkeley and Los Angeles: University of California Press, 1993), 379–404. Most relevant to performance is Rebecca Schneider, *The Explicit Body in Performance* (London and New York: Routledge, 1997), especially the chapter titled "Permission to See," 66–87, in which the author asks questions similar to the ones I am about to pose.

6. Carol Duncan addresses this point in "Virility and Domination in Early Twentieth-Century Painting," *Artforum,* December 1973, 30–39.

7. Each of the seven photographs documenting *Talking about Similarity* (figs. 7–12) takes up a full page in Abramović/Ulay, *Relation Work and Detour* (27–33). In none of the photographs do the artists appear together. In the last two-page layout (fig. 12), a photograph of Ulay is on the left-hand page and one of Abramović is on the right. Abramović appears to be gazing at Ulay, her head turned in his direction. But even here they are separated—by the edges of the photographs and the gutter of the book. Clearly, this photographic distantiation was self-conscious and plays into the meaning of the piece.

8. Thanks to Maud Lavin for discussion of these points.

9. Not all theorists would approve of my broadening of the application of the term "masochism" to include such activities as self-deprecation. Perhaps my most avid opponent would be Paula J. Caplan (*The Myth of Women's Masochism* [1985; reprint, with an afterword, New York: Signet, 1987]). Caplan resists efforts like my own because she feels they impact women in clinical settings, which in turn affects their position in everyday life. Caplan led the fight to get the *DSM-III (Diagnostic and Statistical Manual of Mental Disorders,* 3d ed. [Washington, D.C.: American Psychiatric Association, 1980]) classification for masochism narrowed. She felt that other labels should be sought to describe disorders in women that might be construed as involving self-induced discomfort. The works I am addressing, however, are clearly masochistic and spring from a social context that is itself riddled with institutionalized masochism. In opposition to Caplan's thesis, I feel the term "masochism" should be a household word, especially because it begins at home.

10. For discussion of Lacan's notion of the construction of language, see Rose, "Introduction-II," 31.

11. My narrative of the oedipal scenario is a collage of various theorists' interpretations. By far the most useful is the cross-referencing of Freudian and Lacanian versions of the story in Deborah Bershad, "Icon as Index: Middle Byzantine Art and Architecture," *Semiotica* 43, nos. 3–4 (1983): 275–320. For a more concise synopsis, see E. Ann Kaplan, *Women and Film: Both Sides of the Camera* (New York: Methuen, 1983), 19–20. For commentary directly connected to Lacan's theory, see Jacqueline Rose's and Juliet Mitchell's introductions to Lacan's *Feminine Sexuality,* 1–57.

12. Gilles Deleuze makes a similar analogy in *Masochism: An Interpretation of Coldness and Cruelty,* trans. Jean McNeil (New York: Braziller, 1971), 83.

13. Lacan, "Mirror Stage," 3.

14. For Lacan's reference to "functional fragmentation," see "Intervention of Transference," in *Feminine Sexuality,* 67. "Split self" has become a much-used term (though never by Lacan himself), a simplified and anglicized phrase for the product of the complicated process of *méconnaissance* (Lacan's term) experienced by the child before the mirror. For discussion of *méconnaissance,* see Lacan, "Mirror Stage," 6.

15. Jacques Lacan, "The Meaning of the Phallus" (1958), in *Feminine Sexuality,* 79.

16. For two other theorists' views of the initial moments of masochism, see Kaja Silverman, "Masochism and Male Subjectivity," *Camera Obscura* 17 (May 1988): 31–68, in which she situates the development of masochism in the oedipal scenario. See also her elaboration on this point in *Male Subjectivity at the Margins* (London and New York: Routledge, 1992). For contrast, see Gaylyn Studlar, *In the Realm of Pleasure: Von*

Sternberg, Dietrich, and the Masochistic Aesthetic (Urbana: University of Illinois Press, 1988), in which Studlar argues that masochism begins in the oral stage. My argument focuses on what I see as a gap between Silverman's and Studlar's readings of masochism's origins—that is, a gap between the late oral and early mirror stages. In addition, I hope to clarify how *all* stages of psychic development are implicated in masochistic processes, by investigating not only the initiation of masochism but also the way it gets maintained.

17. Lacan referred to this healing quality as "orthopaedic" in the continuation of his earlier description of the mirror stage. He claims that the mirror stage is a drama leading "from a fragmented body-image to a form of its totality that I shall call orthopaedic—and, lastly, to the assumption of the armour of an alienating identity, which will mark with its rigid structure the subject's entire mental development." Lacan, "Mirror Stage," 4.

18. Kristine Stiles has answered this, in part, in her study of what she calls "destruction art" (see my discussion of her terminology in chapter 1, n. 34). She asserts that "the performative practices . . . associate[d] with destruction art recapitulate the technological conditions, effects, processes, and epistemologies of terminal culture. . . . Destruction art is about open wounds—those caused by the institutions and practices that develop and deploy the weapons of destruction" (Kristine Stiles, "Survival Ethos and Destruction Art," *Discourse* 14, no. 2 [spring 1992]: 76–77). She would not agree with me, however, that such recapitulations (in the form of masochistic performances, for example) are utopian (77).

19. Vito Acconci, "See Through," *Avalanche* 6 (fall 1972): 15.

20. Ibid.

21. Bryan S. Turner, *The Body and Society* (New York: Blackwell, 1984), 7.

22. Ibid., 7–8.

23. For other Lacanian analyses of Acconci's performance work, see Kate Linker, *Vito Acconci* (New York: Rizzoli, 1994), 52–53, 56, 60; and Stephen Melville, "How Should Acconci Count for Us? Notes on a Retrospect," *October* 18 (fall 1981): 79–89.

24. Acconci, "See Through," 15.

25. Ibid.

26. Vito Acconci, interviews with the author, Brooklyn, N.Y., February 1989 and December 1996.

27. Abramović/Ulay, *Relation Work and Detour,* 96–101.

28. Ibid., 96.

29. Ulay has said that in fact the audience functioned for him as a "great energy reflector." Ulay, letter to the author, November 1996.

30. Ulay played with gender construction in an earlier solo work called *Renais Sense* (1973), which consisted of a narrativistic series of auto-Polaroids in which he cast himself in various cross-dressing scenarios. Poster-documents of the work, produced as part of *Instant Issues* (Amsterdam: Seriaal, 1973), are in the de Appel archives, Amsterdam.

31. Helena Kontová. "Marina Abramović/Ulay," *Flash Art,* February–April 1978, 43.

4. THEIR BEDS

1. Effie Stephano and Gina Pane, "Performance of Concern," *Art and Artists,* April 1973, 24. My description of this performance, *Autoportrait(s),* is based on Pane's own account (ibid., 24–26) and on François Pluchart, "Gina Pane's Performances," *arTitudes,* February–March 1973, 15.

2. Didier Anzieu, *The Skin Ego: A Psychoanalytic Approach to the Self,* trans. Chris Turner (New Haven: Yale University Press, 1989), 62.

3. Peter Gabel and Jay M. Feinman, "Contract Law as Ideology," in *The Politics of Law: A Progressive Critique,* ed. David Kairys (New York: Pantheon, 1982), 177.

4. Frank Norris, *McTeague* (1899; New York: New American Library, 1964).

5. Walter Benn Michaels, "The Phenomenology of Contract," in *The Gold Standard and the Logic of Naturalism* (Berkeley and Los Angeles: University of California Press, 1987), 123.

6. Norris, *McTeague,* 276–77.

7. Gilles Deleuze, *Masochism: An Interpretation of Coldness and Cruelty,* trans. Jean McNeil (New York: Braziller, 1971), 88–89.

8. Some feminists would disagree with this view. See, for example, Bracha Lichtenberg Ettinger's "The With-in-Visible Screen," in M. Catherine de Zegher, ed., *Inside the Visible: An Elliptical Traverse of Twentieth Century Art in, of, and from the Feminine* (Cambridge: MIT Press, 1996), 88–113. In Griselda Pollock's introduction to Ettinger's essay (89–92), Pollock synopsizes debates by feminists who believe that phallus-focused theories of the unconscious can exclude or even preclude "a lot of phantasy and traces of archaic sensations and impressions" (90). Ettinger, Pollock explains, "situates her interests not in the pre-Oedipal as presymbolic domain, but in what she calls the subsymbolic—a stratum of subjectivity not at all orchestrated in relation to the phallus, though it exists side by side with the phallic stratum. The subsymbolic that interweaves into the Symbolic network carries pre-Oedipal as well as prenatal inscriptions" (91).

9. Stephano and Pane, "Performance of Concern," 24.

10. Ibid., 26.

11. Ibid. For more discussion of *Posthumous Work,* see Pluchart, "Gina Pane's Performances," 15.

12. I am uncertain about the status of this piece since Pane's death in 1990.

13. Pane thought it possible to do work that would qualify as transformative: "If the artist has a social conscience he feels his responsibility in the society in which he lives. I believe he can become a catalyst of social and moral change because he has complete liberty of expression" (Stephano and Pane, "Performance of Concern," 24). One critic felt that Pane accomplished this goal, at least in *Autoportrait(s)*: "Pane undertook a risk at the Stadler gallery that no artist had yet dared to take. In her suffering, she risked a definition of herself: from her artistic *transformation* to her principle of action upon society . . . she gave her definition of art history by making a peremptory place for herself, and she proved, by the state of tension that she was able to attain, that her art acted directly and immediately on everyone" (Pluchart, "Gina Pane's Performances," 15).

14. For an excellent discussion of the political scenario in France in this period, see Keith Reader, *Intellectuals and the Left in France since 1968* (New York: St. Martin's, 1987), chapter 2.

15. Stiles theorizes this sort of activity as "bearing witness" in her essay "Survival Ethos and Destruction Art," *Discourse* 14, no. 2 (spring 1992): 74–102. See especially her discussion of women's performances under the rubric of destruction art (87–90). She argues that the artists demonstrate an urgent need "to communicate [an] auto-constructed reality *to someone else*—to materialize it. Western culture needs subjects to bear witness to the contents of survival and the historical bodies upon which the text of destruction has been inscribed. The body in destruction art bears such witness and thereby offers a paradigm for a 'resisting body,' that private, complex, signifying system of the self, a person who acts both on behalf of the individual and the social body" (90). Although Stiles mentions Pane only in passing (88), it can be assumed that this quotation applies to her work. Certainly it applies to *Autoportrait(s),* from the very title of the performance (a self-portrait is, after all, an "auto-constructed reality") to Pane's drive to communicate, to her desire to act on behalf of others, to what I argue are the contractual underpinnings of the piece—to which, in effect, Stiles also alludes with the legal terminology "bearing witness."

16. Deleuze, *Masochism,* 80.

17. Ibid., 81.

18. Ibid., 88.

19. Ibid., 82.

20. Ibid., 79.

21. Ibid., 77. For a recent discussion of Deleuze's notion of the masochistic contract that is aligned with my own critique, see Carol Siegel, *Male Masochism: Modern Revisions of the Story of Love* (Bloomington: Indiana University Press, 1995), 111, 127ff.

22. Peter Plagens, "He Got Shot—for His Art," *New York Times,* 2 September 1973, D3. According to Barbara Smith, Burden was considered to be in violation of the California Penal Code, sec. 148.3, which indicts "any individual who reports or causes to be reported to any city [or] county . . . vehicle that an emergency exists knowing that report to be false." Barbara T. Smith, "Burden Case Tried, Dismissed," *Artweek,* 24 February 1973, 2.

23. My description of this piece is based on details provided by two audience members who wrote about the work. See Cara Montgomery, "Reviews: Los Angeles," *Arts Magazine,* March 1973, 66; Barbara T. Smith, "Art Piece Brings Arrest," *Artweek,* 6 January 1973, 3; Barbara T. Smith, letter in "Editor's Mail Bag Re: Chris Burden's Performance," *Artweek,* 10 February 1973, 2; and Barbara T. Smith, "Burden Case Tried, Dismissed," 2.

24. Gordon D. Schaber and Claude D. Rohwer, *Contracts in a Nutshell,* 3d ed. (St. Paul, Minn.: West, 1990), 9.

25. One rare exception to audience passivity took place during Marina Abramović's *Rhythm 5* (1974). She lay down inside a huge five-pointed star she had constructed on the pavement outside the Student Cultural Centre in Belgrade, Yugoslavia. She had doused the star with gasoline and set it aflame but did not realize that because fire consumes oxygen, she would be deprived of the ability to breathe. Two viewers who understood the danger of the situation saw that she was losing consciousness and pulled her out, thereby halting the performance. My description of this piece is from RoseLee Goldberg, "Here and Now," in *Marina Abramović: Objects, Performance, Video, and Sound,* ed. Chrissie Iles (Oxford: Museum of Modern Art, 1995), 12.

26. Smith, "Art Piece Brings Arrest," 3.

27. Ibid.

28. Leslie Woolf Hedley, letter in "Editor's Mail Bag Re: Chris Burden's Performance," *Artweek,* 10 February 1973, 2.

29. Diana Hobson, letter in "Editor's Mail Bag Re: Chris Burden's Performance," *Artweek,* 10 February 1973, 2.

30. Will Glickman, letter in "Editor's Mail Bag Re: Chris Burden's Performance," *Artweek,* 10 February 1973, 2.

31. Smith, letter in "Editor's Mail Bag," 2.

32. See also Stiles, "Survival Ethos," for her conclusion that destruction art functions as a "warning system" (96). Her argument is particularly apropos in light of the letter writer's comment regarding Himmler. As Stiles explains, Gustav Metzger's formulation of "auto-destructive art" (from which she derived her term "destruction art") was directly related to his adolescent experience of losing his Jewish family in the Holocaust (80). Destruction art's function as a warning system is a characteristic shared by masochistic performance.

33. Jennifer Licht, *Eight Contemporary Artists* (New York: Museum of Modern Art, 1974), 10. The Modern Art Agency was run by Lucio Amelio and was sometimes known as Lucio Amelio Gallery. Vito Acconci, interview with the author, Brooklyn, N.Y., December 1996.

34. Vito Acconci, quoted in Stedelijk Museum, *Vito Acconci* (Amsterdam: Stedelijk Museum, 1979), n.p. One learns from Acconci's documentation of this piece in his archives (Brooklyn, N.Y.) that the audiotaped text included another person's voice translating portions of Acconci's lines into Italian and substituting Acconci's use of "I" with "he." The tape played on a loop through the two hours of the performance, which was held three times in three weeks.

35. Acconci emphasized the centrality of the phallic theme through irony. His main focus in the tape was on "the pimples on my ass." But, as he admits toward the end of the tape, "They might think I'm making too much of the pimples, I'm making them more important than they're worth. But that's just the point: if I think it's important, and it's not, then I must be revealing to them what's really on my mind" (from documentation in Acconci's archive, Brooklyn, N.Y.). What was really on his mind, of course, was "the size of [his] prick"—which, in turn, was represented symbolically as the phallus.

36. Amelia Jones, "Dis/Playing the Phallus: Male Artists Perform Their Masculinities," *Art History* 17, no. 4 (December 1994): 547. Jones also argues that relative to that of other male performance artists, Acconci's work is "more sceptical of conventional masculinity" in that he "mark[s] the ultimate exchangeability and interdependence of each element in the supposedly oppositional categories of viewer/viewed, male/female, subject/object" (566). Not all feminist scholars would agree, observing aspects of sexism or at least extreme "masculinism" in Acconci's work. See, for example, Peggy Phelan's response paper to the 1997 College Art Association panel titled "Body Politics: Performativity and Postmodernism" (presented at the annual meeting of the College Art Association, New York, N.Y., February 1997), especially her comments in response to Christine Poggi's "Following Acconci or Beholding as Transgressive Performance" (paper presented on this panel). Conversely, for an exploration of the nonsexist aspects of Acconci's performances from a feminist Foucauldian perspective, see Diane Alison Mullin, "Acconci and the Other Body" (master's thesis, Washington University, 1989), 59ff.

Of additional interest in Jones's argument is the premise from which she argues that "male body artists" such as Acconci depart from paradigmatically modernist strategies. These strategies, she proposes, are based on "the transcendental and singularly masculine conception of artistic authority . . . a conception that relies on the veiling of the actual body of the artist such that his divinity (his phallic prowess) can be ensured" (547). Because Jones bolsters her theory here by quoting one of the key theorists on whom I have relied, Jacques Lacan ("the phallus can only play its role as veiled"), and because Acconci indeed veils himself in *Reception Room,* Jones's arguments could be used to problematize further my reading of this performance, if time and space allowed. Jones quotes Lacan, "The Meaning of the Phallus" (1958), in his *Feminine Sexuality,* ed. Juliet Mitchell and Jacqueline Rose, trans. Jacqueline Rose (New York: Norton, 1985), 82.

37. Vito Acconci, "Projections of Home," *Artforum,* March 1988, 127. For excellent analyses of the metaphor of the home in Acconci's work during and after the 1970s, see Ronald J. Onorato, *Vito Acconci: Domestic Trappings* (La Jolla, Calif.: La Jolla Museum of Contemporary Art, 1987); and Christine Poggi, "Vito Acconci's Bad Dream of Domesticity," in *Not at Home: The Suppression of Domesticity in Modern Art and Architecture,* ed. Christopher Reed (London: Thames & Hudson, 1996), 237–52.

5. HOME AGAIN

1. Quoted in François Pluchart, "Gina Pane's Biological Aggressions," *arTitudes,* December 1971–January 1972, 10.

2. Walter Benn Michaels, "The Phenomenology of Contract," in *The Gold Standard and the Logic of Naturalism* (Berkeley and Los Angeles: University of California Press, 1987), 124.

3. Effie Stephano and Gina Pane, "Performance of Concern," *Art and Artists,* April 1973, 22.

4. Symbolic associations to "hearth and home" were articulated by Effie Stephano as she recalled a conversation with Pane (ibid.).

5. Ibid., 23.

6. Bertolt Brecht, "The Street Scene: A Basic Model for an Epic Theatre" (1950), in *Brecht on Theatre,* ed. and trans. John Willett (London: Methuen, 1984), 125 (my emphases). For more on Brecht's theory of the "A-effect" and a historical contextualizing of his work, see, respectively, Stuart Hood, "Brecht's Theory of Alienation," *Block* 3 (1980): 11–12; and Sylvia Harvey, "Whose Brecht? Memories for the Eighties: A Critical Recovery," *Screen* 23 (May–June 1982): 45–59.

7. Stephano and Pane, "Performance of Concern," 23.

8. For a useful synopsis of the myth of Oedipus and discussion of what Freud leaves out in his application of the myth, see Jessica Benjamin, *The Bonds of Love: Psychoanalysis, Feminism, and the Problem of Domination* (New York: Pantheon, 1988), 141ff.

9. Jean-Jacques Rousseau, "The Social Contract," in *The Essential Rousseau,* trans. Lowell Bair (New York: Meridian, 1975), 9.

10. Philippe Ariès, *Centuries of Childhood: A Social History of Family Life,* trans. Robert Baldick (New York: Vintage, 1962), 404.

11. Alan Watson, *The Evolution of Law* (Baltimore: Johns Hopkins University Press, 1985), 4–28. The five "original" types of contract as Watson sees them are (1) "stipulatio," a "unilateral contract" with rhetoric akin to modern wedding vows, in which a "Do you promise . . . ?" and "I promise" volley takes place; (2) "mutuum," concerning loans; (3) "deposit"; (4) a "consensual contract," of which there are four subtypes (sale, hire, gratuitous service, and pledge) requiring no formal agreement; and (5) "societas," having to do with partnerships.

12. Richard L. Abel, "Torts," in *The Politics of Law: A Progressive Critique,* ed. David Kairys (New York: Pantheon, 1982), 185.

13. Grant Gilmore, *The Death of Contract* (Columbus: Ohio State University Press, 1974), 64.

14. This is not to say that estoppel brings one closer to some notion of "truth." To dispel that myth and further complicate the picture, as law is so wont to do, see the discussion of estoppel in "Restatement, Second, Contracts": "Estoppel prevents a person from showing the truth contrary to a representation of fact made by him after another has relied on the representation." Thus, it still remains to be seen what "the truth" is and who is telling it (ibid., 89 n. 234). Gilmore's source is the tentative draft of the "Restatement, Second, Contracts."

15. Ibid., 88 (my emphasis). Gilmore does not provide source of interior quotation.

16. Ibid., 29.

17. Details concerning *Communist Body/Capitalist Body* are from Marina Abramović/Ulay, Ulay/Marina Abramović, *Relation Work and Detour* (Amsterdam: Ulay/Marina Abramović, 1980), 164–79.

18. For excellent discussions of the relationship between Abramović's Yugoslavian background and her work, see Chrissie Iles, "Cleaning the Mirror," and David Elliott, "Balkan Baroque," both in *Marina Abramović: Objects, Performance, Video, and Sound,* ed. Chrissie Iles (Oxford: Museum of Modern Art, 1995), 21–41 and 55–73, respectively. See also Tom Marioni, "Real Social Realism," *Vision* 2 (January 1976): 7–16, 27–29, for a discussion of the topic in a time frame more contemporaneous with Abramović's early 1970s performances (Marioni discusses other Eastern European artists in the article as well).

19. Ulay/Abramović's artist statement, titled "Art Vital," consists of a string of conditions for their work: "no fixed living-place, permanent movement, direct contact, local relation, self-selection, passing limitations, taking risks, mobile energy, no rehearsal, no predicted end, no repetition." Abramović/Ulay, *Relation Work and Detour,* 19.

20. Ibid., 173. (Note: Ulay's birth name was F. Uwe Laysiepen.)

21. Ibid., 175.

22. Ibid.

23. Ibid.

24. Ibid.

25. For Burden's self-published documentation of *Oh, Dracula,* see Chris Burden, *Chris Burden 74–77* (Los Angeles: Chris Burden, 1978), n.p.

26. For Burden's self-published documentation of *Doomed,* see ibid., n.p.

27. In part, this tampering was intentional. Burden has explained that "Ira Licht, the curator at MOCA Chicago, asked me please not to do 'one of those short performances.' People would be driving in, paying, etc., and it wouldn't be good if I did something thirty seconds long. So, really, I was playing off the institution." He never dreamed, however, that the piece would go on as long as it did. Chris Burden, interview with the author, Newport Beach, Calif., May 1988.

28. Quoted in Dorothy Seiberling, "The Art-Martyr," *New York,* 24 May 1976, 64.

29. Donald Kuspit, "Chris Burden: The Feel of Power," in *Chris Burden: A Twenty-Year Survey,* by Anne

Ayres and Paul Schimmel (Newport Harbor, Calif.: Newport Harbor Art Museum, 1988), 42. There has been a paucity of scholarship on the relationship of the contract to performance artists' work, but this appears to be changing. See, for example, Saundra Goldman, "So Help Me Hannah: Relationship and Social Contract in the Art of Hannah Wilke" (paper presented at the annual meeting of the Midwest Art Historians Association, Cleveland, Ohio, March 1996); and Saundra Goldman, "Hannah Wilke: A Comprehensive Study of Her Work and Its Role in the History of Feminist Art Practice" (Ph.D. diss., University of Texas at Austin, forthcoming). See also my essay "The Performance Artist as Masochistic Woman," *Arts Magazine,* summer 1988, 96–98. For what I believe is the earliest reference to the relationship between the contract and a performance artist's work, see Stephen Melville, "How Should Acconci Count for Us? Notes on a Retrospect," *October* 18 (fall 1981): 80, 86.

30. Kuspit, "Chris Burden," 42. For Parsons's notion of the "social contract," Kuspit cites Talcott Parsons, *The Structure of Social Action* (Glencoe, Ill.: Free Press, 1949), 93, 768.

31. All quotations in this paragraph are from Kuspit, "Chris Burden," 42–43.

32. Kuspit makes a passing reference to Burden's "sadomasochistic mentality" (ibid., 41), but he does not explore sadism or masochism in psychoanalytic terms.

33. For Lacan's notion of the "price" exacted by the mirror stage, see Jacques Lacan, "The Meaning of the Phallus" (1958), in his *Feminine Sexuality,* ed. Juliet Mitchell and Jacqueline Rose (New York: Norton, 1985), 79.

34. Jacques Lacan, "The Mirror Stage as Formative of the Function of the I as Revealed in Psychoanalytic Experience" (1949), in *Écrits: A Selection,* trans. Alan Sheridan (New York: Norton, 1977), 4.

35. Sigmund Freud, "Mourning and Melancholia" (1917), in *A General Selection from the Works of Sigmund Freud,* ed. John Rickman (1937; reprint, Garden City, N.Y.: Doubleday, 1957), 129.

36. Ibid., 131.

37. Ibid., 132.

38. Ibid., 133.

39. Theodor Reik, "Masochism in Modern Man," in *Of Love and Lust: On the Psychoanalysis of Romantic and Sexual Emotions* (1949; reprint, New York: Farrar, Straus & Giroux, 1984), 366.

40. Freud, "Mourning and Melancholia," 130.

41. Freud felt that merely to contradict the melancholiac in a clinical setting was ineffective; a more viable course of treatment was to accept that the melancholiac was, in some measure, accurate in his or her views. In "Mourning and Melancholia," Freud observes that the melancholiac "has a keener eye for the truth than others who are not melancholic. When in his exacerbation of self-criticism he describes himself as petty, egoistic, dishonest, lacking in independence, one whose sole aim has been to hide the weaknesses of his own nature, for all we know it may be that he has come very near to self-knowledge; we only wonder why a man must become ill before he can discover truth of this kind" (128). This line of thinking brings Freud's theory of melancholia close to mine on masochism and its inherent ability to cast light on that which needs to be seen, especially in regard to institutional dysfunction. But, as I have been arguing, without negotiation over what precisely is being illuminated, the masochist's (or melancholiac's) exercise is futile and formalistic. This is where acknowledgment of a contractual structure at work for the masochist is crucial, clarifying the dynamic of agreement between the masochist and another (or other) individual(s) in his or her midst. Freud seems confounded by the melancholiac's (and, I would add, masochist's) strategies of pointing to the "truth," and he more or less gives up on figuring it all out. This might have been unnecessary had he pursued his original point regarding the instructive aspects of seemingly perverse actions; recognized his own status within the unspoken agreement with his patients; and actually negotiated with them over what the instructive aspects of their malady might be. Instead, he concludes his essay by resigning himself to a therapeutic impasse: "We see that the ego debases itself and rages against itself, and as little as the patient do we understand what this can lead to and how it can change" (139).

42. Chris Burden, quoted in Robert Horvitz, "Chris Burden," *Artforum,* May 1976, 25.

43. Burden, quoted in ibid. (my emphasis).

44. Ibid. For a discussion of the relationship between Burden's *White Light/White Heat* and Velvet Underground's song by the same name, see John M. Budosh, "Many Parts/One Experience: An Essay on the Re-representations of Performed Actions Originated by Chris Burden" (master's thesis, University of Maryland at College Park, 1996), 14–17.

45. Burden clearly was drawing on Minimalist sculpture models here, perhaps the mid-1960s work of Robert Morris. For an excellent discussion of the relationship of the performing body to Minimalist sculpture, see Maurice Berger, *Labyrinths: Robert Morris, Minimalism, and the 1960s* (New York: Harper & Row, 1989), 11–12. For discussion and illustration of Burden's own work in sculpture before he turned to performance, see Horvitz, "Chris Burden," 25–27.

46. Robin White and Chris Burden, "Chris Burden," *View* 1, no. 8 (January 1979): 4.

47. Freud, "Mourning and Melancholia," 128.

48. Burden, "Oracle," in *Chris Burden 74–77,* n.p.

49. Freud, "Mourning and Melancholia," 125.

50. Ibid., 127.

6. CONCLUSION

1. See, for example: Maurice Berger, *Representing Vietnam, 1965–1973: The Antiwar Movement in America* (New York: Bertha and Karl Leubsdorf Art Gallery, Hunter College, 1988); Alf Louvre and Jeffrey Walsh, *Tell Me Lies about Vietnam: Cultural Battles for the Meaning of the War* (Milton Keynes, England: Open University Press, 1988); Pam Sporn, "The War in Vietnam/The War at Home," in *Contemporary Art and Multicultural Education,* ed. Susan Cahan and Zoya Kocur (New York: New Museum of Contemporary Art; London and New York: Routledge, 1996), 307–31; C. David Thomas, ed., *As Seen by Both Sides: American and Vietnamese Artists Look at the War* (Boston: Indochina Arts Project, 1991); Jeffrey Walsh and James Aulich, *Vietnam Images: War and Representation* (New York: St. Martin's, 1989); and Reese Williams and the Washington Project for the Arts, eds., *Unwinding the Vietnam War: From War into Peace* (Seattle: Real Comet, 1987).

2. Acconci's *Reception Room* (see chapter 4 of this book) and *Props,* both held in March 1973, were his last two performances that could be considered masochistic. In *Props,* Acconci occupied the front window of a Brussels gallery, his back to the audience. An audiotape of his voice delivered the following provocation: "If you don't do something behind my back, then I'd know I can trust you" (Vito Acconci, untitled notes in *Vito Acconci: Headlines and Images,* ed. Marja Bloem and Dorine Mignot [Amsterdam: Stedelijk Museum, 1978], n.p.). Acconci presented his very last performance of any kind, titled *Ballroom,* in December 1973 in Florence. Here, for the first time since Acconci had started performing, an audience member tried to enter into the performance. Acconci was surprised by this, even though he had been trying to provoke audience members into participating. He later wrote, "After *Ballroom* was over, I could never perform again. Because *Ballroom* now was out in the open as evidence, that stared both myself and others right in the face: it was proof that my 'performances' promised more than they (or I) could (or would) deliver" (from original draft in Acconci's archives [Brooklyn, N.Y.] for a paper titled "Performance after the Fact," presented at "Strategies of Performance," a symposium at the Maryland Institute, College of Art, Baltimore, April 1989; later published in *Documents [Sur l'art contemporain]* [Paris], March 1992, 44–50). In 1974, Acconci started making sculpture and working in an installation format. For a recent survey of Acconci's work, see Kate Linker, *Vito Acconci* (New York: Rizzoli, 1994).

Burden's last performance dealing with issues of masochism was *Oracle* (1975). Although he continued to perform, he turned more toward the use of technology. He also returned to sculpture and started working in an installation format. Of particular interest is his 1991 piece titled *The Other Vietnam Memorial,* a sculp-

ture made of six copper panels, each more than twelve feet high and four feet wide, hinged onto a central steel pole so they can be moved by the viewer. Into the panels are etched three million names of Vietnamese people killed during the United States involvement in Vietnam. Regarding the overt political content of this piece, Burden said, "For me it's sort of problematic because I like the grayer zones better, where good and evil are not so clear. But in this case I don't think you can look at this list and see that there are three million names and not think, 'Jesus Christ, what did we do in Vietnam?'" (Chris Burden, "Artist's Notes," in *Disloca-tions,* ed. Robert Storr [New York: Museum of Modern Art, 1991], 43). For a thorough survey of Burden's work up to 1988, see Anne Ayres and Paul Schimmel, *Chris Burden: A Twenty-Year Survey* (Newport Beach, Calif.: Newport Harbor Art Museum, 1988). For a more recent survey, see Chris Burden and Peter Noever, *Chris Burden: Beyond the Limits* (Vienna: MAK-Austrian Museum of Applied Arts; Ostfildern, Germany: Cantz Verlag, 1996).

 3. Marvin E. Gettleman et al., eds., *Vietnam and America: A Documented History* (New York: Grove, 1985), 496.

 4. See Esther Ferrer and Gina Pane, "The Geography of the Body," *Lapiz,* April 1989, 37–38 (an inter-view with Pane), for Pane's thoughts on the political events of May 1968 in Paris, on the Vietnam War, and on her last performance. Pane does not mention the title of this performance but dates it 1980; from other information she provides about the piece, however, it seems clear that it was *Mezzogiorno a Alimena* (1979). (I have found no substantive descriptions published on this performance). Pane then turned to sculpture, sometimes incorporating photographs of her previous performances. For surveys of Pane's work from her early performances to late sculptures, see the exhibition catalogs for two separate retrospectives held within months of her death in March 1990: Palau de la Virreina, *Gina Pane* (Barcelona: Palau de la Virreina, 1990); and Cadran Solaire, Centre d'Art Contemporain Passages, *Gina Pane* (Troyes, France: Cadran Solaire, Cen-tre d'Art Contemporain Passages, 1990). See also my essay "Gina Pane," in *Dictionary of Women Artists,* ed. Delia Gaze (London: Fitzroy Dearborn, 1997), 1063–66. Thanks to Jeanette Ingberman and Melissa Rachleff of the gallery Exit Art: The First World, in New York, N.Y., for sharing Pane's 1990 catalogs with me during Exit Art's excellent exhibition titled "Endurance: The Information," held in 1995. This exhibition featured photographic documentation of various artists in the twentieth century whose work "test[ed] the physical, mental, and spiritual endurance of the body" (press release for "Endurance: The Information," Exit Art: The First World, New York, N.Y., 1995). Photographs of some early 1970s performances by Acconci, Burden, Pane, and Marina Abramović were included in the exhibition.

 5. C. Carr, "Where Angels Fear to Tread," *Village Voice,* 14 February 1989, 27.

 6. For Ulay/Abramović's reflections on *The Great Wall Walk* and *Nightsea Crossing,* see Chrissie Iles, "Taking a Line for a Walk," *Performance* (London), April–May 1988, 14–19 (an interview with the artists).

 Since *The Great Wall Walk,* Abramović has produced and exhibited prodigious amounts of work. She has continued making videos, a practice begun with Ulay, and has also produced numerous installations and sculptures. She has continued to perform, sometimes incorporating masochistic actions into her pieces. An especially compelling example is *Biography,* a fast-paced, ninety-minute performance presented numerous times since 1992 in which she "anthologizes" key moments in her life and work, including segments of previ-ous performances in which she cut and flagellated herself (prior to her collaborations with Ulay). As she reenacts these segments live, video clips of some of her performances with Ulay are projected onto the back wall of the stage. For RoseLee Goldberg's eyewitness account of *Biography,* see her essay "Here and Now," in *Marina Abramović: Objects, Performance, Video, and Sound,* ed. Chrissie Iles (Oxford: Museum of Modern Art, 1995), 17–18. For a survey of Abramović's performance work with and without Ulay and her other art-work since 1988, see Iles's entire catalog, with essays by exhibition curator Iles, David Elliott, and Thomas McEvilley.

 Since *The Great Wall Walk,* Ulay, for the most part, has returned to photography. For an account of this work, see Thomas McEvilley and Ulay, *The First Act* (Ostfildern, Germany: Cantz Verlag, 1994); and Yam-aguchi Prefectural Museum of Art, *Ulay* (Tokyo: Yamaguchi Prefectural Museum of Art, 1997), especially the

central catalog essay by Wolfgang Winkler, "Ulay's Transfer von Bildern durch Bilder hindurch." However, Ulay recently contributed a performance to a symposium titled "De belichaaming van het woord" (The Embodiment of the Word) at the Theater Academy in Arnheim, the Netherlands. After reading an excerpt from McEvilley's essay on Ulay's photography work in *The First Act,* Ulay opened his shirt and with a scalpel carved the letters of the word FOTO into his chest in a diagonal pattern. He then closed his shirt and walked into the audience. The performance lasted less than two minutes (Ulay, letter to the author, January 1997). See also Ulay, *FOTOTOT* (Zagreb: Galerija suvremene umjetnosti, 1977), for an account of Ulay's early work in photography and performance, before his collaborations with Abramović. Especially apropos of the topics I have discussed in this book is Ulay's documentation in *FOTOTOT* (n.p.) of his 1976 masochistic performance titled "Identity Analysis," in which he stood silently before audience members as they gazed at themselves in a life-size mirror. This mirror, which was shaped like a human figure, was attached firmly to the front of Ulay's naked body. Wearing only a crash helmet, Ulay made himself fall forward, landing squarely on another life-size mirror on the floor in front of him. He remained on the floor until the audience had left the room.

7. Cystic fibrosis is a disease that produces an excess of mucus that is difficult to expel from the body; it resides in the lungs, where it produces a breeding ground for bacteria and viruses. Despite many claims that Flanagan lived longer than any other person with CF, in 1993 he said, "I'm one of the oldest. There's a few people in their early 60s who are still alive." Andrea Juno and V. Vale, eds., *Bob Flanagan: Supermasochist* (San Francisco: Re/Search Publications, 1993), 12.

8. Ibid., 12–17.

9. Ibid., 106.

10. Ibid., 62. The Southern Exposure performance brought Flanagan recognition through an ironic twist that has become all too familiar since 1989: it attracted the hostile criticism of Jesse Helms. Flanagan has said, "We were *nobodies* until he [Helms] targeted us. I should send him a thank-you letter" (63).

11. Ibid., 28.

12. Ibid., 66.

13. Ibid., 64–65.

14. Ibid., 99.

15. Amelia Jones, "Dis/Playing the Phallus: Male Artists Perform Their Masculinities," *Art History* 17, no. 4 (December 1994): 573.

16. Ibid.

17. *Silence = Death* was produced by Phil Zwickler and Rosa von Prauheim. For a still image of Wojnarowicz's act, see *High Performance,* fall 1990, cover.

18. Bob Flanagan also sewed his mouth shut, as is pictured in Juno and Vale, *Bob Flanagan,* 101. Unfortunately, the publication provides no details concerning this piece.

19. Carole S. Vance, "The War on Culture," *Art in America,* September 1989, 39, 41, 43. The terminology of war was popularized further by the publication of Richard Bolton, ed., *Culture Wars: Documents from the Recent Controversies in the Arts* (New York: New Press, 1992).

20. For an account of this accusation and Wojnarowicz's subsequent lawsuit against Wildmon, see Steven C. Dubin, *Arresting Images: Impolitic Art and Uncivil Actions* (London and New York: Routledge, 1992), 217–19.

21. My description of *Transcrypts* is based on my attendance at the performance at the Drawing Center, New York, N.Y., 1992, and on a telephone interview with Simon Leung, January 1997.

22. Kelly Dennis, "Performance Art," in *Encyclopedia of Aesthetics,* ed. Michael Kelly (New York: Oxford University Press, forthcoming).

23. Simon Leung, unpublished text for *Transcrypts: Some Notes between Pricks* (1991–92).

24. Simon Leung, telephone interview with the author, January 1997.

25. Ibid. Interestingly, Leung made the original cut at about the time that he wrote a high school term paper on Chris Burden.

26. Press release for *Proposal for Surf Vietnam,* Simon Leung's installation at Refusalon, San Francisco, Calif., January–February 1997.

27. Simon Leung, unpublished notes for *Warren Piece (in the '70s),* P.S. 1, Long Island City, N.Y., February 1993.

28. Ibid. Leung was born in Hong Kong and immigrated to San Jose, California, with his family in 1974. He prefers to be thought of as a "postcolonial" artist.

29. Ibid.

30. For a description of this segment of the trilogy, see Simon Leung, "Squatting through Violence," *Documents* 6 (spring–summer 1995): 92.

31. Press release for *Proposal for Surf Vietnam.*

32. Kelly Dennis inspired me to think of this concept in terms of borders. See her compelling discussion of performance art in the contexts of framing and boundaries in "Performance Art."

33. A somewhat similar setup occurred in Chris Burden's *Velvet Water* (1974), but only the videotaped version of Burden faced the audience; his physical body was located to the left of the audience, facing in the same direction as the audience. Viewers would have had to crane their necks to catch a glimpse of him behind the wall of lockers. (And even this may have been impossible. See chap. 2, n. 29.)

34. For more on Opie's work, including this piece, see Liz Kotz, "Erotics of the Image," *Art Papers,* November–December 1994, 18–19.

35. According to Ron Athey, the title of this performance has been cited incorrectly as *Excerpted Rites Transformation* in some publications. Telephone interview with the author, April 1997.

36. Interestingly, Catherine Opie has taken photographs of Carlton's back. For a provocative questioning of Carlton's choice to participate in scarification, and of Opie's perceptions of Carlton in the photographic relationship, see Kotz, "Erotics of the Image," 19.

37. Carlton's HIV status was not announced at the time, so it would appear that the audience member was transferring his anxiety about Athey's avowed HIV status to Carlton and, in turn, to the hanging prints. My descriptions of Athey's performances have been culled from Mary Abbe, "Bloody Performance Draws Criticism," *Minneapolis Star Tribune,* 24 March 1994, 1A, 15A; Robin Cembalest, "Ritualistic Physical Mortification," *ARTnews,* summer 1994, 56; William Harris, "Demonized and Struggling with His Demons," *New York Times,* 23 October 1994, 31, 35; and Stephanie Cash, "Ron Athey at P.S. 122," *Art in America,* February 1995, 99–100. Expansion on and corrections to these descriptions were provided by Ron Athey (telephone interview with the author, April 1997). For some of the texts Athey delivered in these performances, see "Artist's Notes," his contribution to *Out of Character: Rants, Raves, and Monologues from Today's Top Performance Artists,* ed. Mark Russell (New York: Bantam, 1997), 32–39. The brouhaha over the Walker's use of NEA funding for Athey's piece resulted in a five-percent cut from the NEA budget for 1995. See Ann Landi, "The Unkindest Cut," *ARTnews,* September 1994, 46; and Athey's remarks on the issue in Guy Trebay, "Ron Athey's Slice of Life," *Village Voice,* 1 November 1994, 38.

38. The idea for the release forms, according to Athey, was first suggested to him by Tim Miller at the performance space Highways in Los Angeles.

39. My description of Bacher's *Sleep* is from my own observation of it at the Gramercy Arts Fair and from conversations with the artist in February 1995, November 1996, and January 1997. For more on Bacher's work in general, see Liz Kotz, "Sex with Strangers," *Artforum,* September 1992, 83–85; and "Beyond the Pleasure Principle," *Lusitania* 6 (1994): 125–36.

40. My description of Garfinkel's *Case 61* is from my interaction with it and from numerous conversations with the artist between December 1995 and April 1997. Garfinkel's reason for choosing this specific portion of the human back is that it more or less lines up with the portion of the computer user's body as she or he sits in front of the machine.

41. Richard von Krafft-Ebing, "Case 61," *Psychopathia Sexualis* (1886; reprint, New York: Pioneer, 1953), 156–58.

42. These last two questions are linked, and they form the basis for another book: consider the long-lasting effects of slave contracts in this country. For an illuminating discussion of the contract in the context of race, class, and gender, see Carole Pateman, *The Sexual Contract* (Stanford: Stanford University Press, 1988), especially chapter 3, "Contract, the Individual, and Slavery," 39–76.

43. Leung, "Squatting through Violence," 97.

SELECTED BIBLIOGRAPHY

Note: Citations that do not reveal a connection to the text are followed by brief annotations. Interviews are also indicated.

Abbe, Mary. "Bloody Performance Draws Criticism." *Minneapolis Star Tribune,* 24 March 1994, 1A, 15A. On Ron Athey.

Abel, Richard L. "Torts." In *The Politics of Law: A Progressive Critique*, edited by David Kairys, 185–200. New York: Pantheon, 1982.

Abramović, Marina. "Marina Abramović." *Flash Art*, June 1974, 78.

Abramović, Marina/Ulay, Ulay/Marina Abramović. *Relation Work and Detour*. Amsterdam: Ulay/Marina Abramović, 1980.

Acconci, Vito. "Drifts and Conversions." *Avalanche* 2 (winter 1971): 82–95.

———. "Notebook: Vito Acconci on Activity and Performance." *Art and Artists*, May 1971, 68–69.

———. *Notes on the Development of a Show (Sonnabend, New York, January 15–29, 1972)/Notes toward Performing a Gallery Space*. Hamburg, Germany: Hossmann, 1973.

———. "Performance after the Fact." *Documents (Sur l'art contemporain)* (Paris), March 1992, 44–50.

———. "Projections of Home." *Artforum*, March 1988, 126–28.

———. *Pulse (for my mother) (pour sa mère)*. Paris: Multiplicata, 1973.

———. "Some Notes on Activity and Performance." *Interfunktionen* 5 (1975): 138–42.

———. "Television, Furniture, and Sculpture: The Room with the American View." In *The Luminous Image*, edited by the Stedelijk Museum, 13–23. Amsterdam: Stedelijk Museum, 1984.

Acconci, Vito, and Liza Béar. *Avalanche* 6 (fall 1972). Special issue on Acconci.

Albertazzi, Liliana. "Gina Pane: Oeuvre et Artiste." *Galeries Magazine*, December 1987, 76–79.

Allsopp, Ric, and Scott deLahunta. *The Connected Body?* Amsterdam: Amsterdam School of the Arts, 1996.

Anzieu, Didier. *The Skin Ego: A Psychoanalytic Approach to the Self*. Translated by Chris Turner. New Haven: Yale University Press, 1989.

Ariès, Philippe. *Centuries of Childhood: A Social History of Family Life*. Translated by Robert Baldick. New York: Vintage, 1962.

Art & Design. *Performance Art into the 90s*. London: Art & Design, 1994.

Athey, Ron. "Artist's Notes." In *Out of Character: Rants, Raves, and Monologues from Today's Top Performance Artists*, edited by Mark Russell, 32–39. New York: Bantam, 1997.

Ayres, Anne, and Paul Schimmel. *Chris Burden: A Twenty-Year Survey*. Newport Beach, Calif.: Newport Harbor Art Museum, 1988.

Bal, Mieke. "His Master's Eye." In *Modernity and the Hegemony of Vision*, edited by David Michael Levin, 379–404. Berkeley and Los Angeles: University of California Press, 1993.

Barber, Bruce. "Indexing: Conditionalism and Its Heretical Equivalents." In *Performance by Artists*, edited by AA Bronson and Peggy Gale, 183–204. Toronto: Art Metropole, 1979.

———, ed. *Essays on [Performance] and Cultural Politicization. Open Letter: A Canadian Journal of Writing and Sources,* 5th ser., nos. 5–6. Toronto: Frank Davey, 1983.

Barry, Judith, and Sandy Flitterman. "Textual Strategies: The Politics of Art-Making." *Screen*, summer 1980, 35–48. Reference to Gina Pane.

Barthes, Roland. "Rhetoric of the Image." 1964. In *Image/Music/Text*, translated by Stephen Heath, 32–51. New York: Hill & Wang, 1977.

Bataille, Georges. "Sacrificial Mutilation and the Severed Ear of Vincent van Gogh." In *Visions of Excess: Selected Writings, 1927–1939*, edited and translated by Allan Stoekel, 61–72. Minneapolis: University of Minnesota Press, 1985.

Battcock, Gregory, and Robert Nickas, eds. *The Art of Performance: A Critical Anthology*. New York: Dutton, 1984.

Béar, Liza. "Chris Burden . . . Back to You." *Avalanche Newspaper*, May 1974, 12–13. Interview.

Benamou, Michel, and Charles Caramello, eds. *Performance in Postmodern Culture*. Madison, Wis.: Coda, 1977.

Benjamin, Jessica. *The Bonds of Love: Psychoanalysis, Feminism, and the Problem of Domination*. New York: Pantheon, 1988.

Berger, Maurice. *Labyrinths: Robert Morris, Minimalism, and the 1960s*. New York: Harper & Row, 1989.

———. *Representing Vietnam, 1965–1973: The Antiwar Movement in America*. New York: Bertha and Karl Leubsdorf Art Gallery, Hunter College, 1988.

Bersani, Leo. *The Freudian Body: Psychoanalysis and Art*. New York: Columbia University Press, 1986.

Bershad, Deborah. "Icon as Index: Middle Byzantine Art and Architecture." *Semiotica* 43, nos. 3–4 (1983): 275–320.

Birringer, Johannes. *Theatre, Theory, Postmodernism*. Bloomington: Indiana University Press, 1991.

Blau, Herbert. *To All Appearances: Ideology and Performance*. London and New York: Routledge, 1992.

Blessing, Jennifer. *Rrose is a Rrose is a Rrose: Gender Performance in Photography*. New York: Guggenheim Museum, 1997.

Blincoe, Nicholas. "Deleuze and Masochism." In *Deleuze and the Transcendental Unconscious*, edited by Joan Broadhurst, 81–96. *PLI Warwick Journal of Philosophy* 4, nos. 1–2. Warwick, England: University of Warwick, 1992.

Bolton, Richard, ed. *Culture Wars: Documents from the Recent Controversies in the Arts*. New York: New Press, 1992.

Borden, Lizzie. "Cosmologies." *Artforum*, October 1972, 45–50. Reference to Vito Acconci.

Bourdon, David. "Body Artists without Bodies." *Village Voice*, 24 February 1975, 85–86. On Vito Acconci and Chris Burden.

———. "An Eccentric Body of Art." *Saturday Review of the Arts*, February 1973, 30–32. On Vito Acconci.

Brecht, Bertolt. "The Street Scene: A Basic Model for an Epic Theatre." 1950. In *Brecht on Theatre*, edited and translated by John Willett, 121–29. London: Methuen, 1984.

Brentano, Robyn, and Olivia Georgia. *Outside the Frame: Performance and the Object: A Survey History of Performance Art in the USA since 1950*. Cleveland: Cleveland Center for Contemporary Art, 1994.

Bronson, AA, and Peggy Gale, eds. *Performance by Artists*. Toronto: Art Metropole, 1979.

Brooke Alexander, Inc. *Vito Acconci: Photographic Works, 1969–1970*. New York: Brooke Alexander, 1988.

Broude, Norma, and Mary D. Garrard. *The Power of Feminist Art: The American Movement of the 1970s, History and Impact*. New York: Abrams, 1994.

Brus, Günter. "Notes on the Action *Zerreissprobe*." In *Aktionsraum I oder 57 Blindenhunde*, 141–45. Munich: Aktionsraum, 1971.

Budosh, John M. "Many Parts/One Experience: An Essay on the Re-representations of Performed Actions Originated by Chris Burden." Master's thesis, University of Maryland at College Park, 1996.

Burden, Chris. "Artist's Notes." In *Dislocations*, edited by Robert Storr, 43. New York: Museum of Modern Art, 1991.

———. *Chris Burden 71–73*. Los Angeles: Chris Burden, 1974.

———. *Chris Burden 74–77*. Los Angeles: Chris Burden, 1978.

Burden, Chris, and Jan Butterfield. "Chris Burden: Through the Night Softly." *Arts Magazine*, March 1975, 68–72.

Burden, Chris, and Peter Noever. *Chris Burden: Beyond the Limits*. Vienna: MAK-Austrian Museum of Applied Arts; Ostfildern, Germany: Cantz Verlag, 1996.

Burnham, Linda. "Gina Pane." *High Performance*, spring–summer 1988, 61.

Cadran Solaire, Centre d'Art Contemporain Passages. *Gina Pane*. Troyes, France: Cadran Solaire, Centre d'Art Contemporain Passages, 1990.

Calas, Nicolas. "Bodyworks and Porpoises." *Artforum*, January 1978, 33–37. References to Vito Acconci and Chris Burden.

Caplan, Paula J. *The Myth of Women's Masochism*. 1985. Reprint, with an afterword, New York: Signet, 1987.

Carlson, Marvin. *Performance: A Critical Introduction*. London and New York: Routledge, 1996.

Carr, C. "The Art of the Twenty-first Century: Marina Abramović/Ulay." *Village Voice*, 25 February 1986, 3, 45–46.

———. *On Edge: Performance at the End of the Twentieth Century*. Hanover, N.H.: Wesleyan University Press and University Press of New England, 1993.

———. "This Is Only a Test: Chris Burden." *Artforum*, September 1989, 117–21.

———. "Where Angels Fear to Tread." *Village Voice*, 14 February 1989, 26–34. On Marina Abramović/Ulay.

Carter, Angela. *The Sadeian Woman: An Exercise in Cultural History*. London: Virago, 1979.

Case, Sue-Ellen, ed. *Performing Feminisms: Feminist Critical Theory and Theatre*. Baltimore: Johns Hopkins University Press, 1990.

Cash, Stephanie. "Ron Athey at P.S. 122." *Art in America*, February 1995, 99–100.

Celant, Germano. "'Dirty Acconci.'" *Artforum*, November 1980, 76–83.

Cembalest, Robin. "Ritualistic Physical Mortification." *ARTnews*, summer 1994, 56. On Ron Athey.

Chalupecky, Jindrich. "Art and Sacrifice." *Flash Art*, February–April 1978, 33–35 (English). References to Marina Abramović, Vito Acconci, Chris Burden, and Gina Pane.

Chancer, Lynn S. *Sadomasochism in Everyday Life: The Dynamics of Power and Powerlessness*. New Brunswick, N.J.: Rutgers University Press, 1992.

Clothier, Peter. "Chris Burden: The Artist as Hero." *Flash Art*, January–February 1980, 49–50.

Collins, James. "Chris Burden." *Artforum*, May 1974, 72–73.

Cowan, Lyn. *Masochism: A Jungian View*. Dallas: Spring Publications, 1982.

Davis, Douglas. "Art without Limits." *Newsweek*, 24 December 1973, 68, 73–74. References to Vito Acconci and Chris Burden.

Deleuze, Gilles. *Masochism: An Interpretation of Coldness and Cruelty*. Translated by Jean McNeil. New York: Braziller, 1971. Originally published as *Présentation de Sacher-Masoch*. Paris: Editions Minuit, 1967. Recently published as *Masochism, Coldness, and Cruelty*. New York: Zone, 1989.

Delfgaauw, Leo. "Les investigations de Marina Abramović et Ulay." *Art Press*, March 1989, 44–46.

Dennis, Kelly. "Performance Art." In *Encyclopedia of Aesthetics*, edited by Michael Kelly. New York: Oxford University Press, forthcoming.

Dolan, Jill. *Presence and Desire: Essays on Gender, Sexuality, Performance*. Ann Arbor: University of Michigan Press, 1993.

Drake, Nicholas. "Chris Burden: 'Excuse Me!'" *Public Art Review*, fall–winter 1994, 24–25. Interview.

Dubin, Steven C. *Arresting Images: Impolitic Art and Uncivil Actions*. London and New York: Routledge, 1992.

Dupuy, Jean, ed. *Collective Consciousness: Art Performance in the Seventies*. New York: Performing Arts Journal Publications, 1980.

Durland, Steven. "Chris Burden: Jedi Warrior." *High Performance*, fall 1988, 39–41.

———. "From Warriors and Saints to Lovers: Marina Abramović and Ulay." *High Performance* 34, no. 2 (1986): 50–55.

Egan, Jennifer. "The Thin Red Line." *New York Times Magazine*, 27 July 1997, 20–25ff. Reference to Ron Athey.

Elliott, David. "Balkan Baroque." In *Marina Abramović: Objects, Performance, Video, and Sound*, edited by Chrissie Iles, 55–73. Oxford: Museum of Modern Art, 1995.

Ettinger, Bracha Lichtenberg. "The With-in-Visible Screen." In *Inside the Visible: An Elliptical Traverse of Twentieth Century Art in, of, and from the Feminine*, edited by M. Catherine de Zegher, 88–113. Cambridge: MIT Press, 1996.

Favazza, Armando R. *Bodies under Siege: Self-Mutilation and Body Modification in Culture and Psychiatry.* 2d ed. Baltimore: Johns Hopkins University Press, 1996.

Ferrari, Corinna. "Chris Burden: Performances negli U.S.A. e a Milano." *Domus*, August 1975, 50–51 (English). Interview.

Ferrer, Esther, and Gina Pane. "The Geography of the Body." *Lapiz*, April 1989, 36–41. Interview.

Forte, Jeanie. "Focus on the Body: Pain, Praxis, and Pleasure in Feminist Performance." In *Critical Theory and Performance*, edited by Janelle G. Reinelt and Joseph R. Roach, 248–62. Ann Arbor: University of Michigan Press, 1992.

Foster, Hal. *Compulsive Beauty*. Cambridge: MIT Press, 1993.

———. "Convulsive Identity." *October* 57 (summer 1991): 19–54.

Foster, Stephen C., ed. *"Event" Arts and Art Events*. Ann Arbor, Mich.: UMI Research Press, 1988.

Foucault, Michel. *Discipline and Punish: The Birth of the Prison*. 1975. Translated by Alan Sheridan. New York: Vintage, 1979.

———. *The History of Sexuality*. Vol. 1, *An Introduction.* Translated by Robert Hurley. New York: Vintage, 1978.

Frackman, Noel. "Chris Burden." *Arts Magazine*, April 1975, 9.

Frank, Peter. "Auto-art: Self-Indulgent? And How!" *ARTnews*, September 1976, 43–48. References to Vito Acconci, Chris Burden, and Gina Pane.

Freud, Sigmund. "Beyond the Pleasure Principle." 1920. In *A General Selection from the Works of Sigmund Freud*, edited by John Rickman, 141–68. 1937. Reprint, Garden City, N.Y.: Doubleday, 1957.

———. "The Economic Problem of Masochism." 1924. In *The Standard Edition of the Complete Works of Sigmund Freud*, vol. 19, translated by James Strachey, 159–70. London: Hogarth, 1961.

———. "The Ego and the Id." 1923. In *A General Selection from the Works of Sigmund Freud*, edited by John Rickman, 210–35. 1937. Reprint, Garden City, N.Y.: Doubleday, 1957.

———. "Instincts and Their Vicissitudes." 1915. In *The Standard Edition of the Complete Works of Sigmund Freud*, vol. 14, translated by James Strachey, 111–40. London: Hogarth, 1957.

———. "Mourning and Melancholia." 1917. In *A General Selection from the Works of Sigmund Freud*, edited by John Rickman, 124–40. 1937. Reprint, Garden City, N.Y.: Doubleday, 1957.

———. "Three Contributions to the Theory of Sex." 1905. In *The Basic Writings of Sigmund Freud*, edited by A. A. Brill, 553–629. 1938. Reprint, New York: Modern Library, 1966.

Fried, Michael. "Art and Objecthood." *Artforum*, June 1967, 12–23.

Frueh, Joanna. *Erotic Faculties*. Berkeley and Los Angeles: University of California Press, 1996.

Fusco, Coco. "The Other History of Intercultural Performance." In *English Is Broken Here: Notes on Cultural Fusion in the Americas*, 37–63. New York: New Press, 1995.

Gabel, Peter, and Jay M. Feinman. "Contract Law as Ideology." In *The Politics of Law: A Progressive Critique*, edited by David Kairys, 172–84. New York: Pantheon, 1982.

Galerie Isy Brachot. *Gina Pane: Travail d'action*. Paris: Galerie Isy Brachot, 1980.

Gambrell, Jamey. "Disarming Metaphors." *Art in America*, January 1984, 83–87. On Chris Burden.

Garber, Frederick. *Repositionings: Readings of Contemporary Poetry, Photography, and Performance Art*. University Park: Pennsylvania State University Press, 1995.

Gettleman, Marvin E., Jane Franklin, Marilyn Young, and H. Bruce Franklin, eds. *Vietnam and America: A Documented History*. New York: Grove, 1985.

Gibson, James William. *The Perfect War: The War We Couldn't Lose and How We Did*. New York: Vintage, 1986.

Gilbard, Florence. "An Interview with Vito Acconci: Video Works, 1970–1978." *Afterimage*, November 1984, 9–15.

Gilmore, Grant. *The Death of Contract*. Columbus: Ohio State University Press, 1974.

Glickman, Will. Letter in "Editor's Mail Bag Re: Chris Burden's Performance," *Artweek*, 10 February 1973, 2.

Goldberg, RoseLee. "Here and Now." In *Marina Abramović: Objects, Performance, Video, and Sound*, edited by Chrissie Iles, 11–19. Oxford: Museum of Modern Art, 1995.

———. *Performance Art: From Futurism to the Present*. New York: Abrams, 1988. Rev. ed. of *Performance: Live Art 1909 to the Present*. New York: Abrams, 1979.

———. "Space as Praxis." *Studio International*, September–October 1975, 130–35. Reference to Vito Acconci.

Goldman, Saundra. "So Help Me Hannah: Relationship and Social Contract in the Art of Hannah Wilke." Paper presented at the annual meeting of the Midwest Art Historians Association, Cleveland, Ohio, March 1996.

Goldstein, Ann, and Anne Rorimer. *Reconsidering the Object of Art, 1965–1975*. Los Angeles: Museum of Contemporary Art; Cambridge: MIT Press, 1995. Vito Acconci represented in the exhibition.

Gorsen, Peter. "The Return of Existentialism in Performance Art." 1979. In *The Art of Performance: A Critical Anthology*, edited by Gregory Battcock and Robert Nickas, 135–41. New York: Dutton, 1984. References to Marina Abramović/Ulay, Chris Burden, and Gina Pane.

Goy, Bernard. "Marina Abramović." *Journal of Contemporary Art* 3, no. 2 (fall–winter 1990): 47–54. Interview.

Graevenitz, Antje von. "Then and Now: Performance Art in Holland." *Studio International*, July–August 1976, 49–53. References to Marina Abramović/Ulay and Gina Pane.

Greene, Gerald, and Caroline Greene. *S-M: The Last Taboo*. New York: Grove, 1974.

Grobel, Larry. "Chris Burden. Picasso Used Canvas. Michelangelo Used Marble. Chris Burden Uses His Body." *Playgirl*, April 1978, 48–51, 64, 67, 76.

Grosz, Elizabeth. *Jacques Lacan: A Feminist Introduction*. London and New York: Routledge, 1990.

Hamera, Judith Ann. "Within Poetic Coincidence: A Psychological Approach to Imaginal Continuity in Performance Art." Ph.D. diss., Northwestern University, 1987. Section on Chris Burden.

Harris, William. "Demonized and Struggling with His Demons." *New York Times*, 23 October 1994, 31, 35. On Ron Athey.

Hart, Lynda, and Peggy Phelan, eds. *Acting Out: Feminist Performances*. Ann Arbor: University of Michigan Press, 1993.

Hawkins, Lucinda. "To Be or Not to Biennale." *Studio International*, September–October 1976, 204. Reference to Marina Abramović/Ulay.

Hedley, Leslie Woolf. Letter in "Editor's Mail Bag Re: Chris Burden's Performance," *Artweek*, 10 February 1973, 2.

Henri, Adrian. *Total Art: Environments, Happenings, and Performance*. New York: Oxford University Press, 1974.

Hixon, Kathryn. "New York in Review: Gina Pane." *Arts Magazine*, summer 1991, 94.

Hobson, Diana. Letter in "Editor's Mail Bag Re: Chris Burden's Performance." *Artweek*, 10 February 1973, 2.

Horney, Karen. "The Problem of Feminine Masochism." In *Feminine Psychology*, edited by Harold Kelman, 214–33. New York: Norton, 1967.

Horvitz, Robert. "Chris Burden." *Artforum*, May 1976, 24–31.

Hughes, Robert. "Portrait of the Autist as a Young Man." *Time*, 24 February 1975, 56–57.

Hughes-Hallett, Lucy. "Peace on Earth? Chris Burden's Investigations." *Performance* (London), November 1990, 16–25.

Huxley, Michael, and Noel Witts, eds. *The Twentieth-Century Performance Reader*. London and New York: Routledge, 1996.

Iles, Chrissie. "Catharsis, violence, et aliénation de soi: la performance en Grande-Bretagne de 1962 à 1988."
 In *L'art au corps: le corps exposé de Man Ray à nos jours*, edited by Philippe Vergne, 284–323. Mar-
 seilles: Mac, Galeries Contemporaines des Musées de Marseille, 1996.

———. "Cleaning the Mirror." In *Marina Abramović: Objects, Performance, Video, and Sound*, edited by
 Chrissie Iles, 21–41. Oxford: Museum of Modern Art, 1995.

———. "Taking a Line for a Walk." *Performance* (London), April–May 1988, 14–19. Interview with Marina
 Abramović/Ulay.

Jones, Amelia. *Body Art/Performing the Subject*. Minneapolis: University of Minnesota Press, 1998.

———. "'Clothes Make the Man': The Male Artist as a Performative Function." *Oxford Art Journal* 18, no. 2
 (1995): 18–32. Reference to Chris Burden.

———. "Dis/Playing the Phallus: Male Artists Perform Their Masculinities." *Art History* 17, no. 4 (Decem-
 ber 1994): 546–84. References to Vito Acconci, Chris Burden, and Bob Flanagan.

———. "Interpreting Feminist Bodies: The Unframeability of Desire." In *The Rhetoric of the Frame: Essays
 towards a Critical Theory of the Frame in Art*, edited by Paul Duro, 223–41. Cambridge: Cambridge
 University Press.

———. "Postfeminism, Feminist Pleasures, and Embodied Theories of Art." In *New Feminist Criticism*,
 edited by Joanna Frueh, Cassandra L. Langer, and Arlene Raven, 16–41. New York: HarperCollins,
 1994.

Juno, Andrea, and V. Vale, eds. *Bob Flanagan: Supermasochist*. San Francisco: Re/Search Publications, 1993.

Kaplan, E. Ann. *Women and Film: Both Sides of the Camera*. New York: Methuen, 1983.

Kaplan, Louise J. *Female Perversions*. New York: Anchor, 1991.

Kaprow, Allan. *Assemblage, Environments, and Happenings*. New York: Abrams, 1966.

Kaye, Nick. *Postmodernism and Performance*. New York: St. Martin's, 1994.

Kelly, Mary. "Re-viewing Modernist Criticism." *Screen* 22 (autumn 1981): 41–62. Reference to Gina Pane.

Kirshner, Judith Russi. *Vito Acconci, A Retrospective: 1969 to 1980*. Chicago: Museum of Contemporary Art,
 1980.

Knaän, Dan. "Marina Abramović and Ulay, and the von Graevenitz's Outlook on Violence in Some Body Art:
 Towards a Definition of Intellectual Rubbish." *Naar een definitie van Kunst* (1983): 19–26 (English).

Kontová, Helena. "Marina Abramović/Ulay." *Flash Art*, February–April 1978, 43–44. Interview.

———. "Three Europeans in California." *Flash Art*, January–February 1979, 47. Reference to Gina Pane.

———. "The Wound as a Sign: An Encounter with Gina Pane." *Flash Art*, October–November 1979, 36–37.

Kotz, Liz. "Beyond the Pleasure Principle." *Lusitania* 6 (1994): 125–36. References to Vito Acconci, Lutz
 Bacher, and Gina Pane.

———. "Erotics of the Image." *Art Papers*, November–December 1994, 16–20. Reference to Catherine Opie.

———. "Sex with Strangers." *Artforum*, September 1992, 83–85. On Lutz Bacher. References to Vito Ac-
 conci and Chris Burden.

———. "Video: Process and Duration." In *Acting Out: The Body in Video, Then and Now,* edited by the
 Henry Moore Gallery, Royal College of Art, 16–26. London: Henry Moore Gallery, Royal College of
 Art, 1994. Reference to Vito Acconci.

Kozloff, Max. "Pygmalion Reversed." *Artforum*, November 1975, 30–37. References to Vito Acconci and
 Chris Burden.

Krafft-Ebing, Richard von. *Psychopathia Sexualis*. 1886. Reprint, New York: Pioneer, 1953.

Krauss, Rosalind. "Notes on the Index: Seventies Art in America (Part 1)." *October* 3 (spring 1977): 68–81.

———. "Notes on the Index: Seventies Art in America (Part 2)." *October* 4 (fall 1977): 58–67.

Kristeva, Julia. *Powers of Horror: An Essay on Abjection*. Translated by Leon S. Roudiez. New York: Columbia
 University Press, 1982.

Künstlerhaus Bethanien, ed. *Performance—Another Dimension*. Berlin: Frölich & Kaufmann, 1983. Inter-
 views with Marina Abramović/Ulay and Gina Pane.

Kunst Station Sankt Peter. *Gina Pane: La chair ressuscitée.* Cologne: Kunst Station Sankt Peter, 1989.

Kunz, Martin. "Interview with Vito Acconci about the Development of His Work since 1966." In *Vito Acconci,* n.p. Lucerne: Kunstmuseum Lucerne, 1978.

Kuspit, Donald. "Chris Burden: The Feel of Power." In *Chris Burden: A Twenty-Year Survey,* edited by Anne Ayres and Paul Schimmel, 37–43. Newport Harbor, Calif.: Newport Harbor Art Museum, 1988.

———. *Signs of Psyche in Modern and Postmodern Art.* Cambridge: Cambridge University Press, 1993.

Lacan, Jacques. "The Meaning of the Phallus." 1958. In *Feminine Sexuality,* by Jacques Lacan, edited by Juliet Mitchell and Jacqueline Rose, translated by Jacqueline Rose, 74–85. New York: Norton, 1985.

———. "The Mirror Stage as Formative of the Function of the I as Revealed in Psychoanalytic Experience." 1949. In *Écrits: A Selection,* translated by Alan Sheridan, 1–7. New York: Norton, 1977.

Laplanche, Jean. *Life and Death in Psychoanalysis.* Translated by Jeffrey Mehlman. Baltimore: Johns Hopkins University Press, 1976.

Lawless, Catherine. "Entretien avec Gina Pane." *Les Cahiers du Musée National d'Art Moderne* 29 (autumn 1989): 97–104.

Lebel, Jean-Jacques. "On the Necessity of Violation." 1968. In *Happenings and Other Acts,* edited by Mariellen R. Sandford, 268–84. London and New York: Routledge, 1995. Originally published in *TDR: The Drama Review* 13, no. 1 (T41, fall 1968): 89–105.

Leung, Simon. "Squatting through Violence." *Documents* 6 (spring–summer 1995): 92–101.

Levine, Edward. "In Pursuit of Acconci." *Artforum,* April 1977, 38–41.

Licht, Ira. *Bodyworks.* Chicago: Museum of Contemporary Art, 1975.

Lichtenstein, Therese. "Behind Closed Doors: Hans Bellmer." *Artforum,* March 1991, 118–22.

———. *Behind Closed Doors: Hans Bellmer's Dolls in the Context of Nazi Germany.* Berkeley and Los Angeles: University of California Press, forthcoming.

———. "Hans Bellmer's Dolls: Images of Pleasure, Pain, and Perversion." *Sulfur* 26 (spring 1990): 54–64.

Linker, Kate. *Vito Acconci.* New York: Rizzoli, 1994.

Lippard, Lucy R. "The Pains and Pleasures of Rebirth." *Art in America,* May–June 1976, 73–81. References to Marina Abramović, Vito Acconci, and Gina Pane.

Loeffler, Carl E., and Darlene Tong, eds. *Performance Anthology: Source Book of California Performance Art.* Rev. ed. San Francisco: Last Gasp Press and Contemporary Arts Press, 1989. References to Chris Burden.

Louvre, Alf, and Jeffrey Walsh. *Tell Me Lies about Vietnam: Cultural Battles for the Meaning of the War.* Milton Keynes, England: Open University Press, 1988.

McAdams, Dona Ann. *Caught in the Act: A Look at Contemporary Multimedia Performance.* New York: Aperture, 1996.

MacDonald, Claire. "Assumed Identities: Feminism, Autobiography, and Performance Art." In *The Uses of Autobiography,* edited by Julia Swindells, 187–95. London: Taylor & Francis, 1995.

———. *Feminism and Performance Art: Histories and Strategies.* London and New York: Routledge, forthcoming.

McEvilley, Thomas. "Art in the Dark." *Artforum,* summer 1983, 62–71. Reference to Chris Burden.

———. "Ethics, Esthetics, and Relation in the Work of Marina Abramović and Ulay." In *Modus Vivendi,* edited by Marina Abramović/Ulay, 9–14. Eindhoven, Netherlands: Stedelijk van Abbemuseum, 1985.

———. "Marina Abramović/Ulay." *Artforum,* September 1983, 52–55.

———. "The Serpent in the Stone." In *Marina Abramović: Objects, Performance, Video, and Sound,* edited by Chrissie Iles, 45–53. Oxford: Museum of Modern Art, 1995.

McEvilley, Thomas, and Ulay. *The First Act.* Ostfildern, Germany: Cantz Verlag, 1994.

Mansfield, Nick. *Masochism: The Art of Power.* Westport, Conn.: Praeger, 1997.

Marette, Chantal, Marina Abramović, and Yves J. Hayat. "The House Is My Body/Mon corps de maison." *Galeries Magazine,* summer 1995, 72–78, 124.

Marioni, Tom. "Real Social Realism." *Vision* 2 (January 1976): 7–16, 27–29. Reference to Marina Abramović.

Martin, Carol, ed. *A Sourcebook of Feminist Theatre and Performance.* London and New York: Routledge, 1996.

Mayer, Rosemary. "Performance and Experience." *Arts Magazine*, December 1972–January 1973, 33–36. References to Vito Acconci and Chris Burden.

Melville, Stephen. "How Should Acconci Count for Us? Notes on a Retrospect." *October* 18 (fall 1981): 79–89.

Mennekes, Friedhelm. "Friedhelm Mennekes Interviewing Gina Pane, March 1989." In *Gina Pane: La chair ressuscitée*, edited by Kunst Station Sankt Peter, 54–57. Cologne: Kunst Station Sankt Peter, 1989.

Micha, René. "Gina Pane." *Art International*, summer 1976, 59.

Michaels, Walter Benn. "The Phenomenology of Contract." In *The Gold Standard and the Logic of Naturalism*, 115–36. Berkeley and Los Angeles: University of California Press, 1987.

Millett, Kate. *The Politics of Cruelty: An Essay on the Literature of Political Imprisonment.* New York: Norton, 1994.

Montgomery, Cara. "Reviews: Los Angeles." *Arts Magazine*, March 1973, 66. Reference to Chris Burden.

Moore-Gilbert, Bart. *The Arts in the 1970s: Cultural Closure?* London and New York: Routledge, 1994.

Morgan, Robert C. "Half-Truth: Performance and the Photograph." In *Action/Performance and the Photograph*, edited by Craig Krull, n.p. Los Angeles: Turner/Krull Galleries, 1993.

Morris, David B. *The Culture of Pain.* Berkeley and Los Angeles: University of California Press, 1991.

Morris, Robert. "Some Splashes in the Ebb Tide." *Artforum*, February 1973, 42–49. Reference to Vito Acconci.

Mullin, Diane Alison. "Acconci and the Other Body." Master's thesis, Washington University, 1989.

Murray, Timothy. "The Contrast Hurts: Censoring the Ladies Liberty in Performance." In *The Administration of Aesthetics: Censorship, Political Criticism, and the Public Sphere*, edited by Richard Burt, 260–88. Minneapolis: University of Minnesota Press, 1994.

Museum of Contemporary Art, Chicago. *Performance Anxiety.* Chicago: Museum of Contemporary Art, 1997.

Nemser, Cindy. "An Interview with Vito Acconci." *Arts Magazine*, March 1971, 20–23.

———. "Subject-Object Body Art." *Arts Magazine*, September–October 1971, 38–42.

Nitsch, Hermann. *Orgien Mysterien Theater/Orgies Mysteries Theatre.* Darmstadt, Germany: Marz Verlag, 1969.

Nochlin, Linda. "Why Have There Been No Great Women Artists?" 1971. In *Women, Art, and Power and Other Essays*, 145–78. New York: Harper & Row, 1988.

Norris, Frank. *McTeague.* 1899. New York: New American Library, 1964.

O'Dell, Kathy. "Displacing the Haptic: Performance Art, the Photographic Document, and the 1970s." *Performance Research* (London) 2, no. 1 (spring 1997): 73–81. References to Vito Acconci, Chris Burden, and Gina Pane.

———. "Fluxus Feminus." *TDR: The Drama Review* 41, no. 1 (T153, spring 1997): 43–60.

———. "Gina Pane." In *Dictionary of Women Artists*, edited by Delia Gaze, 1063–66. London: Fitzroy Dearborn, 1997.

———. "The Performance Artist as Masochistic Woman." *Arts Magazine*, summer 1988, 96–98. References to Vito Acconci and Gina Pane.

———. "Performance, Video, and Trouble in the Home." In *Illuminating Video: An Essential Guide to Video Art*, edited by Doug Hall and Sally Jo Fifer, 135–51, 501–5. New York: Aperture, in association with Bay Area Video Coalition, 1990. Reference to Vito Acconci.

———. Review of *The Freudian Body: Psychoanalysis and Art*, by Leo Bersani. *Critical Texts* (New York) 4, no. 3 (1987): 34–37.

————. "Toward a Theory of Performance Art: An Investigation of Its Sites." Ph.D. diss., City University of New York, 1992.

Onorato, Ronald J. *Vito Acconci: Domestic Trappings.* La Jolla, Calif.: La Jolla Museum of Contemporary Art, 1987.

Opheim, Teresa. "Self-Mutilation: Pain to Forget Pain." *Utne Reader*, March–April 1987, 21.

Palau de la Virreina. *Gina Pane.* Barcelona: Palau de la Virreina, 1990.

Pane, Gina. "Action: Laure." *High Performance*, February 1978, 18–19.

————. "The Body and Its Support-Image for Non-linguistic Communication." *arTitudes*, February–March 1973, 10.

————. "Nourriture, actualités télévisées, feu." *arTitudes*, October–December 1974, 39.

————. "Program Notes." In *Il corpo come linguaggio (La "Body-art" e storie simili)*, edited by Lea Vergine, translated by Henry Martin, n.p. Milan: Giampaolo Prearo Editore, 1974.

————. Review of *Il corpo come linguaggio (La "Body-art" e storie simili)*, edited by Lea Vergine. *Domus*, October 1974, 56.

Parker, Andrew, and Eve Kosofsky Sedgwick, eds. *Performativity and Performance.* London and New York: Routledge, 1995.

Pateman, Carole. *The Sexual Contract.* Stanford: Stanford University Press, 1988.

Pellegrini, Ann. *Performance Anxieties: Staging Psychoanalysis, Staging Race.* London and New York: Routledge, 1997.

Pesenti, Laurent. "La mise 'en chair': Entretien avec Gina Pane." *Les nouvelles*, 22 December 1983, 79.

Phelan, Peggy. *Unmarked: The Politics of Performance.* London and New York: Routledge, 1993.

Phipps, Jennifer. "Marina Abramović/Ulay, Ulay/Marina Abramović." *Art and Text*, spring 1981, 43–50.

Pijnappel, Johan. "Marina Abramović: Reflections on the Mental and Physical Conditioning of the Artist." In *Performance Art into the Nineties,* by Art & Design, 48–51. London: Art & Design, 1994. Interview.

Pincus-Witten, Robert. "Vito Acconci and the Conceptual Performance." *Artforum*, April 1972, 47–49.

Plagens, Peter. "He Got Shot—for His Art." *New York Times*, 2 September 1973, D1, D3. On Chris Burden.

Pluchart, François. "Gina Pane: Briser les servo-mécanismes." *arTitudes*, June 1972, 6.

————. "Gina Pane's Biological Aggressions." *arTitudes*, December 1971–January 1972, 9–10.

————. "Gina Pane's Performances." *arTitudes*, February–March 1973, 15.

————. *L'art corporel.* Paris: Editions Rodolphe Stadler, 1975.

————. "Risk as the Practice of Thought." 1978. In *The Art of Performance: A Critical Anthology*, edited by Gregory Battcock and Robert Nickas, 125–34. New York: Dutton, 1984. References to Marina Abramović/Ulay, Vito Acconci, Chris Burden, and Gina Pane.

Poggi, Christine. "Following Acconci or Beholding as Transgressive Performance." Paper presented at the annual meeting of the College Art Association, New York, N.Y., February 1997.

————. "Vito Acconci's Bad Dream of Domesticity." In *Not at Home: The Suppression of Domesticity in Modern Art and Architecture*, edited by Christopher Reed, 237–52. London: Thames & Hudson, 1996.

Pollock, Griselda. *Vision and Difference: Femininity, Feminism, and the Histories of Art.* London and New York: Routledge, 1988.

Pontbriand, Chantal, ed. *Performance Text(e)s and Documents.* Montreal: Parachute, 1981.

Prince, Richard. "Vito Acconci." *Bomb*, summer 1991, 53–59. Interview.

Pultz, John. "1960–1975: The Body, Photography, and Art in the Era of Vietnam." Chapter 5 in *The Body and the Lens: Photography 1839 to the Present*, 113–41. New York: Abrams.

Quarantelli, Ezio, and Gina Pane. "Travels with St. Francis." *Contemporanea*, November–December 1988, 44–47. Interview.

Radice, Barbara. "Chris Burden." *Data*, September–October 1975, 68–69 (Italian), n.p. (English). Interview.

Reader, Keith. *Intellectuals and the Left in France since 1968.* New York: St. Martin's, 1987.

Reik, Theodor. "Masochism in Modern Man." In *Of Love and Lust: On the Psychoanalysis of Romantic and Sexual Emotions*. 1949. Reprint, New York: Farrar, Straus & Giroux, 1984.

Reinelt, Janelle G., and Joseph R. Roach, eds. *Critical Theory and Performance*. Ann Arbor: University of Michigan Press, 1992.

Rickey, Carrie. "Vito Acconci: The Body Impolitic." *Art in America*, October 1980, 118–23.

Robins, Kevin. "Vision and Touch." In *Into the Image: Culture and Politics in the Field of Vision*, 29–33. London and New York: Routledge, 1996.

Rosenthal, Rachel. "Stelarc, Performance, and Masochism." In *Obsolete Body/Suspensions/Stelarc*, edited by James D. Paffrath and Stelarc, 69–71. Davis, Calif.: JP Publications, 1984.

Roth, Moira. "Toward a History of California Performance: Part Two." *Arts Magazine*, June 1978, 114–23. Reference to Chris Burden.

———, ed. *The Amazing Decade: Women and Performance Art in America, 1970–1980*. Los Angeles: Astro Artz, 1983.

Rousseau, Jean-Jacques. "The Social Contract." In *The Essential Rousseau*, translated by Lowell Bair, 1–124. New York: Meridian, 1975.

Rubinfien, Leo. "Chris Burden." *Art in America*, September–October 1978, 79–80. Interview.

Russell, Mark, ed. *Out of Character: Rants, Raves, and Monologues from Today's Top Performance Artists*. New York: Bantam, 1997.

Sacher-Masoch, Wanda von. *The Confessions of Wanda von Sacher-Masoch*. Edited by V. Vale and Andrea Juno. Translated by Marian Phillips, Laura Anders, Caroline Hébert, and V. Vale. San Francisco: Re/Search Publications, 1990.

Sayre, Henry M. *The Object of Performance: The American Avant-Garde since 1970*. Chicago: University of Chicago Press, 1989.

Scarry, Elaine. *The Body in Pain: The Making and Unmaking of the World*. New York: Oxford University Press, 1985.

———. "The Merging of Bodies and Artifacts in the Social Contract." In *Culture on the Brink: Ideologies of Technology*, edited by Gretchen Bender and Timothy Druckrey, 85–97, 144–45. Seattle: Bay, 1994.

Schaber, Gordon D., and Claude D. Rohwer. *Contracts in a Nutshell*. 3d ed. St. Paul, Minn.: West, 1990.

Scheftel, Susan, Amy S. Nathan, Andrew M. Razin, and Peter Mezan. "A Case of Radical Facial Self-Mutilation: An Unprecedented Event and Its Impact." *Bulletin of the Menninger Clinic* 50 (November 1986): 525–40.

Schjeldahl, Peter. "Vito Acconci at Sonnabend." *Art in America*, March–April, 1972, 119.

Schneider, Rebecca. *The Explicit Body in Performance*. London and New York: Routledge, 1997.

Schwartz, Ellen. "Vito Acconci: 'I Want to Put the Viewer on Shaky Ground.'" *ARTnews*, summer 1981, 93–99.

Seiberling, Dorothy. "The Art-Martyr." *New York*, 24 May 1976, 48–66.

Sharp, Willoughby. "Body Works." *Avalanche* 1 (fall 1970): 14–17.

Siegel, Carol. *Male Masochism: Modern Revisions of the Story of Love*. Bloomington: Indiana University Press, 1995.

Silverman, Kaja. *Male Subjectivity at the Margins*. London and New York: Routledge, 1992.

———. "Masochism and Male Subjectivity." *Camera Obscura* 17 (May 1988): 31–68.

Sims, Lowery Stokes. "Aspects of Performance in the Work of Black American Women Artists." In *Feminist Art Criticism: An Anthology*, edited by Arlene Raven, Cassandra Langer, and Joanna Frueh, 207–25. Ann Arbor, Mich.: UMI Research Press, 1988.

Skoggard, Ross. "Vito Acconci Stars and Strips." *Art in America*, November–December 1976, 92–93.

Small, Michael. "He Has Forsaken the Violent Art of His Youth, but Chris Burden Is Still out to Startle." *People*, 28 August 1989, 55–56, 65.

Smith, Barbara T. "Art Piece Brings Arrest." *Artweek*, 6 January 1973, 3.

———. "Burden Case Tried, Dismissed." *Artweek*, 24 February 1973, 2.

————. Letter in "Editor's Mail Bag Re: Chris Burden's Performance." *Artweek*, 10 February 1973, 2.

Sondheim, Alan. "Vito Acconci, Work, 1973–1974." *Arts Magazine*, March 1975, 49–52.

Spector, Nancy. "Performing the Body in the 1970s." In *Rrose is a Rrose is a Rrose: Gender Performance in Photography*, by Jennifer Blessing, 156–75. New York: Guggenheim Museum, 1997.

Sporn, Pam. "The War in Vietnam/The War at Home." In *Contemporary Art and Multicultural Education*, edited by Susan Cahan and Zoya Kocur, 307–31. New York: New Museum of Contemporary Art; London and New York: Routledge, 1996.

Stedelijk Museum. *Vito Acconci*. Amsterdam: Stedelijk Museum, 1979.

Stephano, Effie. "Interrogating the Artist." *Art and Artists*, August 1973, 29, 31–32. On Gina Pane.

————. "Paris." *Art and Artists*, June 1976, 38–39. Reference to Gina Pane.

Stephano, Effie, and Gina Pane. "Performance of Concern," *Art and Artists*, April 1973, 20–27.

Stiles, Kristine. "Between Water and Stone." In *In the Spirit of Fluxus*, edited by Elizabeth Armstrong and Joan Rothfuss, 62–99. Minneapolis: Walker Art Center, 1993.

————. "The Destruction in Art Symposium (DIAS): The Radical Cultural Project of Event-Structured Live Art." Ph.D. diss., University of California at Berkeley, 1986.

————. "Performance and Its Objects." *Arts Magazine*, November 1990, 35–47.

————. "Performance Art." In *Theories and Documents of Contemporary Art: A Sourcebook of Artists' Writings*, edited by Kristine Stiles and Peter Selz, 679–94. Berkeley and Los Angeles: University of California Press, 1996. Book includes writings by Marina Abramović/Ulay, Vito Acconci, and Chris Burden.

————. "Sticks and Stones: The Destruction in Art Symposium." *Arts Magazine*, January 1989, 54–60.

————. "Survival Ethos and Destruction Art." *Discourse* 14, no. 2 (spring 1992): 74–102. Reference to Gina Pane.

————. "Synopsis of the Destruction in Art Symposium (DIAS) and Its Theoretical Significance." *The Act* 1, no. 2 (spring 1987): 22–31.

————. "Unbosoming Lennon: The Politics of Yōko Ono's Experience." *Art Criticism* 7, no. 2 (1992): 21–54.

Studlar, Gaylyn. *In the Realm of Pleasure: von Sternberg, Dietrich, and the Masochistic Aesthetic*. Urbana: University of Illinois Press, 1988.

Szasz, Thomas. *Pain and Pleasure: A Study of Bodily Feelings*. 2d ed. 1957. Reprint, Syracuse: Syracuse University Press, 1988.

Thomas, C. David, ed. *As Seen by Both Sides: American and Vietnamese Artists Look at the War*. Boston: Indochina Arts Project, 1991.

Thompson, Bill. *Sadomasochism: Painful Perversion or Pleasurable Play?* London: Cassell, 1994.

Tickner, Lisa. "The Body Politic: Female Sexuality and Women Artists since 1970." *Art History* 1 (June 1978): 236–51. Reference to Gina Pane.

Tomić, Biljana. "Marina Abramović." *Data*, September–October 1975, 74–75.

Trebay, Guy. "Ron Athey's Slice of Life." *Village Voice*, 1 November 1994, 38.

Tucker, Marcia. *Choices: Making an Art of Everyday Life*. New York: New Museum of Contemporary Art, 1986. Marina Abramović/Ulay represented in the exhibition.

Turner, Bryan S. *The Body and Society*. New York: Blackwell, 1984.

Ugwu, Catherine, ed. *Let's Get It On: The Politics of Black Performance*. Seattle: Bay, 1995.

Ulay. *FOTOTOT*. Zagreb: Galerija suvremene umjetnosti, 1977.

Ulay/Marina Abramović, Marina Abramović/Ulay. "Art Vital." *Dutch Art and Architecture Today*, June 1980, 27–32.

Van Baron, Judith. "Chris Burden." *Arts Magazine*, April 1974, 66.

Vance, Carole S. "The War on Culture." *Art in America*, September 1989, 39, 41, 43.

Vergine, Lea. "Bodylanguage." *Art and Artists*, September 1974, 22–27. Reference to Gina Pane.

————. *Gina Pane: Partitions, opere multimedia, 1984–85*. Milan: Radiglione d'Arte Contemporanea, 1985.

———. "Milan." *Art and Artists*, July 1974, 44. Reference to Gina Pane.

———, ed. *Il corpo come linguaggio (La "Body-art" e storie simili)*. Translated by Henry Martin. Milan: Giampaolo Prearo Editore, 1974.

Vergne, Philippe, ed. *L'art au corps: Le corps exposé de Man Ray à nos jours*. Marseilles: Mac, Galeries Contemporaines des Musées de Marseille, 1996.

Verzotti, Giorgio. "Richard Long, Gina Pane, Salvatore Scarpitta." *Flash Art*, April 1986, 75.

Walsh, Barent W., and Paul M. Rosen. *Self-Mutilation: Theory, Research, and Treatment*. New York: Guilford, 1988.

Walsh, Jeffrey, and James Aulich. *Vietnam Images: War and Representation*. New York: St. Martin's, 1989.

Watson, Alan. *The Evolution of Law*. Baltimore: Johns Hopkins University Press, 1985.

Weinberg, Thomas S., ed. *S and M: Studies in Dominance and Submission*. Amherst, N.Y.: Prometheus, 1995.

White, Robin, and Vito Acconci. "Vito Acconci." *View* 2, nos. 5–6 (October–November 1979): 1–47. Interview.

White, Robin, and Chris Burden. "Chris Burden." *View* 1, no. 8 (January 1979): 1–19. Interview.

Williams, Reese, and the Washington Project for the Arts, eds. *Unwinding the Vietnam War: From War into Peace*. Seattle: Real Comet, 1987.

Winkler, Wolfgang. "Ulay's Transfer von Bildern durch Bilder hindurch." In *Ulay*, by the Yamaguchi Prefectural Museum of Art. Tokyo: Yamaguchi Prefectural Museum of Art, 1997.

Withers, Josephine. "Feminist Performance Art: Performing, Discovering, Transforming Ourselves." In *The Power of Feminist Art: The American Movement of the 1970s, History and Impact*, edited by Norma Broude and Mary D. Garrard, 158–73. New York: Abrams, 1994.

Wortz, Melinda Terbell. "An Evening with Chris Burden." *Artweek*, 22–29 December 1973, 5.

Yamaguchi Prefectural Museum of Art. *Ulay*. Tokyo: Yamaguchi Prefectural Museum of Art, 1997.

Zegher, M. Catherine de, ed. *Inside the Visible: An Elliptical Traverse of Twentieth Century Art in, of, and from the Feminine*. Cambridge: MIT Press, 1996.

Zelevansky, Lynn. "Is There Life after Performance?" *Flash Art*, December 1981–January 1982, 38–42.

I N D E X

Compiled by Eileen Quam and Theresa Wolner

K A T H Y O ' D E L L is assistant professor of art history and theory in the Department of Visual Arts at the University of Maryland Baltimore County. Her writings on performance art have appeared in *Artforum, Art in America, Arts Magazine, Link, Performance Research,* and *TDR: The Drama Review.*